Historic
WHITEFISH BAY

STREET MAP OF THE
**VILLAGE OF
WHITEFISH BAY,
WISCONSIN**

Showing Proposed Historic Neighborhoods

Historic WHITEFISH BAY

A Celebration of Architecture and Character

Jefferson J. Aikin
and Thomas H. Fehring

The History Press

Published by The History Press
Charleston, SC
www.historypress.net

Copyright © 2017 by Jefferson J. Aikin and Thomas H. Fehring

All rights reserved

Front cover, clockwise from top left: the Joseph E. and Josephine Langois House, 700 East Briarwood Place, circa 1892; the Kellogg Patten House, 4684 North Wilshire Road, circa 1930; the Harry and Ada LeVine House, 5230 North Lake Drive, circa 1923; the E.A. and Anita Weschler House, 4724 North Wilshire Road, circa 1929, designed by architect Armin C. Frank; Whitefish Bay High School, 1200 East Fairmount Avenue, circa 1932, designed by architect Herbert Tullgren; and the John J. and Laura McCoy House, 1093 East Circle Drive, circa 1927.

Back cover, left: The James and Anna (Juneau) McGee House, 5569 North Lake Drive, circa 1893, one of the Lake Drive Twins. Pictured here are Henry R. King, James McGee's business partner and owner, with Marian (Juneau) King, Anna McGee's sister, of the second twin at 5559 North Lake Drive; Pauline McGee (on donkey); Harry King; and Paul Juneau King (the girl in the cart could not be identified); *right*: stairs to Lake Michigan constructed by Works Progress Administration (WPA) crews during the Depression of 1929 for Big Bay Park; *inset*: a map of Whitefish Bay showing the twelve residential historic districts and the two church complexes—St. Monica and Holy Family—proposed for placement in the National Register of Historic Places by the Wisconsin Historical Society.

First published 2017

Manufactured in the United States

ISBN 9781467137591

Library of Congress Control Number: 2017945029

Notice: The information in this book is true and complete to the best of our knowledge. It is offered without guarantee on the part of the authors or The History Press. The authors and The History Press disclaim all liability in connection with the use of this book.

All rights reserved. No part of this book may be reproduced or transmitted in any form whatsoever without prior written permission from the publisher except in the case of brief quotations embodied in critical articles and reviews.

To Mimi Bird, without whose pioneering work Whitefish Bay would have no history to remember.

"As we all know, life with Mimi is never dull."

—the *Tower* yearbook, Whitefish Bay High School, Class of 1950

CONTENTS

Acknowledgements 9
Preface 11
Introduction 17

1. The Early Settlers 21
2. Historic Day Avenue 36
3. A Stroll down Lake Drive: The Grand Homes of Lake Drive
 (and One Historic Restaurant and Park) 49
4. Bay Residents You Wish You Had Known 81
5. Important Architects and Designers 118
6. Downtown Whitefish Bay 135
7. Whitefish Bay Institutions: Churches, Schools, Clubs and Lodges 146
8. Lake Heights, Lawndale and the Bay Ridge and
 Kent Avenues Historic Districts 162
9. Pabst, Idlewild and Lake Crest Historic Districts 176
10. Fairmount and Highland View, Cumberland Forest
 and Palo Alto, Big Bay Park and Bay Village Historic Districts 191
11. Lake Woods and Ortonwood Triangle and Wilshire Historic Districts 203

Appendix. Properties on the Whitefish Bay Architecture
 and History Inventory (AHI) 215
Index 233
About the Authors 239

ACKNOWLEDGEMENTS

The authors would like to acknowledge and thank the following for their helpful assistance:

- Architect Jennifer Lehrke and her Wisconsin Historical Society survey team whose intensive survey provided direction and guidance on Whitefish Bay's history, and whose members were helpful in providing assistance.
- Miriam "Mimi" Bird, whose early research into the village's past produced an extensive archive that is invaluable to anyone interested in learning about Whitefish Bay history.
- The Whitefish Bay Historic Preservation Commission for its work to preserve the history of Whitefish Bay's historic homes and highlight the many architectural gems located throughout the community, and to its members who provided support, encouragement and advice toward this endeavor.
- The Whitefish Bay Historical Society for providing the use of its files of historic photographs of the village.
- The staff of the Whitefish Bay Library for their frequent, helpful and patient assistance in researching this book.
- The Whitefish Bay Women's Club for the use of its facilities and research materials.
- The Milwaukee County Historical Society for its assistance, advice, research materials and photographs.

Acknowledgements

- The Medical College of Wisconsin and the Zilber Family Foundation for their assistance in obtaining photos of village residents.
- The Whitefish Bay School District and the following photographers and photo studios for the use of their *Tower* yearbook student class photos: Worzella Photography, Cilento Photography dba Lifetouch, John E. Platz Photographers, Gersen Bernhardt, the Schroeder Studio and the Morrison Studio.
- John "Eagle-Eye" Hoylman for his proofreading of this manuscript.

PREFACE

Residents of Whitefish Bay have long thought that there was something special and uniquely charming about the homes in their community, but it was not until 2011 that they learned in greater detail about the treasures in their midst.

That was the year that the Wisconsin Historical Society, a state government agency, and a team lead by architectural historian Jennifer Lehrke completed an intensive survey of Whitefish Bay's residential and business structures. Digging deep into village and historical records—an effort handicapped by a 1927 flood that destroyed nearly 50 years of village records up to that time—Lehrke's team spent nearly 2 years investigating and cataloguing every historic property in Whitefish Bay. Lehrke's four-hundred-page report is today the village's definitive compilation of its 150-plus years of architectural history. It separately documented nearly three thousand individual buildings that were deemed to be historic properties. It found that approximately 60 percent of the nearly five thousand residential, commercial and institutional structures in Whitefish Bay are considered historic or architecturally significant.

This book uses the 2011 survey report as the jumping-off point to describe the properties discussed in this book. That work was combined with additional research of village and historical records by members of the Whitefish Bay Historic Preservation Commission and with information and submissions from other institutions and individuals who have contributed to this book.

Preface

What makes a property *historic*? Is a property historic just by being old? What are the benefits that come with owning a historic property, and do all historic properties realize these benefits? Are there disadvantages to owning a historic property? Here are the various ways the term *historic* is used in this book.

- Per the U.S. Department of Interior, which maintains the National Register of Historic Places program that provides qualifying properties with income tax credits, a building is historic if it is at least fifty years old and is intact; that is, the structure is essentially unchanged from when it was built and the materials used to repair it are the same as the original. For example, the deteriorated siding of a wood frame house has been replaced with new wood siding, not vinyl or aluminum siding; or a dilapidated shale roof has been replaced with shale, not composite asphalt shingles. All of the nearly three thousand properties surveyed by the state meet these minimum standards. But that alone does not earn them recognition in the National Registry.

In cataloguing the nearly three thousand historic properties in Whitefish Bay, the state survey identified approximately two thousand homes as *contributing historic properties*. These residences meet the criteria of age and intactness, and in addition, there are so many of them clustered in a specific neighborhood that collectively they form a *proposed residential historic district*. The homes in the district must share a certain unity, such as having been built during the same period in history, or have a certain architectural style or method of construction in common. By themselves, none of the contributing historic properties would qualify for the National Registry or the income tax credits that come with the listing. But as contributing properties in a historic district, all of the homes are placed in the National Registry and all qualify for income tax credits once the historic district is recognized.

Individual homes described in this book that are contributing historic properties are so noted. In addition, maps of the 12 proposed residential historic districts, showing their boundaries and each of the contributing historic properties in each district by house number, accompany the chapters about the districts. Just under 2,000 homes, or roughly half of Whitefish Bay's residential buildings, are in one of the 12 historic districts, which range in size from 11 homes to 397 homes. What makes Whitefish Bay unique among older Wisconsin communities is that its historic districts are

remarkably intact. Indeed, no fewer than 94 percent of the homes in each historic district qualify as contributing historic properties.

- In addition to identifying the contributing historical properties included in each of the proposed historic districts, the State Historical Society determined that 107 properties are *individually eligible* for placement in the National Registry. In the Whitefish Bay survey, these properties qualify because they are architecturally distinctive or because they are an exemplary example of an architectural style. The owners of these properties do not need to be in a historic district to obtain the income tax credits. They can apply for them immediately. About one-third of the 107 individually eligible properties lie outside the proposed historic districts, so this status is especially important to owners who wish to take advantage of the income tax credits. Properties that are individually eligible are so noted, and are listed in the appendix as "Individually Eligible for Listing in the NR."
- Fourteen homes in the Bay have already been placed in the National Register of Historic Places through the efforts of historic preservationists in the 1980s. These properties are so noted and are identified in the appendix as "On National and WI Registers"
- Six historic sites have been identified as historic landmarks by the Milwaukee County Historic Society. Those properties are so noted and are shown in the appendix as "Milwaukee County Landmark."
- Homes on the Whitefish Bay Architecture and History Inventory (AHI) have been identified, researched, catalogued and publicized for informational and educational purposes by the Whitefish Bay Historic Preservation Commission. There are nearly 230 historic properties on the AHI to date, including the 14 properties now in the National Registry and the 107 properties individually eligible for listing. But some properties on the Whitefish Bay AHI are not recognized as historic by the State Historical Society but are considered historic by the village. For example, the state did not deem the Lake Drive Twins at 5559 and 5569 North Lake Drive, both built in 1893, to be historic properties because their façades have been altered over the past 124 years and the materials used for repairs differ from the original. Despite these shortcomings, the village still considers them historic because their original owners were both nationally prominent businessmen in their industry and important in Milwaukee and Whitefish Bay history, and both of their wives were the granddaughters of Solomon Juneau,

Preface

a Milwaukee founding father and the city's first mayor. Every property address that is bold-faced in this book is in the Whitefish Bay AHI. The complete list of properties on the AHI is listed in the appendix.
- There are four homes on the AHI that are in the Whitefish Bay Register of Historic Places. This is a local registry separate from both the National Registry and from the village's AHI. This local registry uses the same strict standards that the state uses for determining whether a property is individually eligible for the National Registry. However, listing in the village's registry does not by itself obtain tax benefits for the owners. Properties in this category are so noted and are listed as "Whitefish Bay Landmark Status" in the appendix.

In her report, Lehrke and the Wisconsin Historical Society identified the twelve proposed residential historic districts; placement in the National Registry would qualify the owners of homes in those districts for federal and state income tax credits for the cost of repairs, maintenance and upgrades to their properties. The state survey alone did not place any proposed historic districts in the National Registry—for that separate applications must be submitted to and approved by the State Historical Society. But by proposing the districts in its survey, the state has laid the groundwork for such applications and provided a running start toward approval and recognition of each of the historic districts.

The state survey also identified two religious complexes that are individually eligible for placement in the National Registry—the St. Monica Church and Dominican High School complex north of Silver Spring Drive and the Holy Family Church and school complex north of Hampton Road.

Whitefish Bay's downtown district between Lydell Avenue and Lake Drive was not considered a proposed historic district—although twenty-eight of its thirty-eight properties are considered historic and fifteen structures, including the Fox Bay Building, the Gotfredson Building and the former Whitefish Bay Pharmacy Building, are individually eligible for placement in the National Registry.

What is the benefit of a property being in the National Registry, either as individually eligible or as part of a historic district? First, it does not mean that the owner's use of the property is restricted in any way. Home and business owners may generally alter, remodel, modify or modernize the property however they wish. They may even raze the property.

The National Registry program provides a financial incentive through the use of income tax credits for owners to maintain and repair their homes and

business buildings in a manner that is sympathetic to the property's historic character. Homeowners receive a 25 percent income tax credit on the total cost of the work—20 percent from the state and 5 percent from the federal government. For business properties, the credits total 40 percent—state 20 percent and federal 20 percent. The unused credits carry over year to year until fully consumed. For example, if a homeowner did $10,000 of qualifying repairs to his or her residence, he or she would receive a $2,000 state income tax credit and a $500 federal income tax credit. If he or she only used $1,000 of the state credit the first year, the remaining $1,000 credit could be used as offsets to state income taxes the following year and in future years until the credit is all used up.

Qualifying repairs include work on the exterior of the property such as painting and roof replacement; repair and replacement of electrical wiring, plumbing and mechanical systems such as furnaces, air conditioning and water heaters; and structural work such as tuck pointing or foundation or floor jacking—tasks that virtually every property owner performs. The project must cost at least $10,000 and no more than $40,000 and must be completed over a two-year period, extendable to five years upon request. Small jobs can be combined to reach the $10,000 minimum, and large projects can be broken down into two or more smaller jobs to keep each under the $40,000 maximum, allowing the homeowner to receive tax credits on all of them. However, before starting any tax-favored project, the homeowner must first submit it to the State Historical Society to be certain that it qualifies for the tax credits. Tax credits cannot be granted retroactively once the project begins.

For more information about historical tax credits, readers should check the Wisconsin Historical Society website.

Readers can find the current list of properties on the Whitefish Bay Architecture and History Inventory and information about each by going to the Historic Preservation Commission's page on the village's website. Readers can also obtain information about each AHI property and their location on a village map by scanning this QR code with their smartphones.

INTRODUCTION

In retrospect, given its idyllic lakeside setting, its easy commute to downtown Milwaukee and its location in the North Shore corridor of affluent neighborhoods and villages that developed from Milwaukee's downtown to Ozaukee County, it is easy to believe that Whitefish Bay was always destined to be the pleasant, upscale community it is today.

But in fact, looking back over 150 years, Whitefish Bay's early history suggests it was as likely to become an industrial city like West Milwaukee or Butler as it was to take on the tranquil appeal of Fox Point, Shorewood and Milwaukee's East Side. Whitefish Bay was home to a munitions plant, a major cement factory and quarry was located near its southwest border and the major economic forces in play at that time determined Whitefish Bay would contain a major railroad yard. The area immediately west of the village was being considered for the Wisconsin State Fairgrounds (which was ultimately placed in West Allis), a large lumberyard was located adjacent to the railroad tracks near Santa Monica Boulevard and Hampton Road and land to the north and east had been zoned industrial.

In a paper written by Donald C. Rambadt of the Department of Geography at the University of Wisconsin–Whitewater on the occasion of Whitefish Bay's 1992 centennial, Rambadt traced the political and business developments that bent Whitefish Bay's destiny in another direction. Whitefish Bay, Rambadt wrote, "was the first community in the State of Wisconsin that established its own political entity as a suburb." And that event was critical in making Whitefish Bay what it is today.

Introduction

In 1833, when Wisconsin was still a territory, the U.S. government signed a treaty with the Indian tribes in eastern Wisconsin to obtain 2.5 million acres of land, including what is now Whitefish Bay, and sold it at auction for $1.25 an acre. Much of the land was sold to speculators. The first land purchase in the Bay occurred in 1835 when Joel Buttles of Columbus, Ohio, bought 240 acres in an area extending from what is today Silver Spring Drive south to Hampton Road and from Lydell Avenue east to Idlewild Avenue.

The early settlers were farmers. In 1838, A. Markert settled on thirty-two acres in an area near Fairmount and Lydell Avenues just north of where the Bay Village Apartments on Hampton Road are today. The Swain family cleared land and planted an apple orchard in the 1840s. In 1844, E.G. Everts arrived from New York and bought thirty-five acres near what is now Klode Park.

In 1847, another family of settlers arrived. William and Hannah Consaul moved from Toledo, and in 1853, they built a home at **716 East Silver Spring Drive** that is believed to be the oldest structure in Whitefish Bay. Consaul's descendants also built homes that still stand today. Frederick Gustave Rabe left Germany, settling in the Armory Park area, and in 1872, he built a home that would later serve as the residence to the Whitefish Bay Armory commanders before it was razed in 2002.

By 1858, when the first plat map was drawn, twenty-two farmers were working the land that would become Whitefish Bay. But after the Civil War, "a change occurred in the transportation system that had a major impact on the development of the area," according to Rambadt.

First was the construction of a toll road in 1869 along the lakefront from what is today Lafayette Place on Milwaukee's East Side to present-day Henry Clay Street, then known as Washington Street. Then, in 1874, the Milwaukee, Lakeshore and Western Railway ran its lines south from Manitowoc to Milwaukee and built a depot near where Whitefish Bay Middle School now sits. In 1886, Guido Pfister, owner of the Pfister Hotel, and others formed the Milwaukee and Whitefish Bay Railway, better known as the dummy line, that went from Farwell and North Avenues in Milwaukee to Henry Clay Street in the Bay, later extended to Day Avenue in 1897.

The presence of the two railroads, the toll road and steamboats from Milwaukee sparked a land boom in 1887, especially along the lakeshore. The Pabst Whitefish Bay Resort opened in 1889 north of what is now Henry Clay Street, and large areas along the lake to the north and south of the resort had been platted for summer homes and housing subdivisions by 1893, the first being the Day Avenue subdivision.

Introduction

The easy access to downtown Milwaukee by rail encouraged commuting. Among the first regular commuters were Henry King and James McGee, prominent businessmen who built their grand Victorian homes, known as the Lake Drive Twins, side by side within a short walk to the rail terminal on Henry Clay Street. They, along with business partner Alonzo Fowle, a Day Avenue developer and resident, and others pushed for the rail lines to be extended to Day Avenue. This encouraged more development, as well as many more summer vacationers and weekend Pabst Resort visitors.

This would seem as it should be. After all, the *Milwaukee Sentinel* had predicted as early as 1872 that the area of Whitefish Bay was "destined to become the summer resort of our citizens."

But the Milwaukee, Lakeshore and Western Railway had other ideas. The railroad had been created to link logging operations in northern Wisconsin to industries in Milwaukee, and in 1887, it purchased huge chunks of land in the future village. Its plans included turning a three-quarter-mile-long stretch between what is now Courtland Place and Henry Clay Street into freight yards and rail car repair shops. The rail business was booming at the time, and such a massive development seemed imminent—until the bubble burst.

February 1893 saw the start of the worst economic depression the United States had ever experienced up to that time, caused by the collapse of railroad overbuilding and shaky railroad loans. The Milwaukee, Lakeshore and Western Railway was forced to scrap its plans, and the newly incorporated Village of Whitefish Bay jumped at the opportunity to decide its own fate.

The village, which had been created by a 72 to 14 vote of its 312 residents on June 7, 1892, so as to form a school district, began rezoning all of the railroad's lands and acquired some for its own needs. Rail yards to the north became Richards School and the German-American Academy, later to become the University School, and today it is the Jewish Community Center. Land along Marlborough Drive was designated for the village hall, the library, the police and fire departments and the first school. The proposed freight yard to the south was set aside for future use. That land would later be used by the Whitefish Bay High School, Whitefish Bay Middle School, Cumberland School, Cahill Square Park and three churches.

In 1922, the village board adopted an ordinance guaranteeing that Whitefish Bay would stay a bedroom suburb of Milwaukee by zoning most of the community residential and making it "unlawful in the Residence District to carry on any trade, business, or industry, or to erect, alter or use any building or structure except for residential purposes."

Introduction

Later, Rambadt wrote, "the automobile would have an enormous impact on the access to various parts of the community, thus impacting on land value and appeal....The changes in the role of the transportation system and the aspirations of the population, especially for an elementary school, were the prime factors in the establishment of the village as a suburb."

Today, 125 years after its incorporation, Whitefish Bay is a leafy "Tree City," a 2.4-square-mile community of approximately five thousand residential and business structures—the vast majority single-family homes—a vibrant half-mile downtown business district in the village's middle and one of the best public school systems in the nation, from which more than 95 percent of its graduates go on to higher education.

What follows is *a* history of Whitefish Bay, not *the* history of Whitefish Bay. This book does not pretend to tell the complete saga of our village. Rather, it attempts to capture some of the nearly two centuries of Whitefish Bay's history through a description of its neighborhoods and homes, sprinkled where known with the stories and tales of the people who lived in them. Whitefish Bay has been the home not just of several illustrious citizens, but also many hardworking and civic-minded residents who loved their community and made Whitefish Bay what it is today. It's also had a few notorious characters. A major part of all their legacies is in the homes they built and the lore they leave behind. We hope this book will help you learn more about these people and appreciate the historic heritage of the beautiful structures they left for us to enjoy.

1
THE EARLY SETTLERS

French trappers were in the Whitefish Bay area as early as 1785. Most prominent was Jacques Vieau, a French Canadian fur trader who was the first white settler in the Milwaukee area; he built his cabin on a bluff over the Menomonee River at what is now Mitchell Park.

In 1818, Vieau hired Solomon Laurent Juneau, a French Canadian trapper who later married Vieau's daughter, Josette Vieau, and established a settlement he named Juneautown on the east bank of the Milwaukee River. (Solomon's cousin was Joseph Juneau, who founded the city of Juneau, Alaska, the state's capital.) Juneautown, along with settlements established by Byron Kilbourn and George Walker, merged in 1846 and became the city of Milwaukee, with Solomon Juneau serving as the city's first mayor.

Marian and Anna Juneau, Solomon Juneau's granddaughters—and the great-grandchildren of Milwaukee's first settler Jacques Vieau—would later become a key part of the history of Whitefish Bay.

In 1833, the Treaty of Chicago forced the Indian tribes out of land west of Lake Michigan. White settlers, especially German immigrants fleeing wars and oppression, began to move into the area in the 1840s and 1850s. Nestled between Lake Michigan and the Milwaukee River, Whitefish Bay was a choice location. The Bay's first settlers were farmers who sold their tomatoes, melons, apples and green vegetables at the city market in downtown Milwaukee. Over the past 170 years, the contributions of many residents have helped make Whitefish Bay the community it is today. But

three family dynasties played especially important roles: the intermarried Kaestner/Mohr/Leu kin, the extended Consaul clan and the four-generation Isenring family.

The Kaestner, Mohr and Leu Families

Among the first settlers were three families—the Kaestners, the Leus and the Mohrs—who emigrated from Germany and settled in the southwestern part of the village. The homes of the original settlers no longer stand, but four houses built in the 1880s by their descendants in the popular Queen Anne style still do.

In 1849, German George Kaestner married Mary Mohr, daughter of John and Eva Mohr. (Eva was John's first wife.) The Kaestners farmed land south of Henry Clay Street, then known as Washington Street. Their son, Henry, and his wife, Alvina, built the house at **106 West Henry Clay Street** in 1880. It originally stood on the south side of Henry Clay Street. Henry and Alvina's daughter, Clara Kaestner, married Fred Mohr, a great-grandchild of John and Ava Mohr, and moved the house across the road to its present location on the north side of Henry Clay Street.

Henry and Alvina Kaestner House, 106 West Henry Clay Street, circa 1880.

A Celebration of Architecture and Character

Julius and Pauline Leu House, 5020 North Santa Monica Boulevard, circa 1880.

In 1850, John and Ava Mohr (John's second wife) lived on twenty acres near what is now Henry Clay Street and Santa Monica Boulevard. The house at **5020 North Santa Monica Boulevard** was originally built in the 1880s on the south side of Hampton Road near Idlewild Avenue by Julius and Pauline Leu. Lester Mohr, John and Ava's grandson and Julius's nephew, moved the house to its Santa Monica Boulevard site in 1889.

Julius Leu came to Milwaukee with his parents in 1865, married Pauline Schreiber and farmed near Lancaster Street and Santa Monica Boulevard for twenty years. Their son, Ludwig, built the house at **400 East Hampton Road** on the south side of Hampton Road near Diversey Boulevard in 1886. It was moved to the north side of Hampton near Berkeley Avenue in 1889 and later occupied by Adelaide Mohr, a granddaughter of Ludwig Leu's, as well as Adelaide's nephew and his wife, the Gordon Mohrs. Adelaide lived in the home until 1992. Ludwig Leu also built the house at **519 East Hampton Road**, in 1880.

In addition to building classic, sturdy homes, all lovingly maintained by their future owners, the three families contributed to the village's civic

Ludwig Leu/Adelaide Mohr House, 400 East Hampton Road, circa 1886.

history. Julius Leu was a village trustee from 1896 to 1899 and from 1908 to 1917. He also served as the village's street commissioner and headed its department of public works. John and Ava Mohr's son, Philip, became the treasurer of the Town of Milwaukee, the township that covered the North Shore before today's suburban municipalities were incorporated. Philip Mohr's son, William, became the village's first lamplighter.

The four homes built by the families are all listed on the Whitefish Bay Architecture and History Inventory (AHI).

THE CONSAUL FAMILY

William Consaul was born in 1796 near Schenectady, New York. He married Eliza Henry in 1816, and they had eleven children, four of whom died in infancy. Eliza died in 1837, and William married Hannah Everts. The family lived in Toledo, Ohio, before moving to Milwaukee in 1847, with most of William's children joining the couple. In 1853, Consaul became one of Whitefish Bay's earliest settlers, farming thirty acres between Lake Michigan and Santa Monica Boulevard and from Silver Spring Drive to

Lake View Avenue. He later bought an additional fifteen acres north of Lake View. His home at **716 East Silver Spring Drive** is believed to have been built around 1853, which would make it the oldest structure still standing in Whitefish Bay. William died in 1855 and is buried in the Town of Milwaukee Cemetery located at the southwest corner of Lydell and Montclair Avenues northeast of Bayshore Mall.

William's son William Henry Consaul inherited the family farm at the age of thirty-five. He married Ruth, an English immigrant, and they lived in his father's home at 716 East Silver Spring Drive. In 1864, William Henry

William and Hannah Consaul House, 716 East Silver Spring, circa 1853. It is believed to be the oldest structure in Whitefish Bay.

and his brother Theodore began operating a fishing company, netting and selling three hundred to six hundred pounds of fish weekly. They later sold the business to Lewis F. Scheife, who married William Henry's daughter, Mary Jane, in 1884. William Henry and Ruth Consaul built a home at **5654 North Santa Monica Boulevard** in the Victorian Gothic style popular in Milwaukee during that period sometime in the 1870s or 1880s. They passed on the house at 716 East Silver Spring Drive to Lewis and Mary Jane Scheife, who later also lived at the 5654 North Santa Monica Boulevard residence. Ruth died in 1886, and William Henry passed in 1889. Both are buried in the Town of Milwaukee Cemetery.

William T. Consaul was the son of William Henry and Ruth. He married Catherine Patricia Carney in 1876, and they lived in a converted bunkhouse constructed to house farm workers. It had been built in the Colonial Revival style at **5668 North Santa Monica Boulevard** sometime in the 1870s. They lived there until around 1895 when they constructed a house in the Victorian Gothic style at **5682 North Santa Monica Boulevard**. Their house was next door to the home of William T.'s brother, Frank Consaul, and his wife, Louise (Loennecker), at **5700 North Santa Monica Boulevard**, built in 1893. William T. was involved in the incorporation of Whitefish Bay in 1892 and was elected as one

The William T. and Patricia Consaul House, 5668 North Santa Monica Boulevard, circa 1870.

A Celebration of Architecture and Character

Lewis and Mary Jane Scheife House, 314 East Beaumont Avenue, circa 1893. Formerly, this house was the first village hall.

of the seven original village trustees. In 1896, he partnered with Lewis Scheife, his brother-in-law, to operate a hardware store at 436 East Silver Spring Drive, a lot now occupied by the Associated Bank Building.

After living in both the Silver Spring and Santa Monica homes, Lewis and Mary Jane Scheife purchased the former village hall, which was located at the time at Fleetwood Place on land that is now Old Schoolhouse Park. The building had originally been a saloon built in 1893 on Lexington Boulevard to handle the overflow crowd from the Pabst Whitefish Bay Resort. The village bought the building in 1902 and moved it to the Fleetwood Place location to serve as the village hall. After Lewis and Mary Jane bought the structure from the village, they relocated it to **314 East Beaumont Avenue** in 1919, where it is now a residence. Lewis was one of the seven original village trustees following incorporation in 1892. He also served as Whitefish Bay postmaster from 1892 to 1900.

By the early 1900s, there were many Consaul descendants living in the area. One of them was Ruth Nelson, great-granddaughter of William

Consaul, the family patriarch. In 1921, Ruth and her husband, Gordon Nelson, built the white clapboard home at **5685 North Consaul Place** on the street named for her family.

The seven Consaul family homes are listed on the Whitefish Bay AHI.

The Isenring Family

Galus and Wilhelmina (Zetteler) Isenring lived at a modest residence at **808 East Lake View Avenue**. The couple, both Swiss, met on a ship that was bringing them to the United States. Records indicate they had two sons and four daughters. The earliest parts of Galus's home, which date to the 1860s, were incorporated into the current imposing lakeside Queen Anne Victorian residence, making it the site of one of the earliest homes in Whitefish Bay. Hannah Consaul, William's widow, sold Galus Isenring the fifteen acres north of Lake View Avenue in 1860. He worked a farm for eleven years and built a log cabin, portions of which may be under and within this extensively remodeled home. The oldest part of the house still features an aged root cellar and the fieldstone foundation. The house passed through two other owners before being purchased by Ralph T. Friedman, owner of Schuster's Department Stores. Friedman was the grandson of Edward Schuster, the store's founder.

Friedman lived in the Galus Isenring House from the 1930s to the 1950s and added extensive additions. Noted Milwaukee architect H. Russell Zimmermann, who did remodeling work on the house in the 1990s, described the house this way: "The limited part that showed through (the original house) was Queen Anne, with some Art Deco additions. What we have now is overtones of the Shingle style with neo-classical leanings; kind of a cleared up Queen Anne. You could say it is similar to an oceanfront house found on the Hamptons [on New York's Long Island]."

Galus's son was Frederick Galus Isenring. Given his real estate, civic and business activities, it could be said that Fred Isenring did more than anyone else to develop Whitefish Bay into the community it is today. Indeed, three subdivisions in the Bay were named after him. Fred was born in and grew up in the Lake View home. In 1877, Fred purchased eighteen acres of land bounded by Lake Michigan, Lake Drive and Henry Clay Street for $1,600, which he later sold to the Pabst Brewing Company in 1888 for $20,000 to construct the Pabst Whitefish Bay Resort. Fred then managed the resort

Frederick G. Isenring House, 920 East Sylvan Avenue, circa 1892. Razed 2009.

from 1889 until 1894, living in a house on the property. He was one of thirty-five citizens involved in the incorporation of Whitefish Bay in 1892 and served as the first president of the village board, from 1892 to 1895. He also served on the Milwaukee County Board. Fred had his house built in 1892 on Fleetwood Place. Fred Isenring's house was later relocated by his friend, Dr. Thaddeus W. Williams, to **920 East Sylvan Avenue**, where it later was converted into a duplex before being razed in 2009.

Fred Isenring was elected Milwaukee County sheriff in 1896. He left office the following year, but $20,000 from sheriff sales of foreclosed properties was found to be unaccounted for by the district attorney, a dollar amount equal to about $600,000 today. It is believed that Fred fell into deep financial trouble during the recession that began in 1893 when the bottom fell out of the real estate market. When Fred ignored an order to appear in court regarding the missing money, a warrant was issued for his arrest. A few days before Christmas 1899, Fred left for Fond du Lac on business but never returned. At least so said Fred's wife. In a 2016

interview, Larry Isenring, the great-grandson of Fred, said family lore has it that instead of going on a business trip, Fred went to the outhouse one winter day with the money in his pocket—and was never seen again. Does that mean that Fred's remains and the money could still be at that location in Whitefish Bay?

One might think that after such a bad experience with Fred Isenring and the missing money, another family member, Wynand G. Isenring, might not be trusted when it came to handling public funds. Wynand was Fred's nephew. Instead, he served as Whitefish Bay treasurer from 1917 until his death in 1941. He also founded the Bank of Whitefish Bay in 1930 with partners Allan J. Roberts, August M. Krech and Howard S. Swan and served as one of the bank's vice presidents. The Bank of Whitefish Bay was the first to be established on the North Shore, and in 1934, it became the first bank in Milwaukee County to become a member of the Federal Deposit Insurance Corporation, which protected bank customers' deposits. Wynand built a house at 1036 East Lexington Boulevard in 1905. He built a second home at 1009 East Henry Clay Street in 1920.

Warren Isenring, Wynand's son, graduated from Marquette University with a degree in engineering and was a prominent business owner in

Wynand Isenring second house, 1009 East Henry Clay Street, circa 1920. His first home was at 1036 East Lexington Boulevard, circa 1905.

A Celebration of Architecture and Character

Horace W. and Marion Hatch House, 739 East Beaumont Avenue, circa 1925. This Ernest Flagg–designed home was the residence of businessman Warren Isenring.

Whitefish Bay. Warren started a repair shop for small appliances on Silver Spring Drive before his business expanded to the selling of larger items such as kitchen appliances and television sets. By 1939, the business occupied much of the Gotfredson Building in the 500 block of Silver Spring Drive. During World War II, Warren's wife ran the store while Warren worked during the day at a defense plant in Milwaukee and repaired appliances at night. The couple lived at **739 East Beaumont Avenue**. This Cotswold-style stone house was designed by renowned architect Ernest Flagg and had originally been built for Horace W. and Marion Hatch in 1925.

The home at 1036 East Lexington Boulevard is a contributing historic property in the Pabst Historic District. The houses at 808 East Lake View Avenue and 739 East Beaumont Avenue are contributing historic properties in the Lawndale Historic District and 739 East Beaumont Avenue is in the National Register of Historic Places.

OTHER EARLY SETTLERS' HOMES

Around the 1870s, a number of German immigrants, many originating from northern Germany, settled in Whitefish Bay and began farming on land that would become the northern part of the village. An 1876 census map showed the land where several of them farmed. The original homes of six families still exist in some form today.

John and Mina (Vess) Heims farmed land between what would become Santa Monica Boulevard and Lake Michigan. They had four children at the time of the 1870 census and built the home at **6350 North Santa Monica Boulevard**. (Santa Monica was then called Richards Street.) The original part of the home is the two-story portion built in the 1870s. The north and south additions were added later.

Gottfried and Caroline Funke, both from Prussia, bought ten acres south of the Heims farm between Lake Michigan and Santa Monica Boulevard and built the home at **6310 North Santa Monica Boulevard**. The original portion is the southern part with the gable facing the street. Substantial additions were added in 1924. The couple had two children. Son Charles married Mary Kassebaum and became a plumbing contractor. Daughter Lena married Heinrich Post. Gottfried, Caroline, Lena and Heinrich are all buried in the Town of Milwaukee Cemetery.

South of the Funke farm, Carl and Hannah Steffen, both Prussian immigrants, built a farmhouse in the late 1860s at **6166 North Santa Monica Boulevard**. The original part of the house, including the fieldstone basement walls, underlies the current home, which has been extensively remodeled over the years. The original house is said to have been built from wood beams taken from dismantled Lake Michigan schooners. Carl and Hannah had two sons, August and Franz. The couple later moved to **531 East Day Avenue** in the 1890s. Carl, Hannah and their two sons are buried in the Town of Milwaukee Cemetery.

Joseph and Magdalena Patza, both immigrants from Bohemia, a region in today's Czech Republic, built one of the oldest surviving residences in Whitefish Bay at **5932 North Santa Monica Boulevard** in 1869. The original house is the portion with the front door and small upstairs window. Substantial additions were built in later years.

Frederick and Anna (Engel) Grams built their Colonial Revival home at **5967 North Berkeley Boulevard** in 1869. Originally, the home was on farmland that is now Klode Park. The land was sold to Frank C. Klode, and the home was relocated to its current site in 1925. The Grams had nine

An 1876 map of Whitefish Bay showing property ownership.

children. When he died, Frederick left a sizable estate of $18,700, more than $500,000 in today's dollars. One son, Ferdinand, married a woman named Louise and built the home at **5955 North Lake Drive**. Frederick, Anna, Ferdinand and Louise are all buried in the Town of Milwaukee Cemetery.

Farther south, Frederick Gustave Rabe built a gabled, clapboard house in 1870 for his wife and two daughters on a farm that occupied what is now

the Whitefish Bay High School complex and Armory Park. After Rabe's death, Otto Falk, vice president of the Falk Corporation and a prominent officer in the Wisconsin National Guard, purchased the property in 1908 for the guard's use in drill instruction and training. In 1928, the Whitefish Bay Armory was built. Designed by noted architect Herbert Tullgren, the armory was placed in the National Register of Historic Places in 2002 and was also a Milwaukee County Historical Society Historic Landmark. It was demolished in 2004. The Rabe farmhouse served as home for three different National Guard commanding officers and their families and later as office space before it was razed in 2002. In 1929, the guard sold the southernmost thirteen acres of the former Rabe property to the village for construction of a new high school. The high school was also designed by Herbert Tullgren.

In 1865, Johann Bauch built a cream brick home at **5007 North Idlewild Avenue**. It featured segmented arched windows with stone sills and a porch. It was remodeled with an addition in 1924. Originally facing south, it was turned to face east to align with other homes being built on Idlewild Avenue.

Johann Bauch House, 5007 North Idlewild Avenue, circa 1865.

Other early homesteaders included F.H. Bolte, who built the Victorian farmhouse at **828 East Glen Avenue** in 1893; William Fritzke, who constructed the Queen Anne–style clapboard home at **840 East Glen Avenue** in 1895; H.C. Beverung, who in 1895 built a Victorian home at **4631 North Oakland Avenue** that features a two-story pentagon in the south front corner of the house; and Reinhold and Anna Knop, who farmed in the Klode Park area and built the Queen Anne clapboard house at **5915 North Lake Drive** in 1893. Their son Alfred built a home next door at **5925 North Lake Drive** on land given to him by his parents upon his marriage in 1924. In the 1890s, after the village's incorporation, Anna Knop organized a hot lunch program for children at the newly opened Whitefish Bay School, a task later carried out by the Mothers Club, the forerunner of today's parent-teacher association (PTA). A Victorian-style farmhouse was built at **802 East Silver Spring Drive** in 1892 by a developer who at first rented it before selling it to William H. Sherman. The exterior finish was originally stucco and was later sided with wood.

The William Fritzke House at 840 East Glen Avenue is individually eligible for listing in the National Registry.

As the community grew, residents became increasingly unhappy with how they were being governed by the Town of Milwaukee. So on June 7, 1892, Whitefish Bay went to the polls to declare its independence. Unlike other revolts, the galvanizing issue was not taxes or freedoms. It was education. Irate with their children having to trudge three miles to school, the settlement incorporated to get its own school. Fred Isenring was the first village president. The original village board members were Dr. Thaddeus Williams, William T. Consaul, Lewis Scheife, Ernest Timpel, L. Lefeber and A. Ehlers.

2
HISTORIC DAY AVENUE

Amid the blocks of English Tudors and front-entrance colonials in Whitefish Bay is a turn-of-the-century street that has retained its Victorian flavor," is how renowned Whitefish Bay historian Mimi Bird introduced her readers to Day Avenue.

Before there were stately mansions on Lake Drive, before the charming residences on Circle Drive, before summer homes were built in Cumberland Forest, there was Day Avenue—the first residential neighborhood in Whitefish Bay. The twelve homes built on Day between 1891 to 1896 represented the first planned residential subdivision on the North Shore; the first subdivision outside of Milwaukee to have gas, water and sewerage services; and the first street to be paved in Whitefish Bay. The development of Day Avenue in 1891 was likely the impetus for the formation of the Village of Whitefish Bay in 1892, especially since three of the street's original residents were among those involved in the incorporation.

Developers included the Lawndale Land Company, whose president, Fred T. Day, gave his name to the street; the Acme Realty Company; and the Whitefish Bay Association, whose officers lived on Day Avenue. An early real estate advertisement described Day Avenue: "If you desire to become the owner of a Modern Home, a house supplied with gas at little expense, and with pure Spring Water for drinking purposes, containing Bath Room, Furnace, and, in fact, everything that should be in a modern house, at a moderate cost and on very easy terms, then do not fail to call on us."

A Celebration of Architecture and Character

Day Avenue Notables. *Clockwise from top left*: Alonzo Fowle, Fred T. Day, James R. Gregg and H.K. Curtis.

Day Avenue in the 1890s.

The rapid development of Day Avenue was spurred by the extension to Day of the Whitefish Bay Toll Road, later to become Lake Drive, described in a brochure as "the most beautiful drive in the world," and by the construction in 1892 of the dummy line, the Milwaukee and Whitefish Bay Railway that ran from downtown Milwaukee to the Pabst Whitefish Bay Resort north of Henry Clay Street. An extension from Henry Clay to Day in 1897 was paid for by Carl Robert Gether, a subdivision developer. Initially powered by steam, the dummy line converted to electric power in 1898, allowing it to make hourly trips to Milwaukee.

Early homeowners in the area were a mix of summer residents from the city, who built smaller lakeshore cottages on today's Shore Drive—now all but one razed—and permanent residents who commuted to Milwaukee on the dummy line.

In 1893, Day Avenue became the first street to be paved and to have streets lamps. The street was cleared of snow by a horse-drawn snowplow. Initially, well water was pumped to storage tanks in the homes' attics by windmills at every house. In the late 1890s, a pumping station was built at the base of the Day Avenue bluff. A boathouse, bathhouse and a breakwater were also constructed. Wooden steps led from the bluff to the beach. In 1899, a fence was erected from Day Avenue to Silver Spring Drive along the road that would become Shore Drive to prevent horse-drawn vehicles from tumbling over the edge of the bluff.

In 1892, the first subdivision homes built on Day Avenue were 524, 624, 700, 708, 716, 723 and 726 East Day Avenue. In 1894, the homes at 516, 531 and 746 were completed. In 1896, the homes at 506 and 415 went up.

Although most of the homes on Day were built during the Victorian era, they are not designed in a pure style. Rather, builders combined elements of several styles, Queen Anne the most prominent. A 1983 study of Milwaukee

architecture described the designs closest to the "Stick" style, which the study described as "one of the most purely American styles of the 19th century." Stick style details such as paneling and simple gable end trusses are on several of the houses on Day. Although several of the homes in this neighborhood have been modified over the years, most of the homes continue to exhibit their distinctive architectural style. As such, the neighborhood stands out as a unique historical area in the village. The Milwaukee County Historical Society in 1986 declared the three blocks from Lake Avenue to Lake Michigan a historic landmark.

All but one of the twenty-eight homes in the 500, 600 and 700 blocks of Day Avenue are considered contributing historical properties in the proposed Lawndale Historic District.

The first residence on Day Avenue was not part of the new subdivision but an early summer cottage at **738 East Day Avenue**, the only one still standing of the many built along the shoreline north of the Pabst Whitefish Bay Resort in the 1880s. It actually is not visible from Day Avenue. This house and a home at 740 East Day Avenue are set back behind two other houses at **746 East Day Avenue** and 732 East Day Avenue, the driveway

An early summer cottage, later the Glendale Realty Office, 738 East Day Avenue, circa 1880. Arthur O'Connor was the first to use it as his home.

for which provides access to the two back lots. The first owner of this home is not known. It was used by the Glendale Realty Company as an office before being sold to Arthur O'Connor as his residence. Additions have been added to the cottage over the years.

The James R. Gregg family home at **752 East Day Avenue** also was not part of the new subdivision, having been built in the 1880s on land owned by the Gregg family from 1882 to 1895. The home started out as a modest cottage and has been added onto over the years. Gregg was one of the thirty-five signers of the documents that led to the village's incorporation in 1892. The James R. Gregg House is individually eligible for listing in the National Register of Historic Places for the significance and integrity of its Queen Anne architecture.

The H.K. and Alice Curtis Home at **708 East Day Avenue** may have been the first home built in the subdivision in 1892. Alice Curtis was Whitefish Bay's first schoolteacher. She initially taught in Lewis F. Scheife's hardware store on Silver Spring Drive before the village's first schoolhouse was built. H.K. Curtis was one of thirty-five persons who signed the documents that resulted in the village's incorporation in 1892.

Perhaps the grandest house on Day Avenue is the clapboard Queen Anne–style residence Alonzo Fowle House built in 1892 at **624 East Day**

James R. Gregg House, 752 East Day Avenue, circa 1882.

A Celebration of Architecture and Character

H.K and Alice Curtis House, 708 East Day Avenue, circa 1892. Alice Curtis was the Bay's first schoolteacher.

Alonzo Fowle House, 624 East Day Avenue, circa 1892.

Avenue. It features wood shingles in the gables and a spindled wraparound porch. Fowle was president of the Whitefish Bay Association, one of the developers of the subdivision. Fowle also was a partner with the King, Fowle, Lawton and McGee Printing Company in downtown Milwaukee. Two of his partners also built their homes in Whitefish Bay. Henry R. King built his home at **5559 North Lake Drive**, and James McGee built his home next door at **5569 North Lake Drive**—known together as the Lake Drive Twins. The three men were among the Bay's first dummy line commuters. The Alonzo Fowle House is individually eligible for listing in the National Registry for the significance and integrity of its Queen Anne architecture.

L.L. Disbro, president of the Acme Realty Company, which platted the subdivision, built an imposing home at **524 East Day Avenue** in 1892. Disbro was also president of the Franklin Printing Company. He died in 1914. The next owners were Otto and Louise (Steffen) Voek. Otto Voek was the area's coal dealer. The L.L. Disbro House is individually eligible for listing in the National Registry for the significance and integrity of its Queen Anne architecture.

In 1892, Carl Robert Gether, secretary for the Whitefish Bay Association, built his home at **726 East Day Avenue**. Gether was one of the thirty-five individuals who signed papers to incorporate the village in 1892. Extensive

L.L. Disbro House, 524 East Day Avenue, circa 1892.

Carl Robert Gether House, 726 East Day Avenue, circa 1892.

remodeling was done on the residence after a January 1923 fire. As a result, the house has lost much of its original Victorian design.

Carl Robert Gether also built a home for his mother, Marie Gether, and sister, Adolpha, at **700 East Day Avenue**. The home was featured in early sales brochures. The home was extensively remodeled after a November 1924 fire and converted from a Victorian style residence to a Tudor Revival style.

The home at **716 East Day Avenue** was built in 1892 for attorney Herbert Kinne. Although the home has been modified over the past century, it retains its original Victorian appearance. The Herbert Kinne House is individually eligible for listing in the National Registry for the significance and integrity of its Queen Anne architecture.

The house at **723 East Day Avenue** was built in 1892 for Frank W. Baltes. It originally had three stories. The third floor was the maid's quarters, reachable by stairs from a porch on the back. There was a warm-weather sleeping porch on the second level from which a 1890s *Milwaukee Sentinel* story reported Day Avenue residents once gathered to watch a large fire in Milwaukee. The home had a barn/stable/carriage house, and at one time, pigeons were raised on the second floor of the auxiliary structure. The Frank Baltes House is individually eligible for listing in the National Registry for the significance and integrity of its Queen Anne architecture.

Herbert Kinne House, 716 East Day Avenue, circa 1892.

Frank W. Baltes House, 723 East Day Avenue, circa 1892.

A Celebration of Architecture and Character

Clarence and Cora Powers owned the home at **531 East Day Avenue** completed in 1894, which they later sold to Carl and Hannah Steffen, who moved from their farmhouse at **6166 North Santa Monica Boulevard**. Carl died in the home in 1897, Hannah in 1903. The property was left to the Steffens' seven children, and their son Albert and his family lived there.

Robert McAllister was the first owner of the home at **516 East Day Avenue**, built between 1893 and 1894. It later was owned by the Sullivan family and then became the residence of Charles J. Kersten, a Chicago-born Marquette University Law School graduate. Kersten was twice elected to the U.S. Congress, in 1950 and 1952, where he served as chairman of the Select Committee on Communist Aggression. He briefly served in President Dwight Eisenhower's administration as White House consultant on psychological warfare. He then resumed his law practice, remaining active in anti-communist circles until his death in 1972. The Robert McAllister House is individually eligible for listing in the National Registry for the significance and integrity of its Queen Anne architecture.

The residence at **746 East Day Avenue** was built in 1894 for James J. Perkins, who also owned several lots to the east near the bluff to Lake Michigan. In 1905, he sold his home and lots to Dr. Henry Schmidt, who

Robert McAllister House, 516 East Day Avenue, circa 1894.

The Whitefish Bay Sanitarium, 758 East Day Avenue, circa 1905.

opened the Whitefish Bay Sanitarium on the lakeshore bluff at 758 East Day Avenue. The sanitarium offered a full range of therapeutic services available at that time. The sanitarium was later razed.

Mrs. Emma F. (Harry) Barlow was the first owner of the house at **506 East Day Avenue**, which was built in 1896. William M. Stewart purchased it in 1909. Some of the original siding has been replaced and detailing removed, but the house continues to retain its original shape and Victorian features.

The Benjamin A. and Elizabeth (Turner) Keikhofer House at **639 East Day Avenue**, built in 1922, is individually eligible for listing in the National Registry for the significance and integrity of its Colonial Revival architecture.

Built in 1896, the structure at **415 East Day Avenue** was first called the Whitefish Bay Club, became known as the Suburban Club and then became the residence of W.H. Goodall, who served as president of the Whitefish Bay Village Board in 1913–14. News articles from the era report that the building first was the Gregg family residence and was located on the lakeshore bluff before it was moved to its present site for use as a clubhouse. It included parlors, a reception room, a dance hall, a bowling alley in the basement and a billiard room upstairs. A spacious front porch once extended

A Celebration of Architecture and Character

W.H. Goodall House, 415 East Day Avenue, circa 1896. This house was a clubhouse for neighborhood residents before becoming Goodall's home.

on three sides. Tennis and croquet courts were believed to have been on the grounds. The Wheelmen, a bicyclists' club, also met there. While it was an important part of the original subdivision, this home is outside of the Lawndale Historic District.

In succeeding decades, many other homes filled out the three blocks of Day Avenue that are in the historic district. For some, the original owners are unknown. These homes include 507 East Day Avenue (1921); 513 East Day Avenue (1922); 523 East Day Avenue (1923); the Frank E. and Ruth G. Baker House at **601 East Day Avenue** (1928); the Edgar G. and Lacy L. Plautz House at 607 East Day Avenue (1936); the Otto J. and Irene F. Hoff House at 608 East Day Avenue (1927); the A. Cressy Morrison House at **615 East Day Avenue** (1897); the Edward R. and Silvia Droppers House at 616 East Day Avenue (1951); the Mary H. Richardson House at 621 East Day Avenue (1923); the Woernicke Family House at 629 East Day Avenue (1916); the Miner R. and Margaret Rosman House at 711 East Day Avenue (1926); the H. Stanley and Anna Geddes House at 732 East Day Avenue (1925); and the Robert A. Viall House at 740 East Day Avenue (1922). All are contributing historical properties in the proposed Lawndale Residential Historic District.

Four other homes farther west on Day Avenue are historic properties. The Charles A. and Helena M. La Prairie House at 129 East Day Avenue (1927), and the Austin A. and Dorothy Petersen House at 209 East Day Avenue (1935) are contributing historic properties in the Bay Ridge and Kent Avenues Historic District. The Caroline Merz Home at 333 East Day Avenue (1930) and the Frederick and Eleanor Thuemler House at 418 East Day Avenue (1950) are not in a proposed historic district.

3
A STROLL DOWN LAKE DRIVE

The Grand Homes of Lake Drive
(and One Historic Restaurant and Park)

Several of Whitefish Bay's most famous residents were industrial and business titans, important not just locally but statewide and nationally. These were prominent and wealthy families who wanted homes that not only spoke to their immense financial success, but were also situated on sites that rivaled some of the most beautiful residential settings in the world. That would be Lake Drive, particularly the lakeshore side of the street, where a single lot, even in a small urban community, is four to five acres or larger.

This chapter takes a stroll south down Lake Drive starting with one of the most distinctive homes in Wisconsin, the Casa del Lago. Halfway through our walk, we'll stop at one of Whitefish Bay's oldest and most well-known restaurants and also take a look at the park across the street.

CASA DEL LAGO

The Ella S. Frank House
5570 North Lake Drive

Of all the beautiful and striking homes on Lake Drive, one stands out as truly extraordinary, perhaps unmatched by any other residence in Wisconsin, the Casa del Lago—Castle on the Lake—at the intersection of Lake Drive and Silver Spring Drive at **5570 North Lake Drive**.

From left to right: *(top row)* Kurtis R. Froedtert and Julius P. Heil; *(bottom row)* Joseph A. Padway and Carl and Helena Herzfeld.

A Celebration of Architecture and Character

From left to right: (*top row*) Otto L. Kuehn and Harry J. Grant; (*bottom row*) Armin C. Frank and Ella S. Frank.

The home was designed by architect Armin Charenton Frank for his mother, Ella Schandein Frank, who was widowed at the time the home was completed in 1927. Just thirty-three years old at the time, and already prosperous and making a name for himself as an architect, Armin was inspired by a villa he had seen on Lake Como in Italy while recuperating from injuries suffered in World War I.

This spectacular residence features many amenities. And as you'll see, it also comes with a high-society sex scandal in which Ella Frank played a key role.

The house is divided into two parts. The living room–library wing is to the south. The living room faces the street and features a soaring ceiling, a stone fireplace and oak paneling. It was originally Ella Frank's music room, and she had a pipe organ installed in tribute to her late husband, who loved to play the instrument. It has since been removed. Facing Lake Michigan is the library, a two-story design with a curved balcony. This wing of the house is separated from the living quarters by a long, brick passageway.

In the main family wing to the north, the first floor boasts a spacious kitchen, breakfast room, dining room and family room with broad views of

Ella S. Frank House, 5570 North Lake Drive. The Casa del Lago, circa 1927.

the lake. Upstairs are six bedrooms, two of which were once used as servant quarters. All of the windows in the home are leaded glass, and all feature stained-glass ornamentation.

The home has had at least eight owners since Ella Frank, all of whom appear to have treated the property with care and respect. The Ella S. Frank House is individually eligible for listing in the National Register of Historic Places. The home was designated a historic landmark in 1992 by the Milwaukee County Historical Society.

Armin's father was Dr. Louis F. Frank, a first-generation German American who was born in Milwaukee, got his medical degrees at the University of Michigan and the City University of New York and returned to Milwaukee and set up practice as the first dermatologist in the city. He became an important figure in the Milwaukee medical community by embracing scientific medical breakthroughs from Europe. He was the first physician in Milwaukee to use an X-ray machine and the first to use Danish researcher Niels Ryberg Finsen's ultraviolet ray lamp for the treatment of skin diseases, an innovation for which Finsen would later receive the Nobel Prize. Frank loved music and was a founder of the Wisconsin Conservatory of Music. When he retired, he published a book, *The History of the Medical Profession in Milwaukee*. He was married to Emily Inbusch for nine years and had three children with her before she died in 1890. In 1892, he married Ella Schandein.

Ella Schandein, Armin Frank's mother, was the daughter of Emil and Lisette Schandein. Lisette's father was Philip Best, son of Jacob Best and founder of the brewery named after him. Philip Best had two daughters: Maria, who married Captain Frederick Pabst, and Lisette, who married Emil Schandein. Upon Philip Best's retirement, both men purchased half interests in their father-in-law's brewery. Frederick Pabst would later assume control following Emil Schandein's death in 1889.

On a trip to Berlin, Germany, in 1874, Lisette befriended and brought back to Milwaukee a ten-year-old boy, Jacob Heyl. She and her husband, Emil, cared for the boy, but when he was in his teens, Jacob and Lisette began an adulterous affair. In part to conceal the illicit relationship, Lisette had Jacob Heyl marry her eldest daughter, Louise. After Louise died two years later, Jacob married Lisette's second daughter, Clara. Emil Schandein died a few months after Louise's death, and Lisette became first vice president of the Philip Best Brewing Company, which was at that time one of the largest breweries in the nation.

Upon Jacob Heyl and Clara's marriage, they and Lisette moved into a magnificent forty-thousand-square-foot, forty-three-room mansion at

Twenty-Fourth Street and Grand Avenue—later renamed Wisconsin Avenue—which Emil Schandein had built but never had the chance to live in. Given her immense wealth, Lisette naturally socialized in the highest strata of society. President Grover Cleveland and European royalty visited her mansion. But Lisette's living arrangement with Jacob and Clara had stirred up embarrassing gossip about Frederick Pabst's sister-in-law and business partner, leading Captain Pabst to change the brewery's name to Pabst in order to separate it from the increasingly disreputable Best family name. Also concerning to Pabst was that Lisette's secret lover Jacob Heyl had come to own more stock in the brewery than did his own sons.

Upon her death in 1905 of a stroke at age fifty-seven, Lisette's will left $7 million of her estate to Jacob Heyl and Clara, naming Jacob as the executor, with the remaining $800,000 to be split between Ella Frank and her brother, Emil Jr. (Lisette's estate was worth $210 million in today's dollars.) Ella and her brother contested the will, and the resulting trial became a national sensation, attracting reporters from New York to California when Jacob Heyl's affair with Lisette was revealed. Testimony became so seamy that women were asked to leave the courtroom. Maids, servants and family members were called to the stand as witnesses to Lisette's and Jacob Heyl's nocturnal liaisons. Ella Frank testified that Jacob had, among other things, molested her when she was a teenager, and that she had once awoken to find him sitting on her bed with a knife. A year after her death, the probate court upheld Lisette Schandein's will. Clara received the $7 million and promptly obtained a divorce from Jacob, which required him to relinquish all claims to the estate. Clara made generous financial settlements with Ella Frank and her brother and relocated to Berlin, never to return to Milwaukee. Jacob Heyl moved to Buffalo, New York, where he later died.

In the library of Casa del Lago, Ella Frank had a small stained-glass image, about the size of a basketball, inserted into the leaded glass window overlooking Lake Michigan. The image is of three men in a garden. One is in prayerful repose, eyes closed; the other two are looking at him. One looks like a centurion. The story behind the stained-glass image is unknown, but the home's present owner has given it some thought. "It is Christ in the Garden of Gethsemane. Judas is betraying Jesus to the Roman soldier. This was Ella's way of symbolizing the betrayal that had happened in her family."

Ella Schandein and Dr. Louis Frank were married for twenty-six years, giving birth to Armin and Louise. Dr. Frank died after a lingering illness in 1918.

A Celebration of Architecture and Character

Armin C. Frank House, 5486 North Lake Drive, circa 1924.

Armin Frank, who lived from 1894 to 1947, designed a home for himself just a block south of his mother's house at **5486 North Lake Drive** in 1924. While his home is not individually eligible for the National Registry, it is a contributing historic property in the Pabst Historic District.

Frank, along with his partner, Urban Peacock, built numerous homes and commercial structures in Milwaukee, including the palatial 1,430-seat Venetian Theater at 3629 West Center Street, which was demolished in 2007. Frank also designed the E.A. and Anita Weschler House at **4724 North Wilshire Road** in 1929, a residence that is individually eligible for the National Registry.

Perhaps most fitting, in 1928, Armin Frank designed the Ambassador Hotel at 2308 West Wisconsin Avenue. It is located where the Schandein mansion once stood and where his grandmother Lisette carried on her illicit trysts with Jacob Heyl until her death. The home was razed in 1927 to make way for the hotel.

Historic Whitefish Bay

The Lake Drive Twins

Henry R. and Marian King House
5559 North Lake Drive

James and Anna McGee House
5569 North Lake Drive

The home at **5559 North Lake Drive** was built for Henry R. and Marian (Juneau) King. The home at **5569 North Lake Drive** was built for James and Anna (Juneau) McGee.

Marian and Anna were the granddaughters of Solomon Laurent Juneau, one of Milwaukee's founding fathers and its first mayor. They were the daughters of Paul Juneau and the great-granddaughters of Jacques Vieau, a French Canadian voyageur who was the first white man to settle in what would become the city of Milwaukee.

The sisters' husbands were business partners. Henry King and James McGee, along with Alonzo Fowle, who built his home at **624 East Day Avenue**, and a Mr. Lawton, were partners in the King, Fowle, Lawton and McGee Printing Company located in downtown Milwaukee. In 1892, King and McGee were among Whitefish Bay's first commuters, going to and from the city on the newly built Milwaukee and Whitefish Bay Railway dummy line. Fowle was able to join them on the commute five years later when the track was extended to Day Avenue.

Henry King was born in 1855. In 1879, he founded the Milwaukee Athletic Club with two friends. He also served for a time as Whitefish Bay's justice of the peace. Later in their careers, King and Fowle established another printing company known as King, Fowle and Cramer. Still later, King moved to Milwaukee and opened an automobile lamp manufacturing firm.

James McGee was the third president of the Village of Whitefish Bay.

These houses are known as the Lake Drive Twins as they are essentially identical in design. They were built by contractor Wilheim Fritzke in 1893 at a cost of $8,000 each. They may not look much like twins anymore, but at the time, both three-story structures had exteriors of glazed terra-cotta tile and nearly identical floor plans. They were considered the most elegant residences in the area until other grand homes started to be built on the lakeshore side of Lake Drive around 1920.

A Celebration of Architecture and Character

The Lake Drive Twins, 5559 and 5569 North Lake Drive, circa 1893.

The glazed tile exteriors of both homes were later replaced with other exterior materials, perhaps because of deterioration of the original tiles due to exposure to the elements during Wisconsin winters. The first-floor exterior of the house at 5559 North Lake Drive was sided with Lannon stone, and stucco was used on the second and third stories. The house at 5569 North Lake Drive was sided with red brick. While numerous modifications have been made to the exteriors of these homes over the years, both homes continue to exhibit the characteristics of the Queen Anne style.

Both houses had extensive porches that extended over the front entrance. Due to deterioration, both were eventually removed. The porch entryway for the house at 5569 North Lake Drive was recently reinstalled—replicating its original appearance. Both homes are on the Whitefish Bay AHI.

HARRY J. GRANT HOUSE

5370 North Lake Drive

This Lannon stone Tudor Revival home at **5370 North Lake Drive** was built for Harry J. Grant, chairman of the board of the *Milwaukee Journal*, in 1923. Architectural details include a rounded arched entry and a "thatched look" slate roof. Its cost to build at that time was $35,000.

Grant was born in 1881. He joined the *Milwaukee Journal* in 1916 as advertising director. He rose to publisher by 1920 and in 1935 was named chairman upon the death of Lucius Neiman, founder of the newspaper.

Grant is distinguished for having created an employee stock ownership plan (ESOP) in 1937, the first such plan in the United States. It was terminated in 2003 when Journal Communications became a publicly traded company. Grant was recognized as one of the nation's great newspaper publishers, and he was featured on the cover of *Time* magazine in the 1950s. Grant died in 1963.

The Harry J. Grant House is individually eligible for listing in the National Registry due to the significance of its Tudor Revival architecture. It is located in the proposed Pabst Residential Historic District.

Harry J. Grant House, 5370 North Lake Drive, circa 1923.

A Celebration of Architecture and Character

Harry and Ada LeVine House

5320 North Lake Drive

They say clothes make the man. In Harry LeVine's case, it was women's clothes.

Levine emigrated from Austria with his parents when he was ten years old and worked during his teens at the Pabst Whitefish Bay Resort in the early 1900s before later turning his sights to business.

LeVine was a self-made man who eventually worked his way up to become the owner of Rosenberg's, possibly Milwaukee's most fashionable women's clothing store of the day. It was located in Milwaukee's German district on North Third Street a few blocks north of the Joseph Schlitz Brewing Company complex. It later moved into the former Berlin Arcade, an imposing four-story shopping mall with a seven-story clock tower at the corner of North Avenue and Third Street.

LeVine was the president of the store during its most successful years and was very involved with the Upper Third Street Merchants' Association, which promoted the shopping district. His son, Leonard, later became president of Rosenberg's. It remained a fixture of the shopping district until it finally closed in 1963. Upon his death in 2008,

Harry and Ada LeVine House, 5320 North Lake Drive, circa 1930.

Leonard LeVine's estate bequeathed a sizable donation to the Milwaukee Art Museum.

Harry and Ada LeVine built their home at **5320 North Lake Drive** in 1930. The State Historical Society found the residence individually eligible for listing in the National Registry for the significance and integrity of its Tudor Revival styling. The home is a contributing historic property in the proposed Pabst Historic District.

Judge Joseph A. and Lydia Padway House

5312 North Lake Drive

It will probably surprise many that the imposing Spanish Colonial residence at **5312 North Lake Drive** was the home of a socialist.

Joseph Arthur Padway was a lawyer, labor counsel and politician. Born in Leeds, England, in 1891, he immigrated to Milwaukee in 1906. He graduated from Marquette University Law School in 1912 and set up a law practice in Milwaukee. In 1915, he became general counsel for the Wisconsin Federation of Labor. In 1938, Padway left Wisconsin to serve as general counsel for the American Federation of Labor and served in this capacity until his death in 1947.

Padway was elected to the state senate on the Socialist ticket in 1924. He served in the 1925 session but resigned in 1926 to become a Milwaukee County judge, serving on the bench until 1932. He gradually allied himself with Republican progressives and was instrumental in drafting groundbreaking Wisconsin labor legislation that was passed into law between 1915 and 1935. Versions of these statutes would later be adopted by the U.S. Congress, including unemployment compensation, the minimum wage and hour law and laws barring employers from preventing the formation of unions.

Throughout the 1920s, Padway was counsel to a number of Wisconsin unions involved in labor disputes, and he won national recognition for his work during the bitter Kohler Company strike of 1934.

Padway had his home, which was designed by architect Hugo V. Miller, constructed on a bluff overlooking Lake Michigan in 1930 at a cost of $25,000 by the Milwaukee building company Bentley Brothers Inc.

Founded in 1848, Bentley Brothers became one of the most significant general contracting companies in Milwaukee and is one of the oldest in the United States. The only other home the firm is believed to have built

A Celebration of Architecture and Character

Joseph A. and Lydia Padway House, 5312 North Lake Drive, circa 1930.

in Whitefish Bay is a brick Dutch Colonial at 613 East Carlisle Avenue in 1925. But in its 170-year history, the company has erected some large and impressive structures, including the landmark Romanesque Federal Courts Building at 517 East Wisconsin Avenue in 1892; the Tripoli Shrine Center, with design features that replicate the Taj Mahal, at 3000 West Wisconsin Avenue in 1927; Nicolet High School in Glendale in 1954; and multiple buildings over the decades at St. John's Military Academy in Delafield, which was founded in 1884. In 1962, Bentley Brothers built the WITI-TV tower in Estabrook Park, at the time the tallest self-supporting tower in the world.

The Joseph A. and Lydia Padway House is individually eligible for listing in the National Registry for the integrity of its Mediterranean Revival architecture. The Joseph Padway House is a contributing historic property in the proposed Pabst Historic District.

Benjamin F. and Edna D. Saltzstein House

5290 North Lake Drive

This Lannon stone brick Tudor Revival residence at **5290 North Lake Drive** was constructed on a bluff overlooking Lake Michigan for Benjamin F. and Edna D. Saltzstein in 1928. The design features stucco and half-timbering on the second floor and a turret tower facing toward the street entrance. It was constructed by Velguth and Papenthien for an estimated cost of $45,000. A swimming pool was added to the estate in recent years and surrounded by a brick wall. The pool is said to have been placed in the front yard rather than the back because the village would not allow the owner to erect a wall to block headlights from cars going east on Lexington Boulevard. The pool's brick security wall accomplished that purpose.

Benjamin Franklin Saltzstein was born in 1884 in Detroit. Benjamin graduated from the University of Michigan and moved to Milwaukee, where he practiced law. He also was a businessman and entrepreneur

Benjamin F. and Edna D. Saltzstein House, 5290 North Lake Drive, circa 1928.

and invested in real estate. He was president of Congregation Emanu-El B'ne Jeshurun and was active in the Wisconsin Bar Association and the Jewish Federation.

The Benjamin F. and Edna D. Saltzstein House at 5290 North Lake Drive is individually eligible for listing in the National Registry for the significance and integrity of its Tudor Revival styling. It is a contributing historic property in the proposed Pabst Historic District.

Herman A. and Claudia Uihlein House

5270 North Lake Drive

The Grand Dame of Lake Drive, believed by many architects and historians to be among the most expensive, and certainly among the grandest residences in all of Wisconsin, is the Herman A. and Claudia (Holt) Uihlein House at **5270 North Lake Drive**.

The mansion is located on the grounds of the former Pabst Whitefish Bay Resort (1888–1915), and it was the first home constructed on the site after the resort was razed. It was designed by the distinguished architectural firm of Kirchhoff and Rose and built between 1917 and 1919. It features work by master craftsmen, including ornamental iron work by Cyril Colnik.

In 1915, Herman and Claudia Uihlein purchased a lot near where the bandstand stood. Although suburban homes had already begun to dot the landscape, replacing farmland and changing the character of the old fishing village, the Uihlein house introduced a new scale to Whitefish Bay and began attracting other wealthy families to build magnificent homes up and down Lake Drive.

Dramatically sited on a bluff overlooking Lake Michigan, the mansion is an imposing limestone residence characterized by classical detailing, ornate craftsmanship and eclectic interior design. The exterior of the house reflects a monumental yet restrained synthesis of Renaissance Revival and Beaux-Arts motifs, while the interior boasts a variety of period designs executed in lavish materials.

The mansion is constructed of limestone taken from a single level of a Bedford, Indiana quarry. The stone was carved on the job site to avoid damage in shipment. The lavish interior was built with eight different marbles, Caen stone with walnut doors and paneling and ornamental plaster. Extensive

Herman A. and Claudia Uihlein House, 5270 North Lake Drive, circa 1919.

and elaborately crafted ornamental ironwork, including an intricate front doorway grille and a majestic stairway railing, were designed by Cyril Colnik, who spent three years completing the commission. The carefully detailed period interiors of marbles, carved stone and ornamental plaster are embellished by the ornately carved woodwork of Milwaukee's Matthews Brothers firm. Interior fixtures of bronze, silver and iron complement the richness of the design.

In 1980, the State Historical Society identified the Uihlein house as the finest example of its type and period of construction in the village. Even when evaluated in the context of Milwaukee County's lakeshore estates stretching from Milwaukee to Bayside, the house is distinguished by its design, scale, setting and interior. A guidebook to architectural resources in southeastern Wisconsin identifies the house as one of the best built and most finely detailed in the Milwaukee area.

Kirchhoff and Rose designed frequently for the Uihlein family and their businesses. Commissions included the former Second Ward Savings Bank building on Kilbourn Avenue and Third Street (now the Milwaukee County

Historical Center), the Tivoli Palm Gardens in the Walker's Point Historic District and the Paula and Erwin Uihlein house, 3319 North Lake Drive. Formed in 1894 as a partnership between Charles Kirchhoff and Thomas Leslie Rose, the firm continued under the same name after Roger Kirchhoff succeeded his father upon Charles's death in 1915. Two years later, the firm accepted the Herman and Claudia Uihlein project.

Herman Uihlein, son of longtime Joseph Schlitz Brewing Company president Henry Uihlein and heir to a substantial family fortune, was not closely identified with the daily operation of the brewery, although he served on the board of directors. Born in 1886, he graduated from Cornell University in New York in 1908 and studied law at Columbia University in New York City. He took his first job in 1911 when he was appointed president of the newly formed Lavine Gear Company, a manufacturer of steering gears for cars, trucks, tractors and other vehicles. Capitalized at $40,000, the firm had amassed $1 million in capital by 1918, the year that Uihlein constructed his house. Herman and his brother, George, who became general manager, moved the company from Detroit to Milwaukee in 1918 and built it into a major manufacturing force. Herman served as president until his death in 1942 at the age of fifty-two. He also served as president of the Whitefish Bay Village Board from 1922 to 1923. In 1931, he became president of Manerlein Investment Company, a realty firm, and he also served as vice president of the Sanitary Refrigerator Company in Fond du Lac. Together with his wife, the former Claudia Holt, Uihlein was a leading patron of the Milwaukee Philharmonic Symphony Orchestra. Claudia remained in the house until 1946, when she sold it to a real estate company. The home was assessed at $90,000 at that time. The Uihleins had seven children, three sons and four daughters. In 1950, Claudia donated a pipe organ she had retained from the home to the new First Church of Christ, Scientist, **721 East Silver Spring Drive**.

In 1953, the mansion was purchased by the LaSalette Fathers, who used the building as a mission house for five priests and two brothers. In the late 1970s, the Grant C. Beutner family lived in the home for about ten years. Beutner sold the residence to Steve and Christiana Nicolet in 1988. The Nicolets sold the home the following year to Peter and Mary Buffett. Peter is the son of Omaha business magnate, investor and philanthropist Warren E. Buffett. Peter, a music composer and songwriter, moved to the Milwaukee area to accept a position with Narada Productions, a new-age music recording company. In addition, Peter formed his own music production company, Independent Sound, which was briefly located at the mansion. He

scored the "Fire Dance" scene for the motion picture *Dances with Wolves* while living in the mansion.

The Buffets sold the residence to Kailas and Becky Rao, who carefully maintained and restored the property. They added fountains and reflecting pools to the landscape and erected an imposing gated entry. The Raos also added a rug bearing the seal of the president of the United States in hopes that it might persuade Bill Clinton to again visit the home as he had done once as a presidential candidate when the Buffets owned the home. Both Raos had distinguished careers, he in the cellular communications, investment banking and retail computer businesses, she as a professor of law at the University of Oklahoma and academic administrator at the University of Wisconsin–Milwaukee.

The Raos sold the residence in 2007 to Tim Sullivan and his wife, Vivian. At the time, Sullivan was chairman and chief executive officer of Bucyrus International, a Milwaukee manufacturer of mining equipment. Bucyrus is now a part of Caterpillar Inc. After leaving Bucyrus, Sullivan became president and chief executive of REV Group—which operates a number of companies in vehicle fields manufacturing fire trucks, ambulances, shuttle vans and trucks used at freight terminals.

The Uihlein mansion was placed in the National Registry in 1983. It is a contributing historic property in the proposed Pabst Historic District. It is also listed in the Whitefish Bay Register of Historic Places.

The Carl and Helene Herzfeld/Julius P. and Elizabeth C. Heil House

5240 North Lake Drive

Next door to the Uihlein mansion is the brick Mediterranean Revival residence at **5240 North Lake Drive**. It was constructed in 1924 for Carl Herzfeld, founder of the Boston Store, and his wife, Helene, at an original cost of $60,000. It features rounded arched windows, ornate tile floors, a grand living room with arched leaded windows, a fifteen-foot beamed ceiling, a solarium with a Tiffany-style stained-glass dome and three fireplaces. The main bedroom upstairs is a master suite with his-and-hers baths. The residence sits on four acres overlooking Lake Michigan amid formal gardens flanked by bluestone patios, walkways and a pillared stone

garden room. The property also contains an attractive outbuilding with garages and a coach house. It is the largest known house designed by noted architect Russell Barr Williamson.

Born on January 22, 1865, in Bielefeld, Westphalia, Germany, Herzfeld immigrated to the United States along with his brother Hugo in 1884 and moved to Milwaukee, where he started out as a hosiery and undergarment salesman. In 1902, he and a partner, Richard Phillipson, leased the hosiery department in the Julius Simon's department store in downtown Milwaukee. In 1903, he leased several additional departments from Simon, and in 1906, he and another partner, Nathan Stone, bought Simon out. Herzfeld served as the company's president for many years. He died on May 13, 1930, at the age of sixty-five.

The house was also owned for a time by Julius Peter Heil, who was the governor of Wisconsin from 1939 to 1943. Heil was the founder of the Heil Company in 1901. Heil was born on July 24, 1876, in Dussmund an der Mosel, Germany, and immigrated with his family to the United States in 1881, where they settled on a farm in New Berlin, Wisconsin.

Heil quit school at age twelve and became a welder at Falk Manufacturing Company, working as an apprentice on a portable cast welding machine used to repair the streetcar rails on projects in St. Louis, Missouri, and New York City.

Carl Herzfeld/Julius P. Heil House, 5240 North Lake Drive, circa 1924.

Falk eventually sent him to South America to introduce the streetcar rail repair process, after which Heil returned to Milwaukee, where he married Elizabeth Conrad in 1900. The following year, he left Falk and founded the Heil Rail Joint Repair Company, in competition with Falk. Heil eventually decided to use his welding experience to fabricate steel tank cars, and his company became a major provider of welded steel garbage trucks.

Heil held a post in President Franklin D. Roosevelt's administration and then ran for governor in 1938 as a Republican, defeating incumbent Philip F. La Follette. While governor, he created the Department of Motor Vehicles out of five other agencies. He also consolidated welfare and institutional programs into a single Department of Public Welfare. He toured the country to promote Wisconsin's dairy products. Referred to as "Julius the Just," he was featured on the *New York Times* front page in 1939, reporting in part that Heil was known for clowning and silly antics. He was reelected in 1940 but lost in 1942. Heil died of heart failure in Milwaukee on November 30, 1949, at the age of seventy-three.

The residence was used as a backdrop for some of the scenes filmed for the motion picture *Major League* released in 1989. The home is individually eligible for listing in the National Registry and is a contributing historic property in the Pabst Historic District.

THE BENJAMIN AND ANNA ROSENBERG/KURTIS R. AND MARY FROEDTERT HOUSE

5200 North Lake Drive

Kurtis R. Froedtert is locally known for his family's malting business and the hospital he funded that bears his name. But in 1946, he became nationally known because of a black sheep in the Froedtert family.

The large Tudor Revival residence at **5200 North Lake Drive** was originally constructed in 1927 for Benjamin and Anna Rosenberg. Benjamin Rosenberg was the president of The Grand women's apparel shop, which was later operated by his son and then sold to a New York firm before closing in 1966.

The house sits on an extensive lot abutting Lake Michigan, formerly part of the site of the Pabst Whitefish Bay Resort. The exterior is Lannon stone and brick with some half-timbering and stucco at the second level

Benjamin and Anna Rosenberg/Kurtis R. and Mary Froedtert House, 5200 North Lake Drive, circa 1927.

and a slate roof. The home originally consisted of twelve rooms and a three-car garage.

The residence was sold in 1943 to Kurtis R. Froedtert, chairman of the board and president of the Froedtert Grain and Malting Company. He had a substantial addition added to the west side of the home in 1943. Upon his death in 1951 from cancer, Froedtert left an $11 million bequest for the construction of Froedtert Memorial Lutheran Hospital in Wauwatosa, which opened in 1980.

Froedtert was born in 1887 in the basement of a building near Sixth and Vliet Streets in Milwaukee with the assistance of a midwife—his parents felt births were too intimate for doctors. He wanted to attend medical school and was offered a scholarship to the University of Chicago, but his father's health problems forced him to take over the family's malting business upon his father's death in 1915. The company processed germinated barley into malt for use in the brewing industry, and it became the largest such firm in the world. Froedtert also was active in real estate, developing the now defunct Northgate and Southgate Malls, as well as Westgate Mall, which today is Mayfair Mall. Froedtert married Mary Helf in 1927, and they had two daughters, Maize and Suzanne.

In 1946, the disappearance of his sixteen-year-old daughter Suzanne from a girl's boarding school in Madison made national headlines. She was eventually discovered living in Detroit with a twenty-four-year-old truck driver and working in a candy store. Suzanne later eloped to marry a shoe store clerk in northern Indiana. In addition to his $11 million gift for the hospital, Froedtert left $7 million for his wife and Maize. Suzanne was cut out of the will.

The Rosenberg/Froedtert home was designed by Richard Philipps, one of the best-known architects of his day. Philipps designed other grand houses in Whitefish Bay, including the Tudor Revival Herman Reel House at **4640 North Lake Drive**, and was involved in designing Holy Hill Basilica in Hubertus, Wisconsin, and the Romanesque St. Joseph's Convent Chapel of the School Sister of St. Francis at 1515 South Layton Boulevard, Milwaukee.

The Benjamin and Anna Rosenberg House is individually eligible for listing in the National Registry for the significance and integrity of its Tudor Revival architecture. It is a contributing historic property in the proposed Pabst Historic District.

Pandl's Whitefish Bay Inn

1319 East Henry Clay Street

During the heyday of the Pabst Whitefish Bay Resort from 1888 to 1915, numerous taverns, stores and small businesses sprang up in the Armory Park area, across the street from Lake Drive and near the rail depot that was located just east of where Whitefish Bay Middle School now sits on Henry Clay Street.

One of them was George Bentley's Whitefish Bay Inn, a combination tavern, restaurant and grocery store at **1319 East Henry Clay Street** established in 1900. In 1915, Bentley sold the enterprise to John and Anna Pandl, who changed the name to Pandl's Whitefish Bay Inn and made it a full-service family-style restaurant. The building's porch was enclosed to become the main dining room. In 1925, John and Anna constructed their home next door at **1305 East Henry Clay Street**. While other businesses were abandoning the area with the closing of the Pabst Resort in 1915, the Pandls stayed put and made their restaurant a great success, a popular must-stop for visitors to the North Shore for over one hundred years. It was often

A Celebration of Architecture and Character

Pandl's Whitefish Bay Inn, 1319 East Henry Clay Street, circa 1900.

frequented by the officers and soldiers who lived and drilled at the Whitefish Bay National Guard Armory across the street. Today, Pandl's is the oldest family-owned and continuously operated business in the same location in the state of Wisconsin.

But it almost wasn't so. Pandl's was nearly forced to close during Prohibition because it was a speakeasy.

In 1932, John Pandl died, leaving the restaurant to Anna. Anna was then a single mom with five children. The following year, Pandl's was faced with a mortal threat. Law enforcement agents raided Pandl's on rumors—that were true—that it was illegally serving alcohol. Anna's younger children, returning home, noticed a police vehicle outside the restaurant, and asked, "What's the paddy wagon doing here?" Their older sibling said, "They're taking mom to jail."

It is not known how long Anna spent in jail, but presumably, she was released soon. Village trustees and officials were among Pandl's most frequent imbibing customers, and they got nervous. Oh, the scandal! Anxious to put a righteous face on the matter, the village board obtained an injunction to

shut down Pandl's on the flimsy grounds that the restaurant was a nonconforming use in a residential district, even though the business had been at its current location for more than three decades, long before any homes were built in the area.

Anna fought the decision. According to an oral history from the daughter of Colonel Phillip C. Westphal, the National Guard commander whose family lived at the time in the former Frederick Gustave Rabe farmhouse across the street from Pandl's, Anna met with the colonel who set up a meeting with Herman Uihlein, a former president of the village board and probably the most powerful man in Whitefish Bay. Uihlein interceded on Anna's behalf, and on December 4, 1933—the day before the official repeal of Prohibition—the village board voted not to enforce the injunction. At the same time, the trustees also gave Anna Pandl a major gift over her local competitors. With Prohibition ending, the board was unsure how to deal with the future sale of alcohol in the village, so it passed an ordinance that made Pandl's the only restaurant in the Bay that could sell liquor. That remained village policy for the next fifty years.

Anna continued to operate the restaurant after John's death with the help of sons Jack and George. George later left to open his own restaurant in Bayside. Jack and his wife, Elaine, took over operation after Anna's death in 1967. It is now owned by Jack's son John and his wife, Laura. The building underwent significant remodeling in the 1960s that changed the building's original appearance with the installation of wood panels and half timbers. The State Historical Society determined that the alterations and modifications too greatly diminished the original architecture of the building, so it could not be individually eligible for listing in the National Registry. However, Pandl's is on the Whitefish Bay AHI for its important role in the village's commercial history. It was also designated a historic landmark by the Milwaukee County Historical Society in 1984.

Armory Park

1225 East Henry Clay Street

Tucked just off the southwest intersection of Lake Drive and Henry Clay Street sits a small grove of a dozen or so trees. It will be difficult for future generations to imagine that this peaceful place, surrounded by

A Celebration of Architecture and Character

Armory grounds in the early 1900s.

Whitefish Bay National Guard Armory, circa 1928. Razed 2004.

pretty homes, schools and athletic fields, was once a place where Wisconsin soldiers trained for war.

In 1870, German immigrant Frederick Gustave Rabe purchased the nineteen acres bordered today by Henry Clay Street on the north, Ardmore Avenue on the east, Fairmount Avenue on the south and Marlborough Drive and Kimbark Place on the west. He built a white frame farmhouse in the northeast corner of the plot for his wife and two daughters. After Rabe's death, the farm was purchased in 1908 by Otto Falk, vice president of the Falk Corporation and a ranking officer in the Wisconsin National Guard, and an artillery brigade began drilling on the property. Upon the closing of the Pabst Whitefish Bay Resort in 1915, two of its buildings were moved to the site. The resort's train depot became the drill hall, and the dance hall became the soldiers' storage lockers. National Guard soldiers trained on the property for the Mexican border war, World War I, World War II and the Korean War, and it became a home for units of the famed Thirty-Second Red Arrow Division, so named because it pierced every enemy line it faced.

In 1928, the red brick fortress-like armory building was constructed. The architect was Herbert Tullgren, who designed the armory in the "West Point" Collegiate Gothic style with a crenellated top. It was thought to be the finest armory in the state and even in the nation by Wisconsin guardsmen, who took particular pride in the quality and appearance of their training bases. Additional drill space and garages were added in 1941. In the early years, the white-clad Rabe farmhouse was a residence for three successive commanding officers and their families. It later became the armory headquarters building and officers' club. It was affectionately dubbed the "White House."

In 1929, the southernmost thirteen acres of the Rabe farm were sold to the Village of Whitefish Bay for construction of the high school, which was also designed by Tullgren.

The armory became an integral part of the Whitefish Bay community. During the 1940s, the armory featured a recreational center called Bay's Back Door. For decades, it hosted weddings, proms, church services, basketball tournaments, police balls and the activities of more than thirty community groups.

In 1995, the Wisconsin National Guard closed the armory and sold the property to the Village of Whitefish Bay for $475,000. The armory served for a time as the village's temporary library while a replacement was being constructed. The armory was razed in 2004, and the site became Armory Park.

The park features a veterans' monument and memorial garden in honor of the rich history of the men and women who served and fought valiantly for our nation. The design of the monument is based on the insignia of the Red Arrow Division. It is a place to pause and reflect on the sacrifices made by service members and their families.

The armory was designated a Historic Landmark by the Milwaukee County Historical Society in 1987. It was placed in the National Registery in 2002. It was delisted in 2011 after its demolition.

The William J. and Adelaide J. Feldstein Home

4930 North Lake Drive

The residence at 4930 North Lake Drive is formally known as the G.L. and Catherine Dodge House, named for the original owners who built the home in 1941. But it became a hotbed of Democratic political activity after 1948 when William Joseph and Adelaide (Jandorf) Feldstein moved in.

Both Bill and Adelaide were born in Chicago, where they married and had a son and two daughters. In 1939, the family relocated to Milwaukee, where Bill took a job with an apparel company. Bill's skills in clothing manufacturing kept the World War II draftee on the Milwaukee homefront making uniforms for the war effort. After the war, Bill Feldstein and his partner Sol Rosenberg founded the nationally known women's clothing line Junior House of Milwaukee. The company was later renamed JH Collectibles by Feldstein's son-in-law Kenneth Ross and again renamed JH Concepts by his grandson.

The Feldsteins were active in Democratic politics and hosted fundraisers and gatherings at their Lake Drive home for governors, senators and other national and state politicians and office-seekers, including presidential candidates Adlai Stevenson, John F. Kennedy, Lyndon B. Johnson and Hubert Humphrey.

In an incident that would become eerily reminiscent four years later, Bill Feldstein was riding in an open limousine with John F. Kennedy during a presidential campaign motorcade down Wisconsin Avenue in 1959 when someone from the crowd hurled a whiskey tumbler at Kennedy. The missile missed Kennedy but struck Bill, gashing his forehead. Kennedy tended to his wound until help arrived.

The Feldsteins became good friends with President Johnson and his family, visiting often at the White House and the LBJ ranch in Texas. In May 1966, Lady Bird Johnson asked Adelaide Feldstein to chaperon her daughter Luci Baines Johnson's trip to Milwaukee to visit fiancé Patrick Nugent, then attending Marquette University, an event that captured considerable local media coverage. Luci and Pat got married later that year.

The Lake Drive residence stayed in the Feldstein family until Bill's and Adelaide's passing in 1994.

Otto L. and Lillian Kuehn House

4890 North Lake Drive

This brick Colonial Revival residence at **4890 North Lake Drive** was constructed prior to 1922. In 1927, it became the home of Otto L. and Lillian (Riedel) Kuehn and their son Walter. The exact date of construction is not known, so it is not clear if the Kuehns were the first family to occupy the home.

Kuehn came to Milwaukee from Germany in May 1881 and was employed as a bookkeeper by the F.F. Riedel Manufacturing Company, where he married the owner's daughter before starting a business of his own. Kuehn founded and was president of the Otto L. Kuehn Company, a nationally known food brokerage firm specializing in canned goods, especially sardines.

As a boy, Kuehn won a medal from the German government for his work in the breeding of pigeons. He brought those talents with him when he immigrated, and during his early years in the United States, his achievements in raising and training carrier pigeons resulted in an award from the U.S. Navy. He became the first president of the West Park Zoological Society when the organization was formed in 1910. The West Park Zoo was established in 1892 in what later became Washington Park before it was relocated to its current location in 1958 and renamed the Milwaukee County Zoo. During his years as the zoo society's president, Kuehn made several trips to Europe and brought back many animals for the zoo, some of which he paid for out of his own pocket. In 1913, he obtained Yacob the hippopotamus, a feature exhibit at the West Park Zoo. A biographer wrote of Kuehn that he was a "naturalist by inclination and a broker by circumstances."

James J. McClymont House

4811 North Lake Drive

This brick Georgian Revival residence at **4811 North Lake Drive** was built in 1930 for James J. McClymont, president of McClymont Marble Manufacturers and Contractors. McClymont was active in the National Association of Marble Dealers, serving as the organization's president during World War I.

The McClymont home was designed by noted architect Alexander Hamilton Bauer, who himself lived at **988 East Circle Drive**. The home had ten rooms and was constructed for $25,000. It features round arches over the first floor windows and stone quoins at the corners. The gables are pedimented in the Grecian style. As befits someone in the marble business, a variety of marble stone is used extensively throughout the house for floors, stairs, bath and kitchen fixtures, fireplace mantels and elsewhere. Original blueprints are on file with the Village of Whitefish Bay.

Alexander Hamilton Bauer formed an architectural practice with Gustav A. Dick in 1921. The architectural team is best known for the design of six movie palaces in Milwaukee, including the Oriental Theater at 2230 North Farwell Avenue. They also designed many commercial buildings, churches and homes. Bauer later collaborated with noted Milwaukee architect Alexander Eschweiller. Bauer was one of the founders of the First Church of Christ, Scientist, 721 East Silver Spring Drive. He died of a cerebral hemorrhage in 1946 at the former Milwaukee County General Hospital, a building he also designed.

Herman and Blanche Reel House

4640 North Lake Drive

Sited on a bluff overlooking Lake Michigan, the Herman and Blanche Reel House at **4640 North Lake Drive** is an imposing Tudor Revival residence characterized by eclectic English Tudor design, quality craftsmanship and ornate interior detailing. Constructed between 1928 and 1929, the exterior walls are constructed of stucco and Lannon stone with some half-timbering on the second level.

Herman and Blanch Reel House, 4640 North Lake Drive, circa 1929.

Herman Reel was born in Witten, Germany, in 1868, the son of Adolph and Jeannette (Rosenberg) Reel. As a young man, Reel studied law at the Milwaukee University Law School, which subsequently merged with Marquette University. He was admitted to the bar in 1897, although he was never engaged in the practice of law.

After working with his father for a time, Herman struck out on his own. In 1912, Reel began the publication of a trade journal called the *Progressive*, covering the fur and wood trades. In 1914, with the assistance of his sister, he opened a fur shop in downtown Milwaukee on Grand Avenue—later renamed Wisconsin Avenue—which became highly successful. Herman Reel married Blanche Ullman in 1904. They had three sons: Robert, Adolph and Frederick.

Subsequent owners of the residence include Herbert Spenner, a prominent member of Milwaukee's German American community. An attorney, Spenner served as legal representative for the governments of West Germany and Austria in Wisconsin for twenty years. He was president of the German American Societies of Milwaukee and of Goethe House at

the Central Public Library. He was active in efforts to establish a sister city relationship between Milwaukee and Munich.

The home was designed by Richard Philipps, a widely known Milwaukee architect who was the original consultant in the planning of Kohler Village for the Kohler Company. He also designed the Kohler building now known as the American Club, the Kohler Design Center, the Schuster Department Stores in Milwaukee and the St. Joseph's Chapel at the School Sisters of St. Francis Convent at 1515 South Layton Boulevard. Philipps and partner Hermann J. Gaul were the architects for Holy Hill National Shrine in Hubertus, Wisconsin.

A complete set of the original drawings, which are beautifully illustrated with elaborate detail, are on file in the Milwaukee Architectural Archive at the Milwaukee Public Library.

The Herman and Blanche Reel House is listed in the Whitefish Bay Register of Historic Places.

Other Grand Lake Drive Homes

The following Lake Drive homes are individually eligible for listing in the National Registry because of the significance of their architectural styles.

- The Bernard Klatt House, **5425 North Lake Drive**, 1918
- The John E. Saxe House, **5375 North Lake Drive**, 1929
- The H.C. Wuesthoff House, **5220 North Lake Drive**, 1924
- The Leonard L. and Laura H. Bowyer House, **5073 North Lake Drive**, 1931
- The Richard D. and Agetha R. Harvey House, **4965 North Lake Drive**, 1929. This home was designed by renowned architect Russell Barr Williamson.
- The Roy W. and Viola A. Johnson House, **4850 North Lake Drive**, 1941
- The George and Margaret Schueller House, **4837 North Lake Drive**, 1926. This home was designed by Russell Barr Williamson.
- The Dr. N.W. and Persephone Stathas House, **4629 North Lake Drive**, 1962
- The Stanley and Ruth Coerper House, **4605 North Lake Drive**, 1950
- The Harold E. and Ester Constant House, **4514 North Lake Drive**, 1946

In addition to the Lake Drive homes above, the following houses are listed on the Whitefish Bay Architecture and History Inventory (AHI).

- The W.O. Robertson House, **5400 North Lake Drive**, 1921
- The Charles E. Inbusch House, **4863 North Lake Drive**, 1925. This home was designed by Russell Barr Williamson.
- The Chester and Mabel Moody House, **4827 North Lake Drive**, 1927
- The Benjamin and Aimee Poss House, **4676 North Lake Drive**, 1929
- The Dr. Jack Hussussman House, **4668 North Lake Drive**, 1971

4
BAY RESIDENTS YOU WISH YOU HAD KNOWN

The histories of Whitefish Bay, Milwaukee and the state of Wisconsin have been shaped by famous, notable and prominent residents, including industrialists, tycoons, business leaders, clergy, politicians, sports greats and well-known entertainers who were either born in the Bay, lived here or graduated from Whitefish Bay High School. Here are some of those interesting people—residents of Whitefish Bay that you may wish you had known.

Jeffrey Hunter (Henry McKinnies Jr.)

4967 North Larkin Street

Until abandoning him later in life, Fate smiled fondly on Henry Herman McKinnies Jr. Movie star looks. Captain of the Whitefish Bay High School football team. Student council president. Honor student in both high school and college. Most would later call "Hank" by his Hollywood name, Jeffrey Hunter, before he passed away after a series of medical misfortunes at age forty-two.

Hunter was born November 25, 1926, in New Orleans, an only child. He was four years old when his parents, Henry Herman Sr. and Edith McKinnies, moved to Whitefish Bay. They first lived at 5529 North Lydell Avenue before later purchasing the home at **4957 North Larkin Street**.

Whitefish Bay notables. *Clockwise from top left*: scientist/writer A. Cressy Morrison, Dr. Thaddeus W. Williams, actress Jane Archer, historian Miriam (Young) "Mimi" Bird and her son David.

A Celebration of Architecture and Character

Whitefish Bay High School class photos. *From left, top row:* skater Sally-Anne Kaminski, actress Kristen Johnston and actress Colleen Dewhurst; (*middle row*) skater Angela Zuckerman, actress Caitlin O'Heaney and activist Bernardine Dohrn; (*bottom row*) baseball player Craig Counsell, actor Jeffrey Hunter and Dr. Hugh Hickey.

Hunter attended Whitefish Bay schools. He was a member of the high school dramatic club and student council president his senior year. He also lettered in football and was co-captain. He played leading roles in high school plays, acted in productions of the North Shore Children's Theater and performed in summer stock with future Oscar winners Eileen Heckart and Morton DaCosta, and Tony winner Charlotte Rae. He also was a radio actor at WTMJ, getting his first acting paycheck in 1945 for the wartime series *Those Who Serve*.

After graduating from high school in 1945, Hunter enlisted in the U.S. Navy, serving for one year before receiving a medical discharge. He attended Northwestern University, graduating with a bachelor's degree in 1949 and further honing his acting skills. He studied under Alvina Krauss, who also taught such Hollywood luminaries as Charlton Heston, Tony Randall, Cloris Leachman, Claude Akins, Jerry Orbach, Ann-Margret and Warren Beatty. Years later, she stated that Hunter was the most talented student she ever had.

Hunter was working on his master's degree at UCLA in Los Angeles when he was discovered during a school production. In 1950 he shot his first film for Twentieth Century Fox, *Julius Caesar*, which featured Charlton Heston as Antony. Studio head Darryl F. Zanuck changed Hank McKinnies's name to Jeffrey Hunter. Within two years, Hunter had worked his way to top billing in *Sailor of the King* (1953). His big break came in *The Searchers* (1956) with John Wayne, and in 1960, Hunter had one of his best roles in *Hell to Eternity*. That year, Hunter landed the role for which he is probably best known—although it is considered far from his best work—as Jesus in *King of Kings*. He made thirty-five films during his twenty-year career.

After starring for two years in a TV western series, *Temple Houston*, Hunter made a momentous career decision. Cast as the captain of the USS *Enterprise* in *Star Trek* in 1964, Hunter quit the role after shooting the pilot episode, deciding to concentrate on his movie career. Footage from the pilot was later incorporated into a two-part episode in *Star Trek*'s first season, but the producers were forced to recast Hunter for a new actor and starship USS *Enterprise* captain, James Kirk, played by William Shatner.

Hunter later lobbied to be cast as Mike Brady for the TV series *The Brady Bunch* opposite Florence Henderson, but the producer would not consider him, telling Hunter he was "too good-looking to be an architect."

Hunter died in 1969 after a series of medical mishaps as dramatic as his acting roles. Hunter was injured in an on-set explosion while shooting

A Celebration of Architecture and Character

N.W. and Audrey Humbaugh House, 4957 North Larkin Avenue, circa 1940. Actor Jeffrey Hunter's childhood home.

a film in Spain, suffering facial lacerations from broken glass and powder burns. Later, he was accidentally hit on the chin with a karate chop when Hunter failed to defend himself in time and banged his head against a door. Then while on the plane back to the United States he suffered a stroke. Hunter recovered and, shortly after signing to star in *The Desperados* (1969), suffered another stroke while climbing stairs in his home, fracturing his skull in the fall. He died on May 27 without regaining consciousness at age forty-two.

The brick Colonial Revival residence at 4957 North Larkin Avenue is known as the N.W. and Audrey Humbaugh House. It was built in 1940 by Roy Haglund and is listed on the Whitefish Bay Architecture and History Inventory (AHI).

Bernardine and Jennifer Dohrn

4736 North Hollywood Avenue

It would be difficult to imagine that there were two sisters in the Bay who led more incongruous lives than Bernardine and Jennifer Dohrn. Both were active and highly successful students at Whitefish Bay High School. Both were in the National Honor Society, and Jennifer was class valedictorian. Both were involved in numerous sports, clubs and school activities. Bernardine was a member of the future nurses' club; Jennifer was in the future teachers' club. They were model students. But then their lives took off on another track.

Within a few years of her high school graduation, Bernardine Dohrn was on the Federal Bureau of Investigation's (FBI) "Ten Most Wanted" list, a militant political activist hunted for bombings of the U.S. Capitol, the Pentagon and several police stations in New York City. Yet after coming out of hiding ten years later, she never spent a single day in jail for the alleged crimes for which the FBI had pursued her. And in a strange bit of irony, her sister Jennifer Dohrn had the deputy director of the FBI convicted of crimes committed against her while the bureau was in pursuit of Bernardine. Despite their dramatic brushes with the law and their lifetime histories as activists, both sisters, now in their seventies, have capped their incredible lives with successful professional careers, Bernardine's in teaching, Jennifer's in nursing—paradoxically the inverse of the clubs they had joined in high school.

Bernardine Dohrn was born on January 12, 1942, and lived at **4736 North Hollywood Avenue**. Bernardine was actually born Bernardine Ohrnstein. She graduated from Whitefish Bay High School in 1959, where she was a cheerleader, treasurer of the modern dance club, a member of the National Honor Society and editor of the *Tower Times*, the school newspaper. She was selected to attend Badger Girls State, a government leadership program sponsored by the American Legion (women's) Auxiliary.

Upon graduation, Bernardine enrolled at Miami University of Ohio where as a freshman an event occurred that may have influenced her life. When she was a senior in high school, her father, Bernard, anglicized the family name from Ohrnstein to Dohrn. Bernardine rushed a popular sorority at Miami, but was black-balled because her father was Jewish. (Her mother, Dorothy Soderberg, was of Swedish descent and a Christian Scientist.) It is likely that Bernardine was already bewildered about her Jewish heritage

A Celebration of Architecture and Character

The Tom P. Gullette House, 4736 North Hollywood Avenue, circa 1947. Activist sisters Bernadine and Jennifer Dorhns' childhood home.

because of her family's perplexing name change a year earlier. Could the sorority's blatant act of discrimination have ignited a rage against injustice that burned throughout the rest of her life?

Bernardine transferred the following year from Miami, a comparatively quiet campus in a small town, to the University of Chicago, a hotbed of student radicalism and unrest. Her high school yearbook described her as having "a trace of the exotic," and she cut a provocative image as a student at Chicago, favoring knee-high boots, tight leather mini-skirts and black bomber jackets. At the University of Chicago, she met and later married William Ayers, the scion of a wealthy Chicago family. If she was to escape her radical destiny, surely Ayers would have been her way out. Instead, she radicalized him.

Bernardine graduated from the University of Chicago with honors in 1963 and obtained her law degree from the University of Chicago in 1967.

It was while attending law school that her social activism began. She worked in the civil rights campaigns of Martin Luther King Jr. and became the first law student organizer of the National Lawyers Guild, a progressive association of lawyers and legal advocates founded in 1937 as a politically liberal alternative to the American Bar Association. After graduating from

law school, she joined the Students for a Democratic Society (SDS), creating a revolutionary splinter group known as the Weather Underground with Ayers, whom she would marry while they were on the run. In speeches, she declared herself to be a "revolutionary communist." She co-wrote a "declaration of war" against the U.S. government that transformed the group from political advocacy to violent action. Even so, some credit Dohrn with ensuring that no lives were lost after she came into leadership of the Weather Underground.

After the Washington and New York bombings, Dohrn and Ayers became fugitives for nearly ten years, during which they were both charged with numerous crimes. In the end, when they both surrendered in 1980, Ayers was not convicted of any crimes and Dohrn pleaded guilty only to aggravated battery and bail jumping—for which she was fined $1,500 and given three years of probation.

Bernardine Dohrn has continued her social activism. In the 1980s, she was employed by a prestigious Chicago law firm before working for the Northwestern University School of Law from 1991 to 2013. While there, she helped found the Children and Family Justice Center, which represents disadvantaged youth and families in legal matters. She serves on the board of numerous human rights organizations. Her husband, Bill Ayers, worked for the University of Illinois–Chicago in what has been characterized as an impactful career in the field of education.

Jennifer Dohrn, Bernardine's younger sister, was born on November 30, 1944, and graduated from Whitefish Bay High School in 1963. She moved to New York City, where she obtained a bachelor's degree from Hunter College and master's and doctorate degrees in nursing from Columbia University.

In the 1970s, while her sister was on the run, Jennifer became a national leader of the Prairie Fire Organizing Committee, an above-ground support group for the Weather Underground, and a spokesperson for her fugitive sister Bernardine. She continued to be involved in radical politics into the 1980s though she was never accused of any crimes. She later married black activist lawyer Haywood Burns, known for his successful defense of black radical Angela Davis against kidnapping and murder charges in connection with an attempt to free black prisoners in a California courtroom.

While Bernardine was on the lam, the FBI did surveillance of Jennifer and others associated with the Weather Underground. The surveillance operation was led by Deputy FBI Director Mark Felt—who would later be revealed as Deep Throat in the *Washington Post* investigation of the Watergate scandal. In 1980, Felt was convicted of criminal charges of

violating the rights of citizens by ordering FBI agents to secretly break into the homes of Jennifer Dohrn and others linked to the radical group. Felt was later pardoned by President Ronald Reagan. Jennifer sued the FBI and reached a settlement, in which she alleged that Freedom of Information Act papers showed that the FBI planned, though never carried out, an attempt to kidnap Jennifer's newborn son in order to force Bernardine to surrender.

Jennifer Dohrn today is an assistant professor of nursing at the Columbia University Medical Center, where she teaches community health, specializing in nurse-midwifery, and is director of the school's Office of Global Initiatives, which provides healthcare training for HIV/AIDS patients in African and other developing nations.

The Dohrn home at 4736 North Hollywood Avenue was built in 1947 by developer Fred A. Mikkelson. The date suggests that it was probably one of Mikkelson's first homes of many he built in the Milwaukee area. Village records show it was built as a six-room, one-bath, two-story home, typical of the Mikkelson-designed homes constructed later in the Bay. Mikkelson's construction cost at that time was $8,000. The first owner was Tom P. Gullette, who in 1950 obtained a permit to add a garage to the property. Village records show the home has had at least four owners, of which the Dohrn family was the second.

Colleen Dewhurst

5139 North Cumberland Avenue

"Tall, luminous and leonine, the legendary Colleen Dewhurst must go down as one of the theater's finest contemporary tragediennes of the late 1900s. With trademark dusky tones and a majestically careworn appearance, she possessed an inimitable down-to-earth fierceness that not only earned her the title Queen of Off-Broadway but allowed her to put a fiery and formidable stamp on a number of Eugene O'Neill's heroines."

That is how the website Internet Movie Database (IMDb) sums up the life of Colleen Dewhurst, perhaps the finest actress, of several, to pass through Whitefish Bay High School.

Colleen was the only child of a nomadic family. She was born on June 3, 1924, in Montreal, Quebec, to Ferdinand "Fred" Augustus and Frances

Marie Dewhurst. Fred was a professional hockey player and a Canadian Football League player who later became a retail manager at several stores. The family left Canada when Colleen was thirteen, moving to Boston, Massachusetts, next to New York City and then to Whitefish Bay.

The family lived at 5139 North Cumberland Avenue. Colleen attended Whitefish Bay High School during her freshman and sophomore years, went to Shorewood High School for her junior year and graduated from Riverside High School in Milwaukee in 1942. Dewhurst attended Milwaukee's Downer College, later to become part of the University of Wisconsin–Milwaukee, for two years before moving to New York City to pursue an acting career. She trained at the American Academy of Dramatic Arts while working as a receptionist and elevator operator and on a telephone switchboard between summer stock roles that took her from New England to the South.

Dewhurst's early career was a struggle. She became strongly identified with a number of Eugene O'Neill plays, but it wasn't until 1956 that she earned her first off-Broadway Obie Award for her work in a series of productions in the New York Shakespeare Festival. It was during her years with the festival that she met actor George C. Scott—in 1959 she played Cleopatra to Scott's Antony in William Shakespeare's *Antony and Cleopatra*—whom she married twice, the first time from 1960 to 1965, during which they had two sons, the second time from 1967 to 1972 after which they divorced again. She later said of Scott, "I have great love and affection for George.…I always said we got on much better during the divorces.…We make a better brother and sister."

In addition to her two off-Broadway Obie Awards, during the 1960s and 1970s, Dewhurst was a frequent contender for on-Broadway Tony Awards, being nominated eight times and winning twice. She stayed busy on the big screen and television, too. She appeared in fifty-six films from 1959 to 1991, including *The Nun's Story* and *Annie Hall*. Her thirty-three years of TV work earned her four Emmy Awards, including two as actress Candice Bergen's worldly mother in the series *Murphy Brown*.

Dewhurst became president of the Actor's Equity Association in 1985, serving until her death six years later. Perhaps her most difficult moment came in 1990 when she was widely criticized in a union dispute over whether a white British actor should perform the role of a Eurasian pimp in the musical *Miss Saigon* on Broadway. She called it a "minstrel show." The union first opposed the actor but later reversed its position, and the actor, Jonathan Pryce, went on to win a Tony Award in the role.

Diagnosed with cervical cancer, Dewhurst's fervent Christian Science beliefs led her to refuse any kind of surgical treatment. She died at age sixty-seven on August 22, 1991.

The Fred and Helen Deutsche Duplex at 5139 North Cumberland Boulevard was built in 1926. It is a contributing historic property in the Fairmount and Highland View Historic District.

Whitney H. and Anna M. Eastman/Kristen Johnston

4716 North Wilshire Drive

The beautiful home at **4716 North Wilshire Drive** was constructed in 1929 for Whitney H. and Anna M. Eastman. Eastman was the president of the William O. Goodrich Company, a subsidiary of the Archer-Daniels-Midland Company (ADM), of which Eastman was a large stockholder. Goodrich had a soybean processing plant in Milwaukee. Historical records indicate that the William O. Goodrich Company was acquired by ADM in 1928.

Whitney H. and Anna M. Eastman House, 4716 North Wilshire Road, circa 1929. Actress Kristen Johnston lived here during her teens.

A subsequent owner of the home was Angela Johnston, the mother of actress Kristen Johnston, who lived there during Kristen's high school years. Kristen was born on September 20, 1967, in Washington, DC. Kristen's father is Rod Johnston, an attorney and former state senator. The family lived in Fox Point, where Kristen attended St. Eugene's Catholic Grade School before Kristen's parents divorced and Angela, a real estate agent, purchased the Wilshire property.

Kristen graduated from Whitefish Bay High School in 1985. She was involved in the American Field Service program and spent some of her teen years as an exchange student in Sweden and in South America. She earned a bachelor of fine arts degree in drama at New York University.

Kristen Johnston is best known for her role portraying Sally Solomon in the TV series *3rd Rock from the Sun*, for which she twice received Emmy Awards. The show ran on NBC from 1996 to 2001. She also starred in the role of Holly Franklin in *The Exes*, which ran from 2011 to 2015 on the TV Land channel. She has appeared in sixteen films, eighteen television series and ten stage productions.

While appearing to be Hollywood glamorous, Johnston's life has actually had its share of adversity. In her 2012 autobiography, *Guts: The Endless Follies and Tiny Triumphs of a Giant Disaster*, Johnston revealed an addiction to alcohol and pills that began when she was in high school, though she has been sober since 2008. Through her charity SLAM, NYC (Sobriety, Learning and Motivation), she mentors New York City high school girls with addiction and self-esteem issues. Tragically, in 2013, she was diagnosed with lupus. She suffers from muscle weakness, has difficulty walking and wears an orthopedic collar to keep her head erect.

Roy C. Otto was the architect and builder for the Eastman home, which was built at a cost of $18,000. Otto also designed over a dozen residences in the Washington Highlands district of Wauwatosa. In spite of the number of upscale residences Otto designed in the Milwaukee area, he eventually left architecture to pursue his true passion—bowling. He operated three bowling alleys in Milwaukee from 1941 to 1965 and served as an officer of the Wisconsin Bowling Proprietor's Association.

The Eastman House is individually eligible for placement in the National Register of Historic Places and is a contributing historic property in the Lake Woods and Ortonwood Triangle Historic District.

A Celebration of Architecture and Character

Dr. Thaddeus W. Williams

942–44 East Sylvan Avenue

What kind of man was Dr. Thaddeus Warsaw Williams?

There is no question that Dr. Williams was an important political figure in Whitefish Bay history. He was one of the founding fathers who led the drive for the village's incorporation in 1892. Following incorporation, he became the village's first health officer and one of its first village board trustees. He also served as the village's second president, from 1895 to 1896, and again from 1900 to 1903. In 1893, Dr. Williams built a stately frame residence with Victorian influences at **942–44 East Sylvan Avenue**. He further enlarged his residence in the late 1890s and gave it a name, the Pines. Two five-story pines still stand on the property.

He was also a good family man. Dr. Williams was born about 1842 in Kentucky. After moving to Whitefish Bay, Dr. Williams's sister and brother-in-law died in Kentucky, leaving five children. Three of the children went to homes with other family members while Dr. Williams and his wife, Alice J. (Gibson), took in a niece and nephew, Grace and Walter.

As a physician, Dr. Williams appears to have been a compassionate caregiver. In *Chronicles of Whitefish Bay*, compiled by historian Thomas Fehring, an essay recalls how a young girl of fourteen suffered a painful spinal cord injury. In a case which might have challenged even modern medicine, the girl praises Dr. Williams's gentle and reassuring bedside manner, describes what appears to be a kind of chiropractics and relates how a crude but novel form of physical therapy allowed her to walk again. "He saved my life," she said.

But what kind of medicine did Dr. Williams practice? If he was like the rest of the American medical establishment in his day, he likely rejected the germ theory of disease. Illness was treated by purging and bloodletting using leeches. If he employed the cures and therapies that were common at the time, he probably prescribed narcotic-laced potions, elixirs, nostrums and other snake oils. Doctors in the late 1800s used the title more for vanity than to imply medical expertise, since there was no licensing requirement and some medical schools were largely diploma mills with some not even requiring literacy for admission. "The medical scene in the 19th century," writes medical historian Elaine Breslaw in her book, *Health Care in Early America*, "was a chaotic free-for-all."

Dr. Thaddeus W. and Alice J. Williams House, 942–44 East Sylvan Avenue, circa 1893. Dr. Williams was the village's first health officer and second village president.

We do know that Dr. Williams bought into some of the quackiest medical conventions of his time. Upon becoming the village's health officer, Dr. Williams published and distributed a fifteen-page public health pamphlet with the unwieldy title of *Be Not Deceived, or Instructions to Young Men on Spermatorrhea, or Seminal Weakness, &c., from Solitary Abuse, and Other Causes*. Spermatorrhea was the medical term doctors used in Dr. Williams's day for male sexual ejaculation, voluntary or involuntary, outside of marital relations. In the nineteenth century, this was considered a serious medical disorder believed to cause severe psychological and physical damage. One remedy was castration. Village records do not show if this disorder was a public health crisis in Whitefish Bay at the time of Dr. Williams's public service, nor do we know how the village's first health officer actually treated the condition given his obvious concern.

We also know that Dr. Williams appears to have had a strange and bizarre imagination. In 1898, he published a three-hundred-page fantasy titled *In Quest of Life; or The Revelations of the Wiyatatao of Xipantl, the Last High Priest of the Aztecs*. The story is about a lost tribe of American Indians who practice

human sacrifice. The victims' blood seeps through the soil where it mixes with an underground river, creating a magic elixir. In one scene, the high priest and his new bride take refuge from an earthquake in a cavern where the magic river flows. His bride suffers a mishap in which she is severed in half. The priest recovers the lower half of her body, impregnates it and immerses it in the elixir river for nine months to preserve the womb and ensure the birth of his heir. Dr. Williams's health pamphlet and novel are still in print today, and copies of the original book can be purchased for $3,500.

When not practicing medicine or governing, Dr. Williams also liked to dabble in real estate and was good friends with Frederick G. Isenring, the village's first president and an active real estate broker in Whitefish Bay. Records show that a number of real estate transactions occurred between the two men, some of which were later claimed to have been fraudulent. In one case, several lots were conveyed from Isenring to Dr. Williams between 1892 and 1895 that the Pabst Brewing Company claimed were transferred by Isenring in an effort to keep the properties from creditors. It is unknown whether these claims were substantiated, but as Isenring's financial problems mounted, he disappeared shortly before Christmas 1899 along with $20,000 of public funds, never to be seen again. Following his disappearance, Dr. Williams purchased the Isenring residence, then located on Fleetwood Place, and had it moved to 922 East Sylvan Avenue, just west of his own house. The Isenring home was razed in 2009.

Information about Dr. Williams's own home on Sylvan Avenue suggests the original core of the residence may be somewhat older than the 1893 construction date. An oral history by an early village resident states that John Luck, who moved to the community in 1862, lived in a residence at that location during the time that he ran a commercial fishing business in Whitefish Bay. If Dr. Williams built his home by including the structure that Luck lived in, which would not have been uncommon in those days, the original portion of the Dr. Williams's house could be among the oldest structures in the village.

The Dr. Thaddeus W. and Alice J. Williams House at 942–44 East Sylvan Avenue was built as a single-family house but has been subsequently enlarged and remodeled at least twice since then. One of the modifications converted it into a duplex. It is a contributing historic property in the proposed Pabst Residential Historic District.

Jerome "Chip" Zien

5267 North Diversey Avenue

Chip Zien knew pretty early in life that he wanted to be an actor. As a youngster, Zien performed in local theatrical productions, and one of his first roles was as a child in a production of *South Pacific* at the former Melody Top summer outdoor theater on Good Hope Road.

Jerome Herbert "Chip" Zien later in his career became a well-known stage and film character actor best know for playing the lead role of Baker in the original Broadway production of *Into the Woods* by Stephen Sondheim. He played the role of Thénardier in the Broadway production of *Les Misérables* and was Mark Rothenberg in the film *United 93*, which chronicled the September 11, 2001 attacks. He is known for providing the voice of Howard in the film *Howard the Duck*. He also appeared in the vampire comedy movie *Rosencrantz and Guildenstern Are Undead*.

Chip was born on March 20, 1947 to Allen and Phyllis Zien. The family lived at 5017 North Bay Ridge Avenue when Chip was born, but in 1950, his parents moved into a new home at 5267 North Diversey Avenue. Chip graduated from Whitefish Bay High School in 1965 and attended the University of Pennsylvania, where he became chairman of the Mask and Wig Club, the nation's oldest all-male collegiate musical comedy troupe.

Zien got his first major stage role in 1977 in a musical in New York City and proceeded to enjoy a forty-year career on- and off-Broadway. In 1999, he received the Drama Desk Award for outstanding featured actor in a musical.

Zien made his television debut in 1973 on an episode of *Love, American Style*. More guest roles followed, and in the early 1980s, he began a string of regular TV roles, starting with the series *Ryan's Hope*. He was a regular on NBC's *Love, Sidney* and *Law and Order*, ABC's *Reggie* and several CBS shows, including *Shell Game*, *Almost Perfect* and *Now and Again*. Zien also had regular roles in two daytime soaps, *Guiding Light* and *All My Children*. In 2016, he played the role of a criminal investigator in the acclaimed HBO drama *The Night Of*.

The Allen and Phyllis Zien House at 5267 North Diversey Avenue is a contributing historic property in the proposed Lake Crest Residential Historic District.

Craig J. Counsell

5905 North Berkeley Boulevard

Whitefish Bay High School has seen several of its graduates play in Major League Baseball and the National Football League, but none has had as much success in his sport as hometown hero Craig John Counsell.

From his birth in South Bend, Indiana, on August 21, 1970, Craig's life always seemed destined for baseball. His parents, John and Jeanette, relocated to Milwaukee in 1979 and purchased a home in Whitefish Bay. His father was the director of community relations for the Milwaukee Brewers from 1979 to 1987. His mother worked as a teacher. In his youth, Craig would walk from his home at **5905 North Berkeley Boulevard** to Bayshore Mall to take a bus to Mike Hegan's Field of Dreams in Brookfield, where he had an after-school job. After the store closed, Craig would take batting practice and get tips from Hegan, a former Brewers player and later a well-known sportscaster.

Craig Counsell graduated from Whitefish Bay High School in 1988, attended the University of Notre Dame and then played sixteen years in the big leagues as an infielder for five teams. Counsell is best known for his playoff performances in 1997 with the Florida Marlins and in 2001 with the Arizona Diamondbacks, helping both teams to win World Series championships. He scored the winning run in the bottom of the eleventh inning of game seven of the 1997 World Series for the Marlins after tying the game in the bottom of the ninth with a sacrifice fly. Counsell batted .381 in the 2001 National League Championship Series (NLCS) and won the NLCS Most Valuable Player Award. He was hit by a pitch to load the bases in the bottom of the ninth inning of game seven of the 2001 World Series, after which the next batter drove in the winning run for the Diamondbacks.

Counsell was traded to the Brewers in 2003, where he played for one season, went back to the Diamondbacks for two more seasons and then returned to the Brewers in 2007 for five more seasons. He recorded his one-thousandth career hit in August 2008. In 2011, he was the fourth-oldest player in the National League and had the second-best fielding percentage (.991) of all active second basemen. In 2010, he was reported to be the thirteenth-smartest athlete in sports by *Sporting News* magazine.

In 2012, Counsell retired as a player after 1,624 games and spent three years in the Brewers' front office. He was a special assistant to the general

manager and was a color analyst on Brewers' radio broadcasts. In May 2015, he was hired to become the Brewers' field manager.

Counsell and his wife, Michelle, a native of Whitefish Bay—the couple met in high school—have four children: sons Brady and Jack and daughters Finley and Rowan. They live in Whitefish Bay. The Whitefish Bay High School baseball diamond in Cahill Square Park has Counsell's name on the left field fence, and Craig Counsell Park north of Lydell Avenue is the home of the village's Little League teams. He is in the Whitefish Bay High School Athletic Hall of Fame.

Counsell's childhood home at 5905 North Berkeley Boulevard is known as the Lester and Grace Arnow home and was built in 1950.

Frederick C. Miller

4614 North Murray Avenue

As his life was tragically cut short, one can only imagine how much more Frederick C. Miller could have accomplished in a career already filled with achievement.

Frederick C. Miller was the grandson of Frederick J. Miller, founder of the Miller Brewing Company. His mother, Clara, married Carl A. Miller, who owned the former lumberyard located on Hampton Road west of the Bay Village Apartments complex. It was a major supplier of lumber used to build homes in Whitefish Bay during the early decades of the twentieth century.

Born on January 26, 1906, young Fred attended the University of Notre Dame where he was an All-American football star at tackle under legendary coach Knute Rockne on the 1926, 1927 and 1928 teams, captaining the 1928 team. Bright, as well as athletic, he had one of the highest scholastic averages ever by a Notre Dame athlete. He was posthumously elected to the College Football Hall of Fame in 1985.

While a junior executive in the family business, Fred married Adele Kanaley of Winnetka, Illinois, in 1930. Soon thereafter they moved into the home at **4614 North Murray Avenue**. Dubbed the "Miller Honeymoon Cottage," it was built by Fred O. Mueller, who lived next door at 4604 North Murray Avenue. Fred and Adele moved in to the Mueller home in 1936 when the Mueller family moved out and stayed there until 1940.

Young Fred was the nephew of Frederick C. Miller, son of the founder, who died in 1943 while chairman of the board. Succeeding his younger cousin Harry John (who later devoted himself to founding the De Rance Corporation, the world's largest Catholic charity until its dissolution in 1992), Fred was elected president in May 1947. Under his leadership, the Miller Brewing Company expanded, and sales grew from 650,000 barrels in 1947 to more than 3 million in 1952, making Miller beer a major national brand.

An avid sports enthusiast, Miller was an unpaid assistant football coach at Notre Dame, regularly flying between South Bend, Indiana, and Milwaukee during the fall. He also volunteered as a coach for the Green Bay Packers and helped fund the team through difficult financial times, making Miller Brewing Company the largest stockholder of the Green Bay Packers.

Miller is credited for bringing major league baseball to Milwaukee. In 1950, he attempted to purchase and bring back to Milwaukee the American League St. Louis Browns, which had originated as the Milwaukee Brewers before moving to St. Louis in 1901. The deal fell through, and the Browns became the Baltimore Orioles, but in 1953, Miller led a group that brought the Boston Braves to Milwaukee.

Miller also was active in civic and charitable affairs. In 1953, he was made a Knight of St. Gregory by Pope Pius XII in recognition of his work in raising funds for Catholic orphanages.

Miller was an avid aviation enthusiast, and the Miller Brewing Company purchased a converted B-34 twin-engine, twin-tailed U.S. Army bomber (Lockheed Ventura) in 1951 as part of its corporate fleet and used it extensively. On the evening of December 18, 1954, Miller and his son, Fred Jr., set out from Mitchell Field in the B-34 during inclement weather on a hunting trip to Canada with two pilots, brothers Joseph and Paul Laird. A minute after takeoff, with the plane barely fifty feet above the ground, Paul Laird radioed that an engine was on fire and he would try to return. Seconds later, the plane crashed and burst into flames, burning for two hours.

While the pilots and his son were trapped inside, Fred Miller had been thrown from the wreckage and was conscious. A resident from a nearby home rushed to the crash site, where he found Miller. According to news accounts, Miller cried to him, "My God, don't bother about me. There are three others in the plane." Police and firefighters tried in vain to rescue the others. Miller was rushed to a hospital, where he died of burns and other injuries at age forty-eight.

The Restless Ghost

4604 North Murray Avenue

At first it was believed that Fred O. Mueller was the ghost who haunted the house at **4604 North Murray Avenue**. A real estate and insurance man, Mueller built the home in 1928 for himself and his wife, Viola, but then had been hit hard by the Depression and committed suicide. Many thought he had died in his home. But Mueller was actually found hanging from a water pipe in a vacant North Side home by Milwaukee police, leaving behind a touching suicide note to his wife and daughter that read, "Goodbye loved ones. I hate to do this but it is the only way out. Take good care of Muriel, my darling daughter. Viola, my love, I am sorry to put this burden on you but it is for the best."

That was in 1939, and the Muellers had moved out in 1936. So who was the ghost haunting this handsome six-bedroom Storybook home on Murray Avenue? The house had gone through a number of owners, and there were several possibilities.

The second owner also died a dreadful death. Frederick C. Miller and his wife, Adele, lived in the house from 1936 to 1940. A grandson of the founder of the Miller Brewing Company, Miller ran the company from 1947 to 1954. He died in a plane crash at Mitchell Field. But even though he died a shocking death, Fred Miller did not turn out to be the ghost.

After the Millers, there were the Boemers from 1944 to 1959, the Holmes from 1962 to 1972, the Lindemans from 1972 to 1976 and the Cavanaughs from 1976 to 1989, who sold the house to the present owners, a well-known Milwaukee business executive and corporate CEO and his artist wife and their two young children. Did the ghost come from any of those earlier families?

The ghost began haunting the current owners almost immediately.

"We began to hear rumblings right away," the present owner said. "I was talking with Mrs. Cavanaugh a few weeks after the sale, and she asked, 'Have you met the ghost yet?' That gave me the feeling something was happening here. But I just dismissed it. I don't believe in ghosts. I thought it was something like floorboards creaking."

But these weren't floorboard-type noises. The owners began to hear unsettling stirrings at night. "I would wake up and hear soft footsteps pacing the hallway outside our bedroom. I thought it was the kids, but when I would check they were sound asleep."

A Celebration of Architecture and Character

Fred O. and Viola Mueller House, 4604 North Murray Avenue, circa 1928. Home of the restless ghost.

Once the owner came home to strange noises. She refused to enter and asked a contractor working next door to go in to make sure there was no intruder. There was no one. On another occasion she was playing with her son when they both heard footsteps, bumping and knocking. She grabbed a butcher knife from the kitchen and fled with her son. Surely an intruder had broken in. But police said no, there was no one in the house.

A former resident, Warren Holmes, paid a visit one day. He asked if he could see the house where he had grown up during the 1960s. Over coffee, he asked, "Have you seen the ghost?"

"Warren told me that his sister had seen an apparition in one of the bedrooms," the current owner recalled. The ghost, Warren Holmes told her, would do mischief for which he and his sister got in trouble. The ghost would loosen the screws securing wall plates on light switches. It would leave open cabinet doors around the house. "Our parents would scold us for doing that but we would always tell him, 'But Dad, it wasn't us,'" Warren said.

In 2002, the current owners allowed Historic Milwaukee to show their home as part of its annual Spaces and Traces tour. During the tour, a woman

stopped to talk with the owner. This had been the home of her grandfather Richard Boemer, and her sister, Susie, had gotten married in it. Susie could not make the tour but could she visit another time? A date was set.

Susie brought her wedding album, and she and her sister spent the afternoon with the owner. Touring the house, they came to a bedroom. "Now this was Aunt Irene's bedroom," Susie said. "This is the room where she died."

This was a revelation to the owner. Now they knew someone had really died in the house, and she knew who it was. There was nothing nefarious about Aunt Irene's death. She had died peacefully though at the relatively young age of fifty-six. Aunt Irene had obtained bachelor's and master's degrees from Marquette University and taught for twenty-five years in the Milwaukee public schools. She had never married and lived with her parents at the home on Murray Avenue.

Much of the afternoon was spent in Aunt Irene's bedroom with Susie and her sister telling the owner about the house, its history, their family, the wedding—and Aunt Irene.

If Aunt Irene had died without incident, what had made her such a restless ghost? Might she have contracted an illness that could not at that time be correctly diagnosed and treated causing her premature death? Had an illness, a work conflict or other event perhaps caused her to miss Susie's wedding? Susie said she and her aunt were very close, so she surely would have wanted to be there. Was Susan a favorite niece whom she desperately wanted once more to see? What was the unfinished business without which its completion Aunt Irene could not rest?

After Susie and her sister visited, a remarkable thing happened. "The noises stopped," the owner said. "Ever since that visit we have never heard anything again. It's as if Aunt Irene's ghost left the house with Susie. She had finally found closure."

The home at 4604 North Murray Avenue is known as the Fred O. and Viola Mueller House. It is individually eligible for placement in the National Registry and is a contributing historic property in the Lake Woods and Ortonwood Triangle Historic District.

A Celebration of Architecture and Character

Caitlin O'Heaney (Kathleen Heaney)

4835 North Oakland Avenue

For Kathleen Heaney, acting was in her family DNA. She made her theatrical debut at the age of eight when her mother, a drama teacher, cast her as Peter Pan in a Cumberland School production. Growing up, she and her two older sisters turned their garage at 4835 North Oakland Avenue into a theater.

Kathleen was born on August 16, 1953. At the age of eleven, she joined the North Shore Children's Theater touring company. She played clarinet in the Whitefish Bay High School orchestra and was a member of the school choir, graduating in 1970. At seventeen, she won a scholarship to the prestigious Juilliard School of Drama in New York City, where she studied under Oscar-winning actor John Houseman. Along the way, Kathleen adopted her professional name Caitlin O'Heaney.

O'Heaney has worked extensively in the theater, but is perhaps best known for playing Sarah Stickney White, the female lead on the ABC series *Tales of the Gold Monkey*, in the early 1980s, and for her role as Snow White Charming in ABC's *The Charmings*.

O'Heaney has spent much of her career in theaters on the East and West Coasts working with such stars as Katharine Hepburn and Christopher Reeves. While in Hollywood, she appeared in several movies and television series. She played the female lead in the 1980 horror feature *He Knows You're Alone*, which was actor Tom Hanks's first film. She worked in three Woody Allen movies: *A Midsummer Night's Sex Comedy* in 1982, *Zelig* in 1983 and *The Purple Rose of Cairo* in 1985. She also acted in Steven Spielberg's *Three O'Clock High*. She was a regular on the daytime drama *One Life to Live* and played in the television series *Spenser: For Hire, St. Elsewhere, Murder, She Wrote, L.A. Law* and *Matlock*, among others.

In the mid-1970s, O'Heaney modeled briefly for surrealist Spanish artist Salvador Dalí until his wife, Gala, objected. O'Heaney never married but had a lengthy relationship with Jared Martin, who played ranch hand Dusty Farlow in the TV series *Dallas*.

O'Heaney is a descendant of Jacob Best, founder of what became the Pabst Brewing Company.

O'Heaney's childhood home at 4835 North Oakland Avenue is known as the John N. and Elizabeth Meyer Duplex. It was built in 1925 and is a contributing historic property in the Lake Woods and Ortonwood Triangle Historic District.

A. Cressy Morrison

615 East Day Avenue

Abraham Cressy Morrison is probably the most famous person you have never heard of. A man of diverse talents and interests, he may be the most influential yet largely unknown person to have ever lived in Whitefish Bay. He built the house at **615 East Day Avenue** in 1897 as his summer cottage, but the dormer was added in later years.

Born in Wrentham, Massachusetts, on December 6, 1864, an early biography states that while a child his parents "met with reverses," and he had to "give up all educational advantages and devote himself to the serious problem of life" at the age of thirteen. Morrison drifted through a variety of jobs selling goods ranging from machinery, tools, syrups and molasses to coal, wood and rubber. He worked in a hotel as well as a lawyer's office. He finally landed a management job with a pharmaceutical business, Maltine Manufacturing Company, in Brooklyn, New York, before relocating to Milwaukee to become the advertising/publicity manager with the Pabst Brewing Company at the age of twenty-three.

In Milwaukee, Morrison became an early proponent of bicycling. He was active in the League of American Wheelmen, holding local and national positions in the organization. He also worked to promote better roads in Wisconsin and nationally.

In 1897, Morrison became chairman of the committee on credits and collections of the National Wholesale Druggists Association. He also chaired the committee on advertising of the Proprietary Association which represented non-prescription drug companies. While in Milwaukee he wrote

A. Cressy Morrison House, 615 East Day Avenue, circa 1897.

several historical articles, including a history of Milwaukee and a history of the brewing industry.

Morrison eventually moved back to the East Coast, where he worked as an executive of the Union Carbide Corporation. He joined the New York Academy of Sciences in 1924, becoming its president in 1936. At the academy, he established an annual prize—known as the A. Cressy Morrison Award—for scientific achievement, which continued to be bestowed until the mid-1990s. Several recipients of the Morrison Award went on to win Nobel Prizes.

Morrison wrote and published extensively. He was the author of *Man in a Chemical World*, *Encyclopedia of Superstition* and other books. He also wrote *Seven Reasons Why a Scientist Believes in God*, an essay still quoted today by believers and non-believers. He died in Brooklyn, New York, on January 9, 1951.

The A. Cressy Morrison House at 615 East Day Avenue is a contributing historic property in the proposed Lawndale Residential Historic District.

Jane Archer

5251 North Idlewild Avenue

Her life story sounds like it was written for Broadway—a wartime romance, stranded behind enemy lines, friendships with some of the most famous people of her time. It is lucky Jane Archer was an actress.

Born in Connecticut in 1910 and for many years a performer on Broadway and in Europe, Jane Archer and her husband, Horst Schillbach, eventually settled in Whitefish Bay and lived for nearly fifty years in a Craftsman-style home at **5251 North Idlewild Avenue**.

Aspiring to act, in her twenties she went to Vienna, Austria, to the Max Reinhardt School of Acting where she met, among other luminaries, Otto Preminger, an instructor who would become a famous director and actor in the United States. They became friends, and Preminger taught her acting while Archer taught him English. Preminger later directed Archer in plays in the United States.

Archer also met Horst Schillbach, an engineering student at the University of Munich. Archer returned to the States to act on Broadway with Helen Hayes, Lynn Fontanne, Alfred Lunt and other stars but maintained a long-

Leland and Sylvia Thorpe House, 5251 North Idlewild Avenue, circa 1926. Stage actress Jane Archer made her home here for nearly fifty years.

distance relationship with Schillbach. She returned to Germany in 1938 to marry him.

Archer took a job with the English Repertory Theater in Berlin and was intending to be there only one year when World War II broke out. Schillbach was then a research engineer at a Siemens AG electronics plant, making it impossible for them to leave the country. The couple endured bombings of both their neighborhood and Schillbach's plant. They were able to escape to Munich as Soviet troops were closing in on Berlin in 1945.

The two made their way to the United States after the war, and in 1948, they settled in the home at 5251 North Idlewild Avenue. Their son Robert was born in 1949. Archer for many years performed a one-person show titled *Helen Hayes: Life-Career-Roles*, in which she would tell details from Hayes's life and dramatized scenes from her plays. Archer died in 1999 at the age of eighty-nine. Schillbach worked for many years at Allen-Bradley Corporation, today Rockwell Automation Inc. He died in 2002 at age ninety-four.

Their home at 5251 North Idlewild Avenue was built in 1926 by architect Herbert Ebling. It features a high-pitched hipped roof and a large bay

window centered at the front of the house. The first owners were Leland and Sylvia Thorpe. The home is a contributing historic property in the proposed Lake Crest Historic District.

Miriam "Mimi" Bird

5142 North Idlewild Avenue

Local historian Miriam "Mimi" Young was born in Milwaukee to Final and Opal Young in 1933. Two years later, the Young family built a home at **5142 North Idlewild Avenue**, where Mimi spent her childhood. She married John D. Bird in 1959, and they settled in Whitefish Bay, living at 5155 North Bay Ridge Avenue. The family moved to 6123 North Lydell Avenue in 1968 and moved to Glendale in 1994.

John Bird's parents, John D. and Lois C. Bird, built a home at 6048 North Bay Ridge Avenue in 1935 at a cost of $8,500, and it is a contributing historical property in the Bay Ridge and Kent Avenues Historic District.

Through an interest in genealogy, Mimi joined the Whitefish Bay Historical Society and began researching the history of the community in depth. She studied the minutes of every village board meeting from 1892, when the village was incorporated, to 1950, the year she graduated from Whitefish Bay High School. She interviewed longtime residents, dug out news articles, obtained family letters and diaries and researched old documents. Eventually, her research efforts expanded to include the histories of the Town of Milwaukee, which would later become the seven North Shore suburbs, and the Town of Granville, which today is the northwest portion of Milwaukee.

Mimi produced a book in 1992 on Whitefish Bay history on the 100th anniversary of the village's incorporation. After her death in 2002, Mimi's research papers were donated to the Whitefish Bay Library. Her twenty-seven volumes of historical research were placed online in 2011 and are accessible to everyone through a link on the Whitefish Bay Library's website. Fittingly, her husband, John, and sons David and Peter chose to have her buried in the Town of Milwaukee Cemetery, a graveyard she trod many times while researching the historic gravestones. She placed great value in learning about the early life of her community, and her work will continue to pay dividends for future generations.

Final and Opal Young House, 5142 North Idlewild Avenue, circa 1935. Bay historian Mimi Bird's childhood home.

The Final and Opal Young House at 5142 North Idlewild Avenue is listed on the Whitefish Bay AHI in recognition of their daughter Mimi Bird's significant civic role in researching and archiving the history of Whitefish Bay.

SID STONE

5129 North Kimbark Place

Perhaps one of the wittiest and cleverest people to have lived in Whitefish Bay was raconteur Sid Stone—painter, salesman, cartoonist, television game show host, TV producer, ad man and real estate developer.

Sid first made his name with the cartoon *Chester the Pup*, which ran in the *Milwaukee Journal* and was syndicated in newspapers around the country. He then became known for his game show on WTMJ-TV, *It's a Draw*, a take-off on charades. As Sid drew his cartoon, a celebrity panel would try to guess what saying, song, book or figure he was illustrating. Some examples:

- Two drunken bass fiddlers denoted the baseball phrase "bases loaded."
- A cook flipping pancakes was the baseball expression "batter up."
- A lion with a top hat, monocle, boutonniere and cane was a "dandy lion" (dandelion).
- A tipped whiskey bottle losing a drop of liquid stood for the musical term "diminished fifth."

Born Siegbert Klipstein in Berlin, Germany, in 1911, Sid immigrated to New York City at the age of seventeen with twenty-five dollars in his pocket. At some point in his life, he changed his name to simply Sid Stone. He swept floors and painted signs and store windows for Macy's and other retailers before getting a sales job with the Brillo Manufacturing Company. He was promoted to district manager and assigned to Milwaukee in 1935 where he met Shanah Levant. They married in 1936. The couple lived on Woodruff Avenue before building a home at **5129 North Kimbark Place** in 1950 where they raised sons Robert and John.

For a time, they ran a small grocery store. Shanah persuaded Sid to quit his sales job and continue cartooning full time. Then as TV began to hit its stride in the 1950s, Sid and Shanah, an accomplished woman in her own right, began producing local shows together, including *That's My Pop*, *Half-Pint Auction* and *The Gretchen Colnik Show*. Gretchen Colnik was the only child of master ironwork craftsman Cyril Colnik and her show, which discussed current events, home decorating and crafts and did interviews, ran for fifteen years from 1952 to 1966 on WTMJ-TV and WISN-TV. It is believed to be the longest-running local non-news program in Milwaukee television history. On her passing in 1991, Gretchen left over $1 million to Marquette University, her alma mater.

Sid also opened an advertising agency in downtown Milwaukee, relocating it to 4532 North Oakland Avenue in Whitefish Bay in 1970. His cartooning work over the years included strips *Artie Choakes* and *Private Jones*, editorial and single-panel cartoons and advertising for Brillo and other products, including the whimsical grandpa on Grandpa Graf's root beer, a Milwaukee brand that goes back to 1873. A few of his comics from his early days feature German dialogue, and some cartoons and the Brillo drawings are signed by Sig Klipstein.

In 1972, Sid and Shanah retired to Grafton and developed Stonecroft, a mixed-use residential and retail complex. Shanah operated a gift and candy store there for several years until her death in 2004. Sid died in 2000.

Sid liked to play soccer, the sport he brought with him from Germany, but he was never interested in American sports. His progeny, however, are very athletic. Son John Stone graduated from Whitefish Bay High School in 1959 both as salutatorian and as one of the school's biggest basketball stars. In his senior year as a first-team all-stater, he led the Blue Dukes to a 20-1 record and number two state ranking with a thirty-three points-per-game average. In track, he placed second in the state in both the shot-put and discus, and he was an all-conference infielder and pitcher on the baseball team. John went to Marquette University, where he captained the 1963–64 basketball squad. His future wife, Jacquelyn, also an MU student, designed the men's basketball uniforms and cheerleaders' outfits.

John joined his father's advertising business following graduation and stayed physically active by playing softball. He was twice named to the All-World Softball Team, is a member of the Wisconsin Softball Hall of Fame and was named to the Amateur Softball Association's 1960s Team of the Decade as a first baseman. He is an inductee of the Whitefish Bay High School's Athletic Hall of Fame.

John and Jackie, who live in Whitefish Bay, have four children: Tiffany, Lacey, Michael and Emily. Tiffany Stone was inducted into the High School Athletic Hall of Fame in 2017 for her talents as a basketball and tennis player. Lacey Stone is a widely known celebrity fitness trainer with studios in New York City and Los Angeles.

George Jr. and Lucille M. Meyer

5960 North Shore Drive

The Lannon stone mansion at **5960 North Shore Drive** was built in 1934 for George J. Meyer Jr. and his wife, Lucille, on a bluff immediately north of Klode Park.

Meyer was general manager and then president of the George J. Meyer Manufacturing Co., a manufacturer of bottle cleaning equipment and various associated products that his father founded. The company was at one time the largest producer of automatic bottling equipment in the world—equipment that was particularly useful to Milwaukee's brewers.

After building their house, the Meyers in 1935 began an annual tradition of celebrating the Fourth of July with a spectacular fireworks display. For fifty

years until 1985 their display attracted hundreds into adjacent Klode Park, serving as the village's fireworks celebration during those years. After George died in 1973, Lucille continued the tradition for another dozen years. She died in 2000 at the age of 102.

The George Jr. and Lucille M. Meyer House at **5960 North Shore Drive** is individually eligible for listing in the National Registry because of the significance and integrity of its Tudor Revival style.

Frank E. Baker

601 East Day Avenue

This Williamsburg-style Colonial at **601 East Day Avenue** was built in 1928 for Frank E. Baker, the president of the Wisconsin State Teachers College, which is now the University of Wisconsin–Milwaukee.

Baker served as the president of the college for twenty-two years beginning in 1924 and led the college into national prominence. The college became known for its innovative and experimental programs in

Frank E. and Ruth G. Baker House, 601 East Day Avenue, circa 1928.

teacher education and was considered one of the top teacher training colleges in the nation. Under Baker's tenure, high admission standards and a limited enrollment helped maintain excellence. Its students faced tough academic requirements. Baker Field House, which opened in 1931 on the UWM campus, is named after him.

The residence has been owned by the Rosenbaum family since 1946, when it was purchased from the Bakers by Francis Rosenbaum, a prominent cardiologist. Rosenbaum was previously at the University of Michigan. He served as chairman of the Council of Clinical Cardiology for the American Heart Association from 1965 to 1967.

The house was designed by noted architect Cornelius Leenhouts of the firm of Leenhouts and Guthrie. A harmonious addition was added in 1987. The residence includes a library in half-timber style and generous use of crown moldings. It has an attached two-car garage, which was unusual for homes dating from the 1920s.

The Frank E. and Ruth G. Baker House at 601 East Day Avenue is a contributing historic property in the proposed Lawndale Historic District. The home is listed in the Whitefish Bay Register of Historic Places.

Bay's Champion Ice Skaters

Whitefish Bay has nurtured three ice skating champions—two speed skaters and one figure skater—who have made their names at national and international venues.

Thomas "Thom" Weisel

6361 North Berkeley Boulevard

Other than Jim Thorpe, Thomas "Thom" Weisel was a world-class athlete without equal. Weisel has been passionate about competitive sports his entire life, both as a participant and later in leadership roles for skiing and cycling. Starting when he was ten years old and continuing into his fifties, Weisel has set world records and won national and international championships in three sports: speed skating, skiing and cycling. Today a wealthy investment

banker and philanthropist, he is a major funder of the U.S. Ski Association and U.S. Cycling, as well as a leading benefactor to the arts.

Born in 1941 to Dr. Wilson and Amy Weisel, the family lived at 6361 North Berkeley Boulevard during his youth. Thom took up speed skating at age seven and won the Midget Boys Wisconsin State Championship when he was ten years old. In 1955, at age fourteen, he won his first national speed skating championship and set the national record for juvenile boys. He kept winning, becoming five-time age-group national speed skating champion from 1955 to 1959 and setting five national records at various distances in the process. In 1959, at age seventeen, Thom came in third in Olympic speed skating trials for the 1960 games, narrowly missing the cut.

Weisel started to ski race in his thirties and forties, winning medals and trophies and setting age-group records in downhill skiing, slalom and grand slalom. When Weisel's knees gave out after too much competitive skiing and distance running, he took up bicycle racing. He won five age-group national championships and three world championships between 1989 and 1992, setting two national records for his age group.

Weisel graduated with honors from Stanford University in 1963 and got his MBA from Harvard University in 1966. He founded an investment banking company in San Francisco, California, and made his fortune investing in the early pioneers in the high-tech industry in Silicon Valley. An avid art collector—he once owned seven hundred pieces—he sits on the boards of the Museums of Modern Art in both San Francisco and New York City.

The Dr. Wilson and Amy Weisel House at 6361 North Berkeley Boulevard was built as a seven-room, two-bath brick colonial for $13,000 in 1946. The home is on the Whitefish Bay AHI.

Angela Zuckerman

924 East Fairmont Avenue

Angela Zuckerman, the daughter of Barry and Carol Zuckerman, lived at 924 East Fairmount Avenue, right across the street from Cahill Square Park, where she joined and began training with the Whitefish Bay Speed Skating Club when she was eight years old. She ran on the varsity cross-country and track teams while at Whitefish Bay High School.

Angela graduated in 1983 and began competing internationally, skating in the World Cup circuit from 1986 to 1993. She raced in the 1,500-meter and 3,000-meter events in the 1992 Olympics in France and the 1994 Olympics in Norway. In 1987, she met French speed skater Jerome Davre at an international meet, and they married after the 1992 Olympics. The couple settled in Whitefish Bay, where they have raised two children.

The Zuckerman home at 924 East Fairmount Avenue was built in 1954 as a seven-room, two-bath Cape Cod with wood frame and fieldstone siding for $18,000. Warren Gollon and his wife were the first owners.

Sally-Anne Kaminski

5105 North Lake Drive

Sally-Anne Kaminski grew up at 5105 North Lake Drive. The daughter of Daniel and Linda Kaminski, she graduated from Whitefish Bay High School in 2002. She started ice skating at age eight, began competing when she was ten and was contending at the national and international level while still in high school. At age sixteen, she was a member of the U.S. international team that won the silver medal in the world championships in 2001. She attended Miami University of Ohio from 2002 to 2006, where she was a four-year member of Miami's collegiate synchronized skating team that won the 2003 and 2005 national collegiate championships, earning Rookie of the Year honors as a freshman.

Sally-Anne went on to become a three-time national synchronized ice skating champion and a U.S. figure skating double gold medalist. She is a registered coach with the Wisconsin Edge Synchronized Skating Team and was inducted into the Professional Skating Association Roll of Coaches in 2015.

The Kaminski home at 5105 North Lake Drive was built in 1975. The original owners were Richard and Mary Jaragoske.

Clement Hugh Hickey

4854 North Larkin Avenue

"Long before anyone ever heard of the M*A*S*H movie or the TV series, there were real-life Army docs like Hugh Hickey" wrote the *Milwaukee Journal Sentinel* in its obituary about the Whitefish Bay High School graduate who went on to become a combat surgeon during the Korean War and whose exploits and those of his colleagues would become the basis of the 1970 hit movie and smash television show, which ran from 1972 to 1983.

C. Hugh Hickey was born in 1925 to Dr. Clement and Francis Hickey. The family lived at 4854 North Larkin Avenue, built in 1927. Dr. Hickey was a well-known dentist and orthodontist. After graduating from high school in 1943, Hugh enlisted in the U.S. Navy and was an orderly at the Great Lakes Naval Station Hospital in Illinois until the end of World War II. He then attended the University of Wisconsin–Madison, where he earned his medical degree and met his wife, Sue Zimmerman, whom he married in 1949. He was serving as an orthopedic resident in a hospital in

Dr. Clement and Francis Hickey House, 4854 North Larkin Avenue, circa 1927. MASH surgeon Hugh Hickey was raised here.

Detroit when he was recalled to active duty in the 8055th MASH (mobile army surgical hospital).

One of his fellow surgeons, H. Richard Hornberger, using the pen name Richard Hooker, wrote a book about their experiences, *MASH: A Novel about Three Army Doctors*, which would inspire the movie and TV show. The unit included twenty doctors, a dozen nurses and support staff. "There really was a Hot Lips," Hickey would say later in an interview about the feisty nurse character "Hot Lips Houlihan" played by actresses Loretta Swit in the TV series for which she won two Emmys, and by Sally Kellerman in the movie, for which she earned an Oscar nomination. Hickey did not say whether he was the model for Hawkeye, Trapper John or Duke, "but he had nothing but good to say about those nurses," his son told a reporter.

Hickey recalled that surgery was performed on operating tables set on wooden planks over dirt floors. "One annoying problem, the OR [operating room] lights, made in Japan, would sometimes explode without warning, sending pieces of glass all over, including into the wound. But I can say that ninety-eight percent of the patients we cared for made it."

After the war, Hickey returned to Milwaukee and became a founding partner in North Shore Orthopaedics and later established foot clinics in the area. He retired in 1990 and moved with Sue to Sister Bay, Wisconsin, where he worked for ten years at Door County Memorial Hospital. He died in 2010.

Frank C. Klode

(Or the Curious Story of How Klode Became a Park)

The house that Frank C. Klode lived in at 6040 North Lake Drive no longer stands, but the site where it once was located is now a village park named after him.

Klode served as president of the village board from 1914 to 1918 and again from 1924 to 1934. Wisconsin law then, as it does today, prohibited local elected officials from being party to any public transactions that would enrich them financially.

During Klode's term as president in 1928, the village board wanted to purchase his Lake Drive home and the adjoining land he owned that stretched to Lake Michigan in order to create a public park. To accomplish

that, Klode resigned from the village board and was replaced in the post of president by village trustee Gould Van Derzee. The village then purchased Klode's land from him for $103,000, a deal that in today's dollars would be worth more than $1.5 million. After the property sale was completed, Klode was reappointed to the village board, Van Derzee resigned as president and Klode was re-administered his president's oath of office. The park was then named in Klode's honor.

This end run around Wisconsin's ethics law outraged the *Milwaukee Journal*, which editorialized that Klode had "temporarily removed himself from a public place so that an act, which otherwise might have raised a question of legality, could be consummated....If it is possible to get around the restrictions of a law for a good purpose, it may also be possible to evade them for a questionable purpose."

5
IMPORTANT ARCHITECTS AND DESIGNERS

The 2.4-square-mile canvas that is the village of Whitefish Bay is adorned with a pleasing variety of architectural styles that were fashioned into handsome structures by some of the most renowned architects of the day. Names like Alexander Hamilton Bauer, Armin Frank, Alexander Eschweiler, Richard Philipps and Charles Valentine have decorated the Bay landscape with residences and buildings that have earned placement in the National Register of Historic Places.

While many architects and designers were important to the architectural mosaic that is Whitefish Bay, four made an especially dramatic imprint on the appearance of the village: Ernest Flagg, Russell Barr Williamson, John D. Edwards and the Leenhouts family of architects.

Ernest Flagg

Ernest Flagg, who lived from 1857 to 1947, was one of the most important architects of his day. He is perhaps best known for designing the forty-five-story, 612-foot tall Singer (sewing machine) Building in New York City—at the time the tallest skyscraper in the world. Later in life he became an advocate for urban reform and spoke out about the architecture profession's social responsibilities, leading him to move into designing unique but affordable single-family homes.

A Celebration of Architecture and Character

Noted Architects. *Clockwise from top left*: Russell Barr Williamson, Ernest Flagg, Sara Leenhouts and John Edwards.

Above and opposite: These three adjoining Ernest Flagg–designed homes at 4600 North Cramer Street, circa 1925 (*top*), 1916 East Glendale Avenue, circa 1925, and 4601 North Murray Avenue, circa 1924, were designated historic landmarks by the Milwaukee County Historical Society.

A Celebration of Architecture and Character

Flagg was born in Brooklyn, New York. After working in real estate with his father and brother, he went to work for a local architect, designing plans for an apartment building. Cornelius Vanderbilt II (grandson of the wealthy Commodore Vanderbilt), Flagg's cousin by marriage, was impressed by his work and paid for his study at the prestigious École des Beaux Arts in Paris. (The school's alumni list includes Pierre-Auguste Renoir, Claude Monet, Georges Seurat and other famous French artists.) Flagg opened his practice in 1891 in New York and designed many important buildings, including the Washington State Capitol and numerous buildings at the U.S. Naval Academy in Annapolis, Maryland.

In 1922, at the age of sixty-five, Flagg turned to designing affordable yet aesthetic homes for the average person, preferably costing less than $10,000. His definitive book on the subject describes a system employing "mosaic rubble" flagstone outside walls, solid plaster interior partitions, and extensive use of ridge-dormers to take advantage of the space under sloping roof rafters, eliminating the need for a full second story. "The chief difficulty in designing small houses is to avoid an excessive appearance of height," he wrote. Flagg's distinctive homes are reminiscent of English Cotswold cottages. Flagg system homes are especially interesting today because they have been found to conserve energy.

There are fourteen homes in Whitefish Bay that were designed by Flagg. Twelve were built by Arnold F. Meyer, who so admired Flagg's ideas about small homes that he visited Flagg in New York and returned to construct homes using his designs in Milwaukee. Meyer built a total of twenty-five Flagg homes in 1924 and 1925, the twelve in the Bay, the rest in Shorewood, Fox Point, Wauwatosa and Milwaukee, before going out of business in 1925. All twenty-five homes, including the twelve in Whitefish Bay, are listed in the National Register of Historic Places. The three adjacent Flagg homes at **4601 North Murray Avenue**, **1916 East Glendale Avenue** and **4600 North Cramer Street** were designated Historic Landmarks in 1979 by the Milwaukee County Historical Society.

The other two Flagg homes were built by the Robert Stanhope Construction Company in 1925. The home at **5775 North Santa Monica Boulevard** is also in the National Registry. The home at **5670 North Lake Drive** was only recently recognized as a Flagg designed home. As a result, it is not in the National Registry at this time, is not individually eligible and is not located in a proposed residential historic district. It is on the Whitefish Bay Architecture and History Inventory (AHI).

W. Hall and Amy Wallace House, 5775 North Santa Monica Boulevard, circa 1925. A Flagg-designed home.

While Arnold Meyer concentrated exclusively on Flagg-style homes, Robert Stanhope was much more eclectic, building a dozen homes in Whitefish Bay in Tudor, French Provincial, Williamsburg, Dutch Colonial and other styles, mostly in the Wilshire, Cumberland Forest and Circle Drive neighborhoods, from 1925 to 1931.

The fourteen Flagg homes in Whitefish Bay are:

- **739 East Beaumont Avenue**, Horace W. and Marion Hatch House, 1925
- **984 East Circle Drive**, Paul S. and Margaret E. Grant House, 1925
- **4524 North Cramer Street**, Rufus E. and Lois Arndt House, 1925
- **4540 North Cramer Street**, Harrison C. and Leah S. Hardie House, 1925
- **4600 North Cramer Street**, George L. and Carol R. Anderson House, 1925
- **5461 North Danbury Road**, Allen H. Barfield Duplex, 1924
- **1916 East Glendale Avenue**, William and Meta Von Altena House, 1925
- **829 East Lake Forest Avenue**, John F. and Louise McEwen House, 1925
- **912 East Lexington Boulevard**, Frank J. and Elvira Williams House, 1925
- **1016 East Lexington Boulevard**, Frederick Sperling House, 1924
- **1028 East Lexington Boulevard**, Halbert D. Jenkins House, 1924
- **4601 North Murray Avenue**, B.G. Van Devan House, 1924
- **5775 North Santa Monica Boulevard**, W. Hall and Amy Wallace House, 1925
- **5670 North Lake Drive**, Otto H. and Edna J. Fiebing, 1925

RUSSELL BARR WILLIAMSON

Russell Barr Williamson was born in Royal Center, Indiana, in 1893. After earning a degree in architecture in 1914 at what today is Kansas State University, Williamson got a job in Chicago with Frank Lloyd Wright and became his chief assistant within two years. Williamson supervised all of the architectural planning for the Imperial Hotel in Tokyo, Japan, considered a Wright masterpiece. He also was the supervising architect for the Frederick

Bogk House at 2420 North Terrace Avenue in Milwaukee, for Wright's six "American System-Built" pre-fabricated homes in the 2700 block of West Burnham Street and for the now-razed Arthur R. Munkwitz Duplex Apartments near Burnham, the latter two projects built by Milwaukee developer Arthur L. Richards, who became a close friend of both Wright and Williamson.

Williamson left Wright in 1918, striking out for Kansas City, Missouri, where he established his own short-lived architectural practice. The following year, Williamson moved to Milwaukee at the urging of some of Wright's contractors, got his Wisconsin architectural license and opened a highly successful practice that spanned more than four decades. A bow tie with tails became Williamson's sartorial trademark.

Despite his strong ties to Wisconsin and his Taliesin Fellowship at Spring Green, Frank Lloyd Wright himself left a comparatively light footprint in the Milwaukee area, designing only the three residential projects mentioned above with Williamson, plus an American System-Built home at 2106 East Newton Avenue in Shorewood, discovered in 2015 by the State Historical Society. But Wright did closely supervise the work of several of his apprentices, including Jesse Claude "Cary" Caraway, who appears to be the only other Wright disciple besides Williamson who worked in Whitefish Bay. Caraway designed the W.E. Gifford House at **5961 North Shore Drive**.

A graduate of the University of Texas at Austin with a degree in architecture, Caraway spent seven years with Wright at Taliesin. In 1949, W.E. Gifford, a contractor who had built homes for Wright in Madison and Evanston, Illinois, commissioned Wright to build a home for him on a vacant lot north of Klode Park. Wright delegated the task to Caraway and regularly visited the work site, reportedly fine-tuning the design several times during the two years of construction. The home was completed in 1951 at an estimated cost of $20,000.

Williamson, by contrast, designed sixteen residences in Whitefish Bay, all but one during the 1920s. His last commission in the Bay was in 1953. Only Williamson's own home at **4860 North Oakland Avenue**, built in 1921, is designed in Wright's classic Prairie architectural style. Williamson's other Whitefish Bay homes are designed in more traditional styles of the day, including Tudor Revival, Spanish Revival and Mediterranean Revival, but even several of these residences exhibit strong influences of what architectural historians call Williamson's Modified Prairie style. Williamson built many homes on the North Shore, Wauwatosa and Milwaukee's East

Russell Barr and Nola Mae Williamson House, 4860 North Oakland Avenue, circa 1921.

Side. Perhaps Williamson's best-known work in Milwaukee is the Eagle's Club, built in 1925 at 2401 West Wisconsin Avenue.

As was Wright's practice, Williamson also designed his own furniture for his home's living room, dining room and sunroom, which are separated only by low planters, a common feature of the open-spaced Prairie-style floor plan, which eschews walls. Williamson and his wife, Nola Mae, lived in the Oakland Avenue home with their two children, Naomi and Russell Jr., from 1921 to 1939.

Williamson, like all architects and builders, was hit hard in the 1930s by the Great Depression, as construction dried up. In 1932, he filed for bankruptcy, closed his downtown Milwaukee office on Broadway and worked out of his living room. In 1939, foreclosure forced his family out of their home on Oakland. During the warmer months, the family lived for three years in a summer cottage at 4870 North Lake Drive owned by one of his clients, and because the cottage lacked heat, resided at the Wisconsin Hotel, presumably by invitation of his friend, Arthur Richards, the hotel's owner, during the winters.

During World War II, when the economy was dedicated to the war effort, Williamson took on whatever projects he could. One was to design a durable, portable four-hole latrine to be used by Marines battling from island to

island in the Pacific. Existing models were heavy, cumbersome and broke down in the tropical heat and humidity. His design was so well received that he and a partner formed the U.S. Portable Housing Company to produce the portable outhouses under contract to the federal government.

Williamson lived for a time in Sheboygan Falls after the war, where he was involved with designing and producing pre-fab houses that could be erected in one day. But in 1950, he returned to his true love: designing single-family homes for individual buyers. Williamson built a home on Lake Michigan near Oostburg, Wisconsin, where he and Nola Mae spent their later years. Williamson continued to do projects in Milwaukee until his death in 1964 of a heart attack at the age of seventy-one.

The Williamson home at 4860 North Oakland Avenue was designated a Historical Landmark in 1977 by the Milwaukee County Historical Society. It is individually eligible for placement in the National Registry.

Several of Williamson's homes are in the Lake Woods & Ortonwood Triangle Historic District. All of his homes are on the Whitefish Bay AHI. The eight homes below that are asterisked are individually eligible for listing in the National Registry.

The sixteen Williamson homes in Whitefish Bay are:

- **998 East Circle Drive***, Robert B. and Ivy E. Asquith House, 1923
- **4786 North Cramer Street**, Norman and Natalie Soref House, 1953
- **5456 North Danbury Road**, Thomas F. Regan House, 1925
- **5464 North Danbury Road***, (Original owner unknown), 1920
- **1820 East Hampton Road**, Julius H. and Emilie Gugler House, 1924
- **4837 North Lake Drive***, George and Margaret Schueller House, 1926
- **4845 North Lake Drive**, Frank S. and Jessie Boardman House, 1925
- **4863 North Lake Drive**, Charles E. and Dorothy Inbusch House, 1925
- **4901 North Lake Drive**, Richard Smith and Henrietta L. Davis House, 1926
- **4965 North Lake Drive***, Doll Cokins House, 1929
- **5240 North Lake Drive***, Carl Herzfeld/Julius Heil House, 1924
- **1017–19 East Lexington Boulevard**, Lillie Ketchum Duplex, 1925
- **4850 North Oakland Avenue**, Dr. Edward J. Schleif House, 1920
- **4860 North Oakland Avenue***, Russell Barr and Nola Mae Williamson House, 1921

A Celebration of Architecture and Character

Doll Cokins House, 4965 North Lake Drive, circa 1929.

George and Margaret Schueller House, 4837 North Lake Drive, circa 1926.

- **5260 North Santa Monica Boulevard***, B.F. Fisher House, 1929
- **5664 North Shore Drive***, Clare H. Hall House, 1921

John Douglas Edwards

John Douglas Edwards was one of the most prolific builders of his era. He built a total of forty homes in Whitefish Bay from 1926 to 1939. Indeed, his company claimed to have built over one thousand homes in the Milwaukee area.

Edwards was born in Spencer, Iowa, in 1893. He came to Milwaukee in 1918, worked a variety of jobs in sales and promotion and was employed by the forerunner company of WE Energies. In 1925, he established the John D. Edwards Company, a home builder, with two partners.

In 1928, Edwards began marketing and building what he called "Studi-O-Homes," and which later also became known as "Vaulted Tudors." These came in a variety of sizes and price points in the Tudor Revival style, often employing details typical of more expensive homes. The key feature that was common to all of these homes, according to architectural historian Jennifer Lehrke, "was a prominent, gabled living room that extended perpendicularly from the front of the house. Two stories in height, it typically was accompanied by a second story library overlooking the living room." Edwards planned to build fifty Studi-O-Homes in the Milwaukee area. It is not known if he did so, but he did build at least eighteen in Whitefish Bay. He also built his own home at **4737 North Sheffield Avenue** in 1930. After Edwards's death in 1943, the company was reorganized under his son, Douglas Edwards.

John D. and Myrtle Edwards House, 4737 North Sheffield Avenue, circa 1930.

A Celebration of Architecture and Character

A large number of the homes Edwards built are located in the proposed Pabst Residential Historic District. All of Edwards's homes are on the Whitefish Bay AHI.

The eighteen Edwards Studi-O-Homes in Whitefish Bay are:

- **5262 North Berkeley Boulevard**, Archibald and Eleanore O'Connor House, 1928
- **5263 North Berkeley Boulevard**, Harold C. and Marjorie P. Cheetham House, 1928
- **5320 North Berkeley Boulevard**, Frank J. and Jane J. Kelley House, 1928
- **5936 North Berkeley Boulevard**, Edward T. and Mary McIntyre House, 1931
- **735 East Briarwood Place**, Gordon F. and Doris Daggett House, 1929
- **710 East Carlisle Avenue**, Henry C. and Mattie Hettelsater House, 1928

Harold C. and Marjorie P. Cheetham House, 5263 North Berkeley Boulevard, circa 1928.

Frank J. and Jane J. Kelley House, 5320 North Berkley Boulevard, circa 1928.

- **1086 East Circle Drive**, Edward John and Florence Hornbach House, 1928
- **4903 North Cumberland Boulevard**, Celm and Fawn C. Kalvelage House, 1928
- **5220 North Diversey Boulevard**, Alfred A. and Lydia A. Schmitt House, 1928
- **5518 North Diversey Boulevard**, LeRoy H. and Martha Brown House, 1928
- **5346 North Hollywood Avenue**, Paul C. and Jeanne D. Winner House, 1928
- **5688 North Lake Drive**, Dr. Bruno Warschauer House, 1928
- **633 East Lake View Avenue**, Reinhold C. and Irene Diekelman House, 1928
- **5221 North Santa Monica Boulevard**, Werner J. and Beulah Trimborn House, 1928
- **5501 North Santa Monica Boulevard**, Chester A. and Esther M. Cook House, 1928

- **5701 North Shoreland Avenue**, Lewis P. and Bernadette Kiehm House, 1928
- **1025 East Sylvan Avenue**, Albert S. and Leah Ethridge House, 1929
- **1032 East Sylvan Avenue**, Carl and Gertrude Daun House, 1928

The Leenhouts Family

The Leenhouts family over two generations designed only seven residences and a church in Whitefish Bay, but they did so over a period of four decades in a variety of styles.

Cornelius Leenhouts, the family patriarch, was born in Milwaukee in 1865, the son of Dutch immigrants. He was an apprentice and draftsman at several architectural firms and worked on the construction drawings for the Agriculture and Transportation Buildings at the Chicago World's Fair in 1893.

In 1900, Cornelius began a partnership with Hugh Wilson Guthrie, a Scottish immigrant, creating the firm of Leenhouts and Guthrie. It later became Leenhouts, Guthrie and Leenhouts in 1930 when Cornelius's son, Willis, became a partner. Cornelius stayed active until his death in 1935. Guthrie continued in the practice until his death in 1945.

Cornelius Leenhouts and Guthrie engaged in a varied practice that included the design of numerous houses, apartment buildings and small commercial structures, as well as a few industrial buildings and several churches. The Venetian Gothic–style Kenwood Masonic Temple, built in 1915–16 at 2648 North Hackett Avenue in Milwaukee, later to become the Italian Community Center and today a church, is one of the firm's major surviving works. Both Leenhouts and Guthrie were members of the Kenwood Masonic Lodge as well as other Masonic orders, including the Knights Templar and Shriners.

Willis was born in 1902 and apprenticed at his father's firm before becoming a partner. After his father's death, he worked in the office of another firm where he met Lillian Scott, a recent graduate of the University of Michigan's College of Architecture. They were married in 1943. Lillian became the first woman licensed as an architect in Wisconsin.

After Willis returned from military service following World War II, he and Lillian established a joint architecture practice in Milwaukee. They had over five hundred commissions during their careers, which spanned

from 1936 to 1990. Although they designed several grand homes, they concentrated much of their practice on the design of affordable, energy-efficient housing and were well known for their modernist style and use of passive solar technologies. Willis and Lillian were named fellows of the American Institute of Architecture in 1975 for excellence in their field. It was the first time in the institute's one-hundred-year history that a husband-wife team was so honored. The couple also was instrumental in establishing the School of Architecture at the University of Wisconsin–Milwaukee. They built and lived in a modern but modest home in Milwaukee's Riverwest neighborhood overlooking the Milwaukee River, which doubled as their design studio. Their daughter, Robin, took ownership of their home after her parents died.

Another family member, Sara Leenhouts, daughter of Cornelius and sister of Willis, became interested in architecture while attending the Wisconsin School of Applied Arts at Milwaukee Normal College. She studied architecture at the University of Wisconsin–Madison and at Columbia University in New York City and began working at Leenhouts and Guthrie in 1919. She became Wisconsin's second licensed female architect.

Olaf T. Rove House, 4645 North Cramer Street, circa 1927.

A Celebration of Architecture and Character

Sidney Siesel House, 5843 North Maitland Court, circa 1950.

The Whitefish Bay homes at **4645 North Cramer Street**, **601 East Day Avenue** and **5822 North Shore Drive** are attributed to Cornelius. The properties at **4819 North Ardmore Avenue**, **6018 North Lake Drive** and **6009 North Shore Drive** were designed by Willis. The home at **5843 North Maitland Court** was a joint effort of Willis and Lillian, while the residence at **4780 North Newhall Street** is attributed to Sara. All are on the Whitefish Bay AHI. The three homes by Cornelius and the two homes done by Lillian and Sara are contributing properties in proposed historic districts. The home at 6009 North Shore Drive is individually eligible for placement in the National Registry.

The eight Leenhouts buildings in Whitefish Bay are:

- **4819 North Ardmore Avenue**, Roundy Memorial Baptist Church, 1937
- **4645 North Cramer Street**, Olaf T. Rove House, 1927
- **601 East Day Avenue**, Frank E. and Ruth G. Baker House, 1928
- **6018 North Lake Drive**, Dr. B.G. Narodick, 1955

- **5843 North Maitland Court**, Sidney Seisel House, 1950
- **4780 North Newhall Street**, Albert P. and Marcella Kohler House, 1929
- **5822 North Shore Drive**, John and Tillie M. Geerlings House, 1927
- **6009 North Shore Drive**, Howard and Mary Tobin House, 1939

6
DOWNTOWN WHITEFISH BAY

As Whitefish Bay began to take shape at the turn of the twentieth century, there was a need for grocers, blacksmiths, dry goods stores, eating establishments and other businesses to make it function like a true village. With the growth of Day Avenue and the Lawndale subdivision taking place to the north, and the subdivisions around the former Pabst Whitefish Bay Resort grounds being developed to the south, Silver Spring Drive, bisecting the village at its midpoint, became a natural location for a commercial district to evolve.

Among the first businesses on Silver Spring Drive was Richard Seyfert's soda water factory between Lydell and Bay Ridge Avenues around 1890. Seifert's main customer for his beverages was the Pabst Resort. He may also have distributed to other smaller amusement parks and resorts that had sprung up in the Bay around the turn of the century. Seifert built the Victorian Queen Anne–style clapboard home at **130–34 West Silver Spring Drive** in 1893. In 1897, Conrad and Emile Cassel purchased the factory and home. Children would bring empty soda bottles that they had found on resort grounds to the factory and redeem them for free soda. But by 1916, the soda factory was gone, apparently a casualty of the closing of the Pabst Resort. The former residence was later converted into shops in about the mid-1950s and eventually became offices; it was well maintained by its owners for over a century. It became a welcoming and distinctive Bay landmark for visitors coming to the village from the west. The building was razed in 2010 to make way for a drive-up bank branch.

Historic Whitefish Bay

Richard Seyfert House, 130–34 West Silver Spring Drive, circa 1893. Razed 2010.

The Bay Colony Building at **205–27 East Silver Spring Drive** was constructed in 1946 at the corner with Santa Monica Boulevard. An addition was added in 1951 that extended the building to Shoreland Avenue. In the past seventy years, a wide variety of retail stores have been in the building, including Fritzel's, Packard Rellin and Browning King. The building was designed by architect Ferdinand J. Brimeyer, a Minnesota native born in 1900. Brimeyer earned degrees in architecture and engineering at the University of Minnesota and worked in Chicago before moving to Milwaukee in 1927 to work at the distinguished architecture firm Kirchhoff and Rose, designer of the Herman and Claudia Uihlein mansion at **5270 North Lake Drive**. He established his own firm with two partners in 1938 and engaged primarily in the design of industrial and educational buildings, including work for the Schlitz Brewing Company, Marquette University and the University of Wisconsin–Madison. The Bay Colony Building is individually eligible for placement in the National Register of Historic Places.

A handsome streamlined building, the Fox Bay Theater Building at **302–38 East Silver Spring Drive** has both Moderne and Art Deco influences.

Bay Colony Building, 205–27 East Silver Spring Drive, circa 1946.

In 1937, the Fox Amusement Corporation bought land on Silver Spring Drive to build a movie theater, but construction did not begin until 1948, and the theater did not open until 1951. Its first feature was *Harvey*, a comedy-drama about a man whose best friend is an invisible six-foot-tall rabbit. The movie starred Jimmy Stewart and actress Josephine Hull, who won an Oscar for her role.

A two-story structure faced with Lannon stone and glass, the Fox Bay building originally consisted of the 988-seat theater, seven storefronts and second-floor offices. A two-story addition adding five more storefronts and office space was constructed in 1955.

Henry P. Plunkett of the architectural firm of Ebling, Plunkett and Keyman drew up the design of the theater building, which incorporated sculpted, stylized nautical-themed projections from the upper walls and a stadium-style balcony where one could enter from the auditorium floor as well as the lobby. Plunkett was born in Milwaukee in 1900, studied at the University of Wisconsin–Madison and worked for noted architect Alexander Eschweiler before forming a partnership with Herbert L. Ebling. The homes

Fox Bay Building, 302–38 East Silver Spring Drive, circa 1951.

at 5251 North Idlewild Avenue, constructed in 1926, and 5360 North Hollywood Avenue, built in 1937, both contributing historical properties in the Lake Crest Historic District, were done by the firm. The Fox Bay Building is individually eligible for placement in the National Registry due to the significance of its Art Moderne architecture.

The Berkeley Building at **401–15 East Silver Spring Drive** was constructed by Wisconsin Builders Incorporated in 1961. Throughout its history, a wide variety of businesses have been located at the first-floor retail level and second-story office spaces. The Berkeley Building is individually eligible for placement in the National Registry for the significance of its Contemporary architecture.

The Village Fruit Market, owned and operated by three women—Josephine Storniolo, Rose Accetta and Ida Accetta—opened in 1939, and a new building was constructed for the store in 1946 at **417 East Silver Spring Drive**. The building currently is the home of Schwanke-Kasten Jewelers, who had previously operated in the Fox Bay Building. The Village Fruit Market Building is individually eligible for placement in the National Registry for the significance of its Colonial Revival architecture.

A Celebration of Architecture and Character

Berkeley Building, 401–15 East Silver Spring Drive, circa 1961.

Village Fruit Market Building, 417 East Silver Spring Drive, circa 1946.

Powell Building, 421–27 East Silver Spring Drive, circa 1926. Yesterday and today.

The Powell Building at **421–27 East Silver Spring Drive** was constructed in 1926 by builder H.M. Powell for owner Walter Drew and is the home of the Bay Bakery, the longest continually operating business in downtown Whitefish Bay. The two-story Mediterranean Revival–style

building originally had three storefronts on Silver Spring, four on Diversey and eight upstairs apartments.

The Powell Building was the first home of the Bank of Whitefish Bay, which was established in 1930. When it opened, it was the only bank on the North Shore. In 1934, it became the first bank in Milwaukee County to become a member of the Federal Deposit Insurance Corporation (FDIC). Its four founders all lived in the Bay—Wynand Isenring at 1036 East Lexington Avenue, Allan J. Roberts at 6228 North Lake Drive, August M. Krech at 842 East Lake Forest Avenue and Howard Swan, who lived in a house no longer standing at the southeast corner of Silver Spring Drive and Diversey Boulevard. In 1957, the bank was renamed the Whitefish Bay State Bank. The bank built and moved to the building at 177 East Silver Spring Drive. The Whitefish Bay State Bank later was taken over by M&I Bank, which is now the BMO Harris Bank, still operating at the same location.

In 1932, William and Hannah Meredig, who had emigrated from Rhineland, Germany, bought the Powell Building and opened the Bay Home Bakery & Delicatessen. William was a fourth-generation master baker. After his death, Hannah continued the bakery on her own. In 1980, she turned the bakery over to her son Herbert but remained involved in the business until her death in 1985. The Powell Building and bakery have changed owners since then. In 2007, it became Regina's Bay Bakery, which relocated from Milwaukee's West Side and was established in 1938. The State Historical Society did not consider the Powell Building to be individually eligible for the National Registry because of the many changes that have been made to the building. However, the building is listed on the Whitefish Bay Architecture and History Inventory (AHI) because of its history in the Whitefish Bay business district.

The Gotfredson Building at **501–13 East Silver Spring Drive** was owned by Roy Gotfredson and constructed in 1929 in the Spanish Colonial Revival style. It initially contained three storefronts. In 1930, an addition was built on the east side, adding three more storefronts. There are apartments on the second story. The Gotfredson Building has housed numerous businesses. It was the original location of the Great Atlantic & Pacific Tea Company, better known as the A&P grocery store. It was also home during the mid-1900s to the appliance and electronics store operated by Warren Isenring, the fourth-generation member of the Isenring family who was so important to the development of Whitefish Bay. The Gotfredson Building is individually eligible for placement in the National Registry for the significance of its Spanish Colonial Revival architecture.

Historic Whitefish Bay

Gotfredson Building, 501–13 East Silver Spring Drive, circa 1929. Yesterday and today.

A Celebration of Architecture and Character

Balistreri family members, founders of Sendik's, circa 1926.

Of the few downtown businesses that are strongly identified with Whitefish Bay—the Fox Bay Theater, the Bay Bakery, Dan Fitzgerald Pharmacy and Winkie's Variety Store—none is more iconic than Sendik's Food Market at 500 East Silver Spring Drive. Although the business has expanded to a chain of nineteen Milwaukee-area grocery stores, its one-hundred-plus-year history is rooted in the North Shore and Whitefish Bay.

The Balistreri family, which founded Sendik's, traces its retail roots to 1895, when several members immigrated to Milwaukee from Sant'Elia, Sicily and began peddling quality fruits and vegetables by horse-drawn wagon in downtown Milwaukee and the affluent East Side. The business expanded, and more family members came to the United States. This eventually led to the opening of produce markets on Oakland Avenue in Shorewood in 1926 and Downer Avenue on Milwaukee's East Side in 1929. The two stores were operated by Salvatore Balistreri and two of his five sons, Tony and Tom.

In 1947, Tom Balistreri purchased a village-owned lot on Silver Spring and Lake Drives. There he constructed a building in which he opened Sendik's Fruit Market in 1949. Tom Balistreri became manager of the Whitefish Bay market while brothers Ignatius operated the Shorewood store and Tony ran the Downer Avenue store. Although the stores shared a common name, from that point forward, the Sendik's stores were independently owned and operated. Tony even legally changed his last name to Sendik.

In Whitefish Bay, Tom Balistreri was joined in the business by his two sons, Ted and Tom Jr. In the early 1970s, the brothers took over the operation, and in 1975, the store expanded to include groceries, meat, deli, dairy, baked goods and wine and spirits. In 2001, the third generation of family owners took over. Ted's sons—Ted, Patrick and Nick—purchased Tom Jr.'s

interest in the Whitefish Bay store and, along with their sister Margaret, have continued to expand the business in the Milwaukee area.

The store name Sendik's resulted from a misunderstanding. While purchasing a stove, the clerk asked Salvatore Balistreri for his name. Still struggling with the English language, he thought the clerk was asking how he wanted the stove delivered. "Send it," he said. The clerk wrote the name "Sendik" on the order. When the delivery person asked neighbors where he could find "Mr. Sendik," he was directed to Salvatore Balistreri's home because they knew he was expecting a stove. Salvatore Balistreri became known in the neighborhood as Mr. Sendik, and the nickname stuck.

From the beginning, Balistreri family members took great pride in the quality of the produce they sold, even going to Chicago when they could not find the quality they wanted on Commission Row in Milwaukee's Third Ward. That reputation for quality carried on in their stores.

So how valuable has the Sendik's brand name become? That question was answered in 1997 when John Nehring, longtime specialty food and wine buyer for Sendik's, and his wife, Anne Finch, a former prima ballerina with the Milwaukee Ballet, purchased the Shorewood Sendik's store from the sons of Ignatius Balistreri. A condition of the sale was that the name Sendik's remain attached to the store. This drove the selling price to $1.6 million from its $300,000 appraised value. Lenders placed such stock in the Sendik's name that they agreed to loan the money for the sale even at such an inflated price. Nehring and Finch later purchased the Downer Avenue Sendik's store from Tony (née Balistreri) Sendik's grandchildren in 2013.

The Sendik's Fruit Market Building at 500 East Silver Spring Drive is not individually eligible for the National Registry, as additions and alterations have erased much of the original architecture.

While the grocery itself is no longer eligible for the National Registry, the Sendik's-owned building adjacent to the store at **5623 North Lake Drive** is individually eligible for the National Registry. This building was originally the Whitefish Bay Pharmacy. The pharmacy was established in 1924 and located in a building in the 700 block of Silver Spring Drive before the owners constructed the Lake Drive location in 1950. The building was one of the first to have air conditioning and originally had a four-sided clock tower on the roof. The pharmacy later became the Dan Fitzgerald Pharmacy and relocated to 424 East Silver Spring Drive. The Lake Drive building has been put to multiple uses since the pharmacy left and currently houses Sendik's offices.

A Celebration of Architecture and Character

Whitefish Bay Pharmacy Building, 5623 North Lake Drive, circa 1950.

The State Historical Society determined that the following commercial buildings on Silver Spring Drive are historic, but they are not individually eligible for the National Registry because of alterations to the original structures over the years.

- Dr. Robert E. Wittig Dental Office, 105 West Silver Spring Drive, 1949
- Rice Powell Company Building, 115 West Silver Spring Drive, 1956
- Marcus Theater Addition, 103–9 East Silver Spring Drive, 1978
- Marcus Theater Building Courtyard, 111 East Silver Spring Drive, 1978
- Marcus Theater Building, 127–33 East Silver Spring Drive, 1952
- Whitefish Bay State Bank Building, 177 East Silver Spring Drive, 1957
- Whitefish Bay Liquor Shoppe Building, 342 East Silver Spring Drive, 1955
- Deutsch Shoe Store Building, 400–8 East Silver Spring Drive, 1956
- Sterling S&L Association Building, 430 East Silver Spring Drive, 1962
- National Tea Company Building, 517 East Silver Spring Drive, 1932
- Raydon Variety Store Building, 601–19 East Silver Spring Drive, 1946
- Hannahar Corporation Building, 629 East Silver Spring Drive, 1950

7
WHITEFISH BAY INSTITUTIONS

Churches, Schools, Clubs and Lodges

There are nine churches, a fraternal lodge, a women's club, ten schools and three convents in Whitefish Bay, and of those twenty-four structures, fifteen have been determined by the Wisconsin Historical Society to be individually eligible for placement in the National Register of Historic Places. These institutions not only help to bind Whitefish Bay residents into a community, but also their leaders, members and graduates have made major cultural contributions to Milwaukee County, Wisconsin and the nation.

UNITED METHODIST CHURCH OF WHITEFISH BAY

Methodists were the first known Christian group to hold a church service in Whitefish Bay. The first was held in June 1892 in a meeting hall at Jefferson Park, a small amusement park located on Henry Clay Street. The congregation later met in a small chapel, but it was destroyed by fire in 1923. The current church at 819 East Silver Spring Drive was built in 1925. The State Historical Society determined that additions made in 1944, 1951 and 1961 have too greatly diminished the integrity of the original structure to warrant its placement in the National Register of Historic Places. The congregation remains the village's oldest.

A Celebration of Architecture and Character

Christ Episcopal Church

Of the many pretty church buildings in Whitefish Bay, among the most charming is the Gothic Revival–style Christ Episcopal Church at **5655 North Lake Drive**. While it is home to the second-oldest Christian congregation in the Bay, the church in which its congregants worship is one of the newer church buildings in the community.

In 1894, a group of Episcopalians began holding services in private homes. In 1895, a chapel was built on Silver Spring Drive. They worshiped there only seven years, however, before selling the chapel to the Methodist congregation. The chapel was destroyed by fire in 1923. In 1931, money was raised to build another chapel on a parcel on Beaumont Avenue where the George Washington 1776 Masonic Lodge is now located. The chapel was intended to be temporary. Land for the current church was purchased in 1940 and the building constructed in 1941. The Masonic lodge began renting the old Episcopalian chapel for its meetings, and in 1948, members purchased the building. It was demolished for construction of the current

Christ Episcopal Church, 5655 North Lake Drive, circa 1950.

Masonic lodge in 1964. Christ Episcopal Church has had various additions constructed on its small campus over the years, including a parish house in 1948, classroom and office space in 1952 and an enlarged sanctuary in 1956.

Christ Episcopal Church is individually eligible for listing in the National Registry for the significance of its Gothic Revival architecture.

St. Monica Catholic Church and Dominican High School Complex

The Reverend Peter Ernst Dietz had a grand vision when Archbishop Sebastian Gerhard Messmer appointed him rector to establish the St. Monica Catholic Parish. Dietz hoped to build not just a beautiful church, but a convent, grade school, high school, hospital and a center for the study and display of religious art. He envisioned a multi-block Mediterranean-style campus forming a central courtyard, all joined by a colonnade.

Neither the hospital nor the art museum were ever built, but Dietz did put together much of his ambitious plan. After establishing a parish in 1923 and holding mass in the former village hall, Dietz bought 15.7 acres of farmland at the corner of Silver Spring Drive and Santa Monica Boulevard. A barn on the property was converted into a chapel with an old fireplace as an altar, the hayloft as a choir loft and a chicken coop as a confessional. It was dedicated on May 4, 1924, the Catholic feast day of St. Monica. The chapel remained in use until it was demolished in the late 1960s. Construction of the current St. Monica Church at **160 East Silver Spring Drive** began in 1938, but it was not completed until 1955 due to the Depression and World War II. The basement was used as the church while the rest of the structure awaited completion. Its sanctuary has a capacity of 1,300 worshipers. It was designed by E. Brielmaier and Sons Architects.

St. Monica School at **5635 North Santa Monica Boulevard** was constructed in 1927 and opened for classes in 1928. It was designed by architect A.C. Runzler, who also designed thirteen residences in Whitefish Bay built from 1922 to 1935. The school's most prominent architectural feature is an octagonal library designed as an Italian bell tower. Originally, the parish used the school gymnasium for services. In 1931 a sixty-five-foot-tall belfry was added to house the church's bells, as was an addition for offices, a dining room and a medical clinic. A classroom and gym were added in 1950. An original farmhouse on the property was used as the school's convent

A Celebration of Architecture and Character

St. Monica Catholic Church, 160 East Silver Spring Drive, circa 1955.

until the current St. Monica Convent was completed in 1950 at **5681 North Santa Monica Boulevard**.

In 1952, St. Monica Parish and St. Robert Parish in Shorewood worked with the Sinsinawa order of nuns to build Dominican High School at **120 East Silver Spring Drive**. The three-story high school building was constructed of brick and concrete at a cost of $3.1 million. It opened for classes in 1956. It included twenty-seven classrooms, a cafeteria, a library, an auditorium, a gym and offices. In 1960, a convent was constructed at **135 East Lake View Avenue** for the Sinsinawa sisters who taught at Dominican.

A nun's ghost is said to haunt the high school's third floor. According to The Shadowlands website, the third floor of the high school was used as a convent for eight years before the convent on Lake View Avenue was completed. One night, a fire broke out and killed one of the nuns as she slept. She now roams the halls where she died.

As with any good ghost story, it is a mix of fact and fancy. There is no history of a fire at Dominican between 1952 and 1960, certainly not one in which a sister perished, and there is no record of a nun dying at the school. But there is a ghost, confirmed Bill Crowley, a former biology teacher,

basketball coach and athletic director who joined Dominican in 1959 and is still active with the school as alumni director. Affectionately known as "Mr. Dominican," Crowley verified a tale that has been passed down through the years that the ghost of Sister Antoine who taught physics and the earth sciences at the third-floor science center haunts the school. She died of natural causes in 1977, but Crowley said that the banging of roof air vents on windy days can be heard in the science center, contributing to speculation about the haunting. But Sister Antoine is regarded as a friendly ghost by the students—someone who looks over them. She is called "Mother Earth" because of her teachings about protecting the environment.

The entire St. Monica Church and Dominican High School Complex, consisting of six structures—the church, the elementary and high schools, the two convents and a church rectory built in 1958 at **160 East Silver Spring Drive**—is individually eligible for listing in the National Registry for the significance of the structures' Mediterranean Revival and Contemporary architecture.

As it grew, St. Monica Parish spawned the formation of two other parishes: Holy Family Catholic Church in 1949 and St. Eugene Catholic Church in Fox Point in 1957.

Holy Family Complex

Holy Family Catholic Church was formed in 1949 with a total of six hundred families drawn from St. Monica Church in Whitefish Bay and St. Robert's Church in Shorewood. At first, the Reverend George H. Wollet held masses in the lobby of Whitefish Bay High School.

The Holy Family School Building at **4849 North Wildwood Avenue** was constructed in 1953 by the Meredith Brothers, the builders who also constructed the Fox Bay Theater Building. Mass took place in the school's gymnasium-auditorium until the current church building at **4815 North Wildwood Avenue** was completed in 1969 by builder Michael Mravik, who also built the church rectory at **4810 North Marlborough Drive**. In 1960, a convent was constructed at **4825 North Wildwood Avenue**.

The Holy Family Complex of four buildings—the church, the elementary school, the convent and the rectory—is individually eligible for listing in the National Registry for the significance of the Contemporary architecture.

A Celebration of Architecture and Character

Holy Family Catholic Church, 4815 North Wildwood Avenue, circa 1969.

Roundy Memorial Baptist Church

In 1931, land was purchased at the corner of Hampton Road and Ardmore Avenue for $11,200 for the planned construction of the Ardmore Baptist Church. In 1936, the church was renamed Roundy Memorial Baptist Church in honor of Judson A. Roundy, founder of the supermarket chain that today includes Pick 'n Save and Metro Market stores. Roundy was an ardent Baptist, and half of his estate went to the Wisconsin State Baptist Convention to build churches in the state. Funds from Roundy's bequest helped build the church on Ardmore Avenue. The small congregation held its services at the former Whitefish Bay Armory before moving into its new church building in 1938 at **4819 North Ardmore Avenue**. Noted architect Willis Leenhouts designed the church, and Adam Schmitt & Sons built it at a cost of $20,000.

A large addition was erected to increase sanctuary capacity in 1951. The Roundy Baptist congregation no longer uses the church, and today, the church is used by the University Bible Fellowship Church. Roundy Baptist

Roundy Memorial Baptist Church, 4819 North Ardmore Avenue, circa 1938.

Church was not eligible for listing in the National Registry because additions and alterations diminished the original Gothic Revival style. However, the church is listed on the Whitefish Bay Architecture and History Inventory (AHI) because of its architecture, its link to historical figure Judson Roundy and its design by noted architect Willis Leenhouts.

Bay Shore Evangelical Lutheran Church

There are three Lutheran churches in Whitefish Bay, but only the Bay Shore Evangelical Lutheran Church at **1200 East Hampton Road** is individually eligible for listing in the National Registry for the significance of its Colonial Revival architecture.

The church was organized in 1929, and its congregants originally worshiped in a chapel at the southwest corner of Hampton Road and Marlborough Drive. In 1935, the chapel was relocated to the church's present location, and in 1949, it was replaced by the current church, which was constructed by Arthur C. Wolff Company. The architect was Roy O. Papenthien. In addition to the church, eight homes in Whitefish Bay were

A Celebration of Architecture and Character

Bay Shore Evangelical Lutheran Church, 1200 East Hampton Road, circa 1949.

designed by Papenthien, including his own at 836 Eeast Birch Avenue. The chapel was moved to the north and was used for several years by a Jewish congregation. The chapel was demolished in 1967 to make room for educational facilities and parking.

The other two Lutheran churches are Divinity Evangelical Lutheran Church at 900 East Henry Clay Street and Our Savior Lutheran Church at 6021 North Santa Monica Boulevard. Divinity's congregation was formed in 1924. It merged in 1940 and 1965 with two other congregations. The current church was constructed in 1941. Our Savior Lutheran Church was organized in 1930. The current church was built in 1948. The State Historical Society determined that alterations and additions to both church buildings diminished the character of the original structures.

First Church of Christ, Scientist

Whitefish Bay's Christian Science congregation first came together in 1942, meeting variously in private homes, a storefront at 627 East Henry Clay Street and at Henry Clay School. In 1945, the congregation purchased land

on Henry Clay Street, but the lot turned out to be too small, so it was sold to the Whitefish Bay Women's Club, which later built its clubhouse on the lot at 600 East Henry Clay Street in 1964. In 1947, the congregation purchased a larger property at **721 East Silver Spring Drive** and held its first services in its new church in 1951. Designed by architect Hugo C. Haueser, the sanctuary was designed with opera-style seating instead of pews and seats four hundred. It includes a two-story education wing.

The church's pipe organ was originally in the Herman and Claudia Uihlein mansion at **5270 North Lake Drive** and was donated to the church by Claudia after she sold the home in 1946. It is likely that actress Colleen Dewhurst and her mother, Frances Marie Dewhurst, were members of the church in the late 1930s and early 1940s, as both were ardent Christian Scientists. Dorothy Soderberg, the mother of radical activists Bernardine and Jennifer Dohrn, may also have attended the church, possibly with her daughters. Noted architect Alexander Hamilton Bauer, who designed numerous movie palaces, was a founder of the church. The First Church of Christ, Scientist is individually eligible for placement in the National Registry for the significance of its Colonial Revival architecture.

Whitefish Bay Public Schools

Whitefish Bay incorporated as a village in 1892 because its residents had grown unhappy sending their children to schools miles away. The closest schools were a log cabin built in 1846 where Shorewood High School now stands and a building on Port Washington Road north of Bayshore Mall. One month after residents voted to incorporate, a half-acre of land north of Fleetwood Place was donated for a school by the Tweedy Land Company, which would become a developer in the area. Whitefish Bay's first school was built soon after. Mrs. Alice Curtis, who lived with her husband at **708 East Day Avenue**, had started teaching children in a store on Silver Spring Drive. Alice Curtis moved to the new schoolhouse on Fleetwood Place with fifty pupils. The two-story building had four classrooms on the first floor and an auditorium on the second. A two-classroom addition was completed in 1912. A fire destroyed the building in 1918, and the site is now Old Schoolhouse Park.

Whitefish Bay next built Henry Clay School at 1144 East Henry Clay Street in the early 1920s. The original schoolhouse was a Colonial Revival–style two-

A Celebration of Architecture and Character

> Whitefish Bay's first school with Mrs. Curtis, the teacher. Built in 1893, burned down in 1918. Located at Marlborough and Fleetwood.

Fleetwood School, Whitefish Bay's first school, circa 1893.

story brick and Bedford limestone structure with eight classrooms and an auditorium. East and west wings were added in 1924 for a cafeteria, kitchen and gym. Additions and renovations were made in the 1950s as the Whitefish Bay School District's educational needs changed. For a time, Henry Clay

Historic Whitefish Bay

was closed before becoming the community center. In 1989, it became the Whitefish Bay Middle School for sixth through eighth graders.

From 1920 to 1930, the village's population grew from 882 residents to 5,362. Given such rapid growth, the village commissioned a study that projected Whitefish Bay would grow to 20,000 residents (the village's population peaked at 18,390 in 1960; in 2014, it was 14,122) and that its school enrollment would swell to 3,300 pupils. (The 2016–17 school year enrollment was 3,018.) Based on these projections, blueprints were drawn for the construction of two additional grade schools.

The first to be built on eleven and a half acres of farmland purchased from the Praefke family was Humboldt School at **4780 North Marlborough Drive** in 1927, so named because it fronted on what was then Humboldt

Cumberland School, 4780 North Marlborough Drive, circa 1927.

Avenue. The street was later renamed Marlborough. In 1932, due to the public's confusion with a Humboldt School in Milwaukee, the Whitefish Bay school changed its name to Cumberland School after the Cumberland Forest neighborhood in which the school is located. The name was chosen in a vote of the school's students from four names the students had submitted for consideration.

In 1928, Richards School became Whitefish Bay's third elementary school. It was constructed on five and a half acres of land at **5812 North Santa Monica Boulevard**. Richards was built using the same blueprints as Cumberland School reversed. Like Humboldt, Richards School was named for the street it faced. Richards Street later became Santa Monica Boulevard, but the school name was not changed because St. Monica Church had already established an elementary school with that name on the boulevard.

Both Cumberland and Richards were built of brick and Bedford limestone in the Collegiate Gothic style and were designed to accommodate the construction of north and south wings as needs dictated, and indeed, both schools have seen significant new construction over the years. Fortunately, the original structures of both schools remain intact and unchanged, which allowed both schools to be individually eligible for placement in the National Registry.

In 1950, 7.2 acres were purchased for $21,900 by the Whitefish Bay School District on the west side of Lydell Avenue in Glendale. Three years later, the land was annexed by Whitefish Bay, and Lydell School was built in 1955 with ten classrooms. It was constructed in a minimal Contemporary style that was deemed more economic and functional. In a reorganization in 1989, Lydell closed as a school and became the community center. Lydell School, **5205 North Lydell Avenue**, is individually eligible for listing in the National Registry for the significance of its Contemporary architecture.

For many years, the closest high school for Whitefish Bay students was Milwaukee Riverside High School on Oakland Avenue at Locust Street. In 1927, kids from Whitefish Bay went to the newly opened Shorewood High School, but it soon became so overcrowded that Shorewood stopped accepting Bay students. Richards School served as a stop gap location for ninth and tenth graders until a new high school could be built.

Whitefish Bay High School at **1200 East Fairmount Avenue** opened in 1932 on thirteen acres of land the school district had purchased from the Wisconsin National Guard Armory in 1929. The new high school initially also served students from Fox Point and other communities as far away as Thiensville who had previously gone to Shorewood.

Whitefish Bay High School, 1200 East Fairmount Avenue, circa 1932.

The school was designed in the Collegiate Gothic style by architect Herbert W. Tullgren, who also designed Cumberland and Richards Schools and the National Guard Armory building razed in 2004. Like the other schools, it was designed to accommodate future expansion. The initial building was constructed at a cost of $432,000 and contained twenty-six classrooms and a third-story auditorium as well as a gym, library, cafeteria and office space. The original campus featured tennis courts, a track, football and baseball fields and a field house in the same locations where those facilities are today. In 1948, the Memorial Gym was added, dedicated to graduates who had served in World War II. A theater wing was added in 1956. In 1967, a new north wing replaced the old field house with a new one and added an eight-lane swimming pool and classrooms. Renovations and an addition to the theater wing were done in 2010. Unlike Cumberland and Richards, all of the alterations and additions over the years have diminished the integrity of the original Collegiate Gothic architecture to the point that it is not individually eligible for listing in the National Registry. However, the high school is on the Whitefish Bay AHI for the significance of its architecture on the original building and for its important role in the life of the community.

Jewish Community Center

The Milwaukee Jewish Federation purchased the twenty-eight-acre campus of the University School on Santa Monica Boulevard in 1987. University School had previously consolidated its male campus in Whitefish Bay and its female campus on Fairy Chasm Road in Fox Point onto a new campus in River Hills. The Jewish Community Center (JCC), whose forerunner organization began as the Jewish Mission in 1894, had previously been located at 1400 North Prospect Avenue in Milwaukee since 1955. Since its earliest years, the JCC has sought to provide social, educational, recreational and cultural programs and activities.

The buildings the JCC purchased for its Karl Community Campus were originally built for the former Milwaukee Country Day School. The Senior School at **6201 North Santa Monica Boulevard** for grades eight through twelve opened in the fall of 1917. The Junior School for grades kindergarten through seventh grade was constructed in 1931 at 6255 North Santa Monica Boulevard. Both buildings were faced with brick and constructed in the Tudor Revival style. Additional construction of gyms, libraries, classrooms and dining space were added over the years, and further remodeling has taken place since the JCC's purchase. The campus became the University School in 1964 with the merger of Milwaukee Country Day School, Milwaukee University School and Milwaukee Downer Seminary.

The Milwaukee Jewish Day School, founded in 1981 to serve kindergarten through eighth grade, relocated from the East Side to the JCC in 1987. Also located on the campus are the Milwaukee Association for Jewish Education and the Hillel Academy, another private elementary school. The JCC campus is on the Whitefish Bay AHI.

George Washington 1776 Masonic Lodge No. 337

By 1920, many Freemasons lived in Whitefish Bay and belonged to the Grand Lodge of Wisconsin in Milwaukee. A lodge was proposed for Whitefish Bay, and in 1926, Lodge No. 337 was chartered. Members first met in the United Methodist Church of Whitefish Bay building and then rented the chapel on Beaumont Avenue previously used by the Christ Episcopal Church. The lodge purchased the chapel in 1948. It was demolished in 1964 to make way

George Washington Masonic Lodge No. 337, 517 East Beaumont Avenue, circa 1964.

for the current meeting hall at **517 East Beaumont Avenue**. The Masonic Lodge building is individually eligible for placement in the National Registry for the significance of its Colonial Revival architecture and its role in the village's social movements.

WHITEFISH BAY WOMEN'S CLUB

The Whitefish Bay Women's Club at 600 East Henry Clay Street was founded in 1917. It was formed by twenty-five women organized to advocate for women's suffrage. The Women's Club built its current clubhouse on Henry Clay Street in 1964. Over the past one hundred years, the club has been involved in establishing the fire department, the library and the school district's kindergarten programs. The club was well known for organizing and distributing telephone directories that covered the villages of Whitefish Bay and Fox Point for many years. These

directories have become an important source of historical information on former village residents. The club also pursues social, charitable and volunteering causes, fundraises for the Whitefish Bay Civic Foundation and provides scholarships for groups such as Badgers Girls State and Junior Achievement.

8
LAKE HEIGHTS, LAWNDALE AND THE BAY RIDGE AND KENT AVENUES HISTORIC DISTRICTS

After the Wisconsin Historical Society completed its intensive survey of the properties in Whitefish Bay in 2011, it recommended the creation of twelve residential historic districts. The proposed historic districts are organized around subdivision plats and are identified by their subdivision names. As a general rule, this approach resulted in the homes in a proposed historic district being of similar scale, cost, architectural styles and period of construction, thereby giving the district cohesiveness. But an observer will find many individual exceptions to that rule.

This chapter takes a look at the three proposed residential historic districts that are in the northern part of the village from Silver Spring Drive north to the village limits.

THE LAKE HEIGHTS HISTORIC DISTRICT

With only eleven homes, Lake Heights is the smallest proposed historic district in Whitefish Bay, although its residences are among the largest in the village. The homes are all north of Klode Park and east of Lake Drive with addresses on Monrovia Avenue and Lake Drive Court. Five of the homes sit on the Lake Michigan bluff. The Lake Heights subdivision was platted in 1927. The first home was built in 1930 at 6050 North Lake Drive at the southeast corner of Lake Drive and Monrovia Avenue.

A Celebration of Architecture and Character

Lake Heights (*top*), Lawndale (*right*) and Bay Ridge/Kent Historic Districts.

In 1931, the Tudor Revival–style Rita Jane Goldmann House at **6130 North Lake Drive Court** was constructed on the lakeshore. Rita Jane Goldmann was the widow of Leo Goldmann, whose family emigrated from Lithuania in 1884. Leo and his father, Abraham, founded Goldmann's Department Store in 1884, which became an anchor store on Milwaukee's once thriving Mitchell Street. The Goldmann's store closed in 2007 after 111 years in business. It became known for its quirky wares, stocking goods that could not be found elsewhere, and for its outfitting of portly customers. It sold size 10X sweatpants, dress shirts with twenty-four-inch neck sizes and brassieres up to size 56FF. The Goldmann home is individually eligible for listing in the National Register of Historic Places.

Another prominent family was Joseph J. and Vera Zilber, who built a home at 6110 North Lake Drive Court in 1954. Born in 1917 in Milwaukee to Jewish immigrants from Russia, Joseph became a prominent builder of homes, office buildings, fitness centers, nursing homes and college dormitories in Wisconsin, Florida, Nevada and Hawaii. He also built a rocket-launching gantry at Cape Canaveral, Florida; a heating plant above

Rita Jane Goldmann House, 6130 North Lake Drive Court, circa 1931.

A Celebration of Architecture and Character

Whitefish Bay notables. *Clockwise from top left*: actor Sam Page, builder Joseph Zilber, athlete Cathy Markson and athlete Randy Dean.

the Arctic Circle in Alaska; and fifteen fake missile silos in North Dakota for the U.S. Department of Defense to fool Soviet satellites. He purchased the personal property of serial killer Jeffery Dahmer, which was used in his trial as evidence, and had it destroyed. He and Vera, his wife of sixty-one years, became important philanthropists, establishing the Zilber Family

Foundation. The University of Wisconsin–Milwaukee Graduate School of Public Health is named in his honor.

After the Goldmann home in 1931, the third home in the subdivision was not built until 1945, when Dr. Ross and Mildred A. Weller built a home at 6100 North Lake Drive Court. The other eight homes were built in the late 1940s and 1950s.

The Lawndale Historic District

With the success of Day Avenue—the village's first subdivision and the first neighborhood serviced with utilities and the first street to be paved—further development quickly followed after the village was incorporated in 1892. A primary developer was the Acme Realty Company. To spur interest in the new village's first real estate venture, the company's own officers, including President L.L. Disbro and Secretary Carl Robert Gether, built their homes in the neighborhood. Gether also built a home for his mother and used it in advertising brochures. In 1895, a stretch of Lake Drive along the bluff north of Silver Spring Drive was rerouted a quarter mile to the west. This allowed for development along what became Shore Drive.

All 176 homes in the Lawndale Historic District are located between Lake Michigan and Lake Drive and between Klode Park on the north and Beaumont Avenue on the south. All but 6 residences are considered contributing historic properties. The homes in the historic district are considered outstanding examples of Colonial Revival, Tudor Revival, Queen Anne, Dutch Colonial and Contemporary architecture styles. One of the homes, **739 East Beaumont Avenue**, an Ernest Flagg–designed home known as the Horace W. and Marion Hatch House, is in the National Registry.

Several prominent early residents lived in this historic district. Galus Isenring, patriarch of the family who was so important in the village's development, lived in a log cabin at **808 East Lake View Avenue**. His great-grandson Warren Isenring, who was an important businessman on Silver Spring Drive in the mid-1900s, resided in the Flagg home at 739 East Beaumont Avenue. Alice Curtis, the village's first schoolteacher, lived on **708 East Day Avenue**. Real estate developer and publisher Alonzo Fowle built a home at **624 East Day Avenue**; and ad man turned scientist A. Cressy Morrison had a summer cottage at **615 East Day**

Galus Isenring House, 808 East Lake View Avenue, circa 1870.

Avenue. The Williamsburg-style Colonial at **601 East Day Avenue** was built in 1928 for Frank E. Baker, president of the Wisconsin State Teachers College—now the University of Wisconsin–Milwaukee—from 1924 to 1946. The house was designed by architect Cornelius Leenhouts and is listed in the Whitefish Bay Register of Historic Places. Sidney Siesel, who owned the Siesel Construction Company, which built the Memorial Gym addition to the Whitefish Bay High School in 1950, built his Leenhouts-designed home at **5843 North Maitland Court** the same year.

More recently, twins Randy and Rob Dean have been recognized for their athletic prowess. The sons of Ross and Elizabeth Dean, Randy and Rob, along with older brothers Ross and Richard, lived at 5858 North Maitland Court, built in 1930. Both were football stars at Whitefish Bay High School and were recruited by Northwestern University where Randy played quarterback and Robert was a defensive back from 1973 to 1976. Randy was drafted in 1977 by the New York Giants, for whom he played for three years before being traded to the Green Bay Packers in 1980. Both Randy and Robert were members of the U.S. handball team and competed in the

1976 Olympics in Montreal, Canada, with Randy being the team's high scorer. Randy is in the Whitefish Bay High School Athletic Hall of Fame.

Samuel L. Elliott, better known to television and movie viewers today as Sam Page, is an actor who grew up at 5684 North Shore Drive built in 1925. He has appeared in such popular television shows as *Mad Men*, *Desperate Housewives*, *Switched at Birth* and *Scandal*, as well as *House of Cards* on Netflix. He was born in 1976 to Robert and Pamela Elliott. His father was a Whitefish Bay municipal court judge for fifteen years. Sam graduated from Whitefish Bay High School in 1994 and earned a degree in ecology and evolutionary biology at Princeton University in 1998 before deciding to become an actor. To date, Sam has appeared in thirty-one television shows and in twenty-two short and movie-length films. He is in the Whitefish Bay High School Artists Hall of Fame.

The following homes are individually eligible for listing in the National Registry:

- The Dr. Leon H. and Thelma Guerin House, **5867 North Shore Drive**, 1936

Dr. Leon H. and Thelma Guerin House, 5867 North Shore Drive, circa 1936.

Gerhard H. and Marjorie Kopmeier House, 5731 North Shore Drive, circa 1929.

- The Dr. Edward H. and Katherine Mensing House, **5827 North Shore Drive**, 1927
- The Arthur and Arline O'Connor House, **5776 North Shore Drive**, 1921
- The F.H. Miller House, **5770 North Shore Drive**, 1921
- The Gerhard H. and Marjorie Kopmeier House, **5731 North Shore Drive**, 1929
- The Dr. Dexter H. and Margaret Witte House, **5674 North Shore Drive**, 1928
- The Clare H. Hall House, **5664 North Shore Drive**, 1921
- The M.W. and Sophia Margolis House, **5655 North Shore Drive**, 1939
- The G.C. and Marvel Leucks House, **5626 North Shore Drive**, 1939

The following homes, in addition to those bold-faced above, are on the Whitefish Bay Architecture and History Inventory (AHI):

Clare H. Hall House, 5664 North Shore Drive, circa 1921. Prairie style designed by Russell Barr Williamson.

- The Sidney Siesel House, **5843 North Maitland Court**, built in 1950. It was designed by Willis and Lillian Leenhouts.
- The John and Tillie M. Geerlings House, **5822 North Shore Drive**, built in 1927. It was designed by Cornelius Leenhouts.
- The Henry C. and Mattie Hettelsater House, **710 East Carlisle Avenue**, built in 1928. It is a "Studi-O-Home," also called a Vaulted Tudor, designed by John Edwards.
- The Reinhold C. and Irene Diekelman House, **633 East Lake View Avenue**, built in 1928. It is a Vaulted Tudor home built by John Edwards.
- The Dr. Bruno Warschauer House, **5688 North Lake Drive**, built in 1928. It is a Vaulted Tudor constructed by John Edwards.
- Otto H. and Edna J. Fiebing House, **5670 North Lake Drive**, built in 1925. It was designed by Ernest Flagg.

A Celebration of Architecture and Character

The Bay Ridge and Kent Avenues Historic District

With the Lawndale subdivision attracting more and more new residents, home builders began to develop new housing west of Lake Drive and Santa Monica Boulevard.

The sixty-one acres that stretch from the Fox Point village limits south to Silver Spring Drive were platted in 1924, 1925, 1926 and 1930. The first home was built in 1924 at 5814 North Shoreland Avenue.

Much of the Bay Ridge and Kent Avenues Historic District runs for six blocks down both sides of Bay Ridge and Kent from Devon Street on the north to Lake View Avenue on the south. On Bay Ridge, 19 homes north of Devon and 6 homes south of Lake View are also in the district—so are the two blocks of Shoreland Avenue from Belle Avenue to Lake View Avenue. The district includes 330 homes, all but 2 of which are contributing historical properties.

Development in this historic district of small and modestly sized homes was rapid, with 124 residences built in the 1920s. Construction slowed a bit in the 1930s, when 112 homes were built. The remaining 94 homes went up in the 1940s and 1950s. The homes in the Bay Ridge and Kent Avenues Historic District are representative of the prevailing architectural styles of their time, especially Colonial Revival and Tudor Revival. The original lot sales required construction of single-family homes with minimum setbacks and a minimum cost of construction. The subdivision had an odious restrictive covenant, in effect for twenty-five years, prohibiting the sale of homes to "colored persons."

Examples of two noteworthy homes in this district are:

- The Trayton H. and Marjorie A. Davis House, **6110 North Bay Ridge Avenue**, built in 1930. The Davis home is individually eligible for placement in the National Registry.
- The Lewis P. and Bernadette Kiehn House, **5701 North Shoreland Avenue**, a John Edwards–designed Studi-O-Home built in 1928. It is on the Whitefish Bay AHI.

One of Whitefish Bay's best athletes and most respected community leaders, Catherine Nichols Markson, grew up in the Bay Ridge and Kent Avenues Historic District in a home that her maternal grandparents first owned. The Harlan and Gladys Stoller House was built in 1930 at 6121

Trayton H. and Marjorie A. Davis House, 6110 North Bay Ridge Avenue, circa 1930.

North Bay Ridge Avenue. Cathy's parents, Asher B. and Susan Nichols, later moved into the home where Cathy spent her childhood.

Cathy graduated from Whitefish Bay High School in 1979 as one of the Bay's most acclaimed female athletes. She earned nine letters in four sports. She was a four-year starter on the girls' basketball team, leading the squad to a 70-11 overall record, four Suburban Conference championships and a berth in the first state girls' basketball tournament in 1976. She was the first or second leading scorer all four years. As a freshman and sophomore, she went out for swimming, qualifying for state both years as a member of relay teams. She switched to volleyball her junior and senior years, a sport in which she would also letter at Wake Forest University. Her high school honors included being named a Prep Girl Athlete All-American and a Girls' Basketball All-American by the National High School Athletic Coaches Association. She is an inductee of the Whitefish Bay High School Athletic Hall of Fame. A lifelong Bay resident, Cathy Markson has continued to contribute to the community by taking active roles in several youth sports organizations, including Little League baseball, the Whitefish Bay Soccer

A Celebration of Architecture and Character

Lewis P. and Bernadette Kiehn House, 5701 North Shoreland Avenue, a John Edwards–designed Vaulted Tudor, circa 1928.

Club, Junior Dukes boys' basketball and the high school's girls' basketball and Duke Pride programs.

Thomas Lee Miller, the producer of *Happy Days*, *Laverne and Shirley* and some of America's other beloved television comedies, grew up at **6017 North Bay Ridge Avenue**, the son of Edward A. and Shirley Miller. They were the first owners of the house built in 1937. Born in 1940, Tom started his Hollywood career as a development executive before becoming an assistant to acclaimed movie director Billy Wilder (*The Seven-Year Itch*, *Some Like It Hot*, *The Apartment*). In 1969, Tom launched a production company, writing and producing several TV movies and comedies. He joined with Garry Marshall for the first time in 1972 to co produce the sitcom *Me and the Chimp*—widely considered to be one of the worst shows in American television history—before they hit TV ratings pay dirt in 1974 with *Happy Days*, which had an eleven-year run, and its spinoff *Laverne and Shirley*, which ran for eight seasons. Tom named the characters in the latter show after his mother, Shirley, and his aunt Laverne Plous. Tom's production company was highly prolific, spawning over thirty TV movie titles and

comedy shows, including *Mork and Mindy*, *Perfect Strangers*, *Full House* and *Family Matters*. In some years, Tom had up to six sitcoms on network TV in the same season. Now in his seventies, Tom's production house continues to stay busy, currently producing *Fuller House*, a sequel to *Full House*, now in its third season on Netflix.

Two homes not technically within the Bay Ridge and Kent Avenues Historic District boundaries but part of the subdivisions' historic development are worthy of note:

- The W. Hall and Amy Wallace House, **5775 North Santa Monica Boulevard**, built in 1925. This is an Ernest Flagg home constructed by builder Robert Stanhope who with contractor Arnold Meyer were the two builders of Flagg's Cotswold Cottage–style homes in Whitefish Bay. The Wallace House is listed in the National Registery.
- The Fred E. and Mary Zindler House, **6344 North Santa Monica Boulevard**. This charming brick Tudor residence with a half-timbered turret entrance topped by a "Reddy Kilowatt" weathervane

Fred E. and Mary Zindler House, 6344 North Santa Monica Boulevard, circa 1936. The GE All-Electric Demonstration House.

was constructed in 1936 as an "all-electric" demonstration house built under the General Electric Company's "New American Home" program, a nationwide architectural contest to develop a home that would meet the modern requirements of the typical family at an affordable price. Contest rules required the homes to be completely electrified and "designed to reduce the work and drudgery of the housewife to the very minimum." At that time, this meant refrigerators, ovens, stoves and dishwashers—all commonplace today. GE sponsored the all-electric home contest for several years and featured an electric home at the 1939 New York World's Fair.

9
PABST, IDLEWILD AND LAKE CREST HISTORIC DISTRICTS

After the Pabst Brewing Company closed the Whitefish Bay Resort in 1915, the company became a real estate developer, selling lots and building homes on its lakeshore property and land it purchased west of Lake Drive. Other real estate development companies piggybacked onto the Pabst building boom, developing land farther to the west up to Santa Monica Boulevard and between Silver Spring Drive and Henry Clay Street.

THE PABST HISTORIC DISTRICT

Although much initial development in the village took place in the northern part of Whitefish Bay with the first subdivision on Day Avenue, pockets of the village south of Silver Spring Drive were not being ignored. After the magnificent Herman and Claudia Uihlein Mansion was completed in 1919 at **5270 North Lake Drive**, development of other large and grand homes in the area began apace.

The Pabst Historic District contains 186 homes of which all but 11 are considered contributing historic properties. There are 6 homes already in the National Register of Historic Places, and 21 other residences are individually eligible to go in the National Registry. The district boundaries are roughly Lake Michigan west to Marlborough Drive and Sylvan Avenue north to the south side of Birch Avenue. It includes Danbury Road, as well as 2 houses on Lake Forest Avenue and 1 house on Glen Avenue. There are

A Celebration of Architecture and Character

Lake Crest (*left*), Idlewild (*center triangle*) and Pabst Historic Districts.

9 houses on the north side of Birch Avenue in the historic district and 16 lakeshore homes on the east side of Lake Drive between Henry Clay Street and Lake Forest Avenue.

Most of the residences were built in the 1920s, but the first home was the Queen Anne–style house built for village president and health officer Dr. Thaddeus W. Williams at **942 East Sylvan Avenue** in 1893. The second was built by Wynand Isenring, longtime village treasurer and co-founder of the Bank of Whitefish Bay, who built a home at 1036 East Lexington Boulevard in 1905. Wynand later built a home at 1009 East Henry Clay Street in 1920. By 1922, a total of 24 homes had been built in the area, but in the next seven years, construction took off with 119 more residences constructed by 1929. The remaining homes were constructed during the next three decades. The architectural styles are representative of the times, with many homes in Colonial Revival, Tudor Revival, Mediterranean Revival, Dutch Colonial and Contemporary styles.

Original development plans called for both Lexington and Sylvan to be designed as two grand boulevards in order to attract the building of upscale residences. But in 1918, Sylvan's width was reduced from a boulevard to an avenue. Lexington remains a boulevard as originally platted.

As a farming community, Whitefish Bay residential developments had few, if any, restrictive covenants. But to be safe, the Pabst Brewing

Company imposed a few covenants of its own. Homeowners were expressly prohibited from keeping cows, pigs, chickens, ducks and poultry on their property. It was a reasonable concern. A 1920 personal property census by the village assessor showed there were "55 horses, mules and asses; 59 cattle; 35 swine; 75 wagons, carriages and sleighs; 91 autos and 9 other motor vehicles." Interestingly, the first cars did not appear in Whitefish Bay until 1912.

Numerous prominent people have lived in the Pabst Historic District, many of them in the grand homes on Lake Drive. Several are discussed in chapter 3. Other notable persons are Arthur F. Bues, a major league baseball player who played for the Chicago Cubs and the old Boston Braves in 1913–14. He and his wife, Vivian F., built a home at 1041 East Circle Drive in 1925. Art played for his uncle George Stallings, who managed the Boston Braves to their only World Series championship in 1914. (The Boston Braves became the Milwaukee Braves in 1953 and would win the World Series again in 1957.)

Mel D. and Marion Newald built the Greek Revival home at **1071 East Circle Drive** in 1928 but had to leave in 1930 when the Depression bankrupted his truck dealership. Leon and Mildred Foley moved into the house in 1935 and lived there for fifty years. Foley was senior partner of Foley & Lardner, Wisconsin's oldest and largest law firm. Foley's Irish ancestors came to Wisconsin by way of Quebec when his grandfather eloped with the daughter of the man who hired him to care for his horses.

Another Circle Drive resident was architect Alexander Hamilton Bauer, who designed several elaborate movie theaters in Milwaukee, including the Oriental Theater at 2230 North Farwell Street in Milwaukee. He and his wife, Emma, built their home at **988 East Circle Drive** and lived there from 1929 to 1945. The Bauer House is individually eligible for placement in the National Registery. Bauer also designed the James J. McClymont House at 4811 North Lake Drive, built in 1930, which features a variety of marble used extensively throughout the house.

The Bauer home was purchased in 1961 by Norman and Joan (Wiener) Prince. Joan made her home renowned for its colorful landscaping and bountiful front yard rose garden. She was president of the Milwaukee Rose Society, taught gardening classes at village hall and wrote a column, "In the Garden," for the *Milwaukee Sentinel*. A native of Germany, Joan's family came to Milwaukee in 1936. She got her degree in journalism at the University of Wisconsin–Milwaukee and met her husband while working for *Junior Scholastic* magazine in New York City. The couple later relocated

A Celebration of Architecture and Character

Alexander Hamilton and Emma Bauer House, 988 East Circle Drive, circa 1929.

to Whitefish Bay, and Joan remained in the home until her death in 2005 at age eighty-five.

Architect Armin C. Frank also lived in the community where he designed homes. Frank built his own home at **5486 North Lake Drive** in 1924. He also designed the Casa del Lago at **5570 North Lake Drive** for his mother, Ella S. Frank, and the E.A. and Anita Weschler House at **4724 North Wilshire Road** in 1929. Both his mother's home and the Weschler House are individually eligible for listing in the National Registry. Harold W. Connell, Whitefish Bay Village president from 1934 to 1937, built a home with his wife, Edna, at 832 East Birch Avenue in 1925. Attorney Patrick Matthews, village president from 1984 to 1989 and former member of the Dominican High School Board, lived at 889 East Birch Avenue, which was built in 1912.

The following homes are individually eligible for listing in the National Registry:

- The William J. Oswald Development House, **823–27 East Birch Avenue**, a duplex built in 1922.
- The Otto Robert and Valeska Kuehn House, **968 East Circle Drive**, built in 1924.

- The Robert B. and Ivy E. Asquith House, **998 East Circle Drive**, a Russell Barr Williamson designed home built in 1923.
- The Arthur G. and Elizabeth Gross House, **1013 East Circle Drive**, built in 1925.
- The Dr. Harry R. and Katherine Foerster House, **1074 East Circle Drive**, built in 1925.
- The John J. and Laura McCoy House, **1093 East Circle Drive**, built in 1927.
- The Thomas F. and Adele Regan House, **5464 North Danbury Road**, a Russell Barr Williamson home built in 1920.
- The Edward and Elinor Wenzel House, **908 East Lexington Boulevard**, built in 1931.
- The Gustave N. and Clare Hansen House, **1100 East Lexington Boulevard**, built in 1929.
- The L.E. and Alma Bartholomew House, **1124 East Lexington Boulevard**, built in 1930.

Robert B. and Ivy Asquith House, 998 East Circle Drive, circa 1923. A Russell Barr Williamson–designed home.

A Celebration of Architecture and Character

John J. and Laura McCoy House, 1093 East Circle Drive, circa 1927.

Thomas F. and Adele Regan House, 5464 North Danbury Road, circa 1920. Designed by Russell Barr Williamson.

The following homes, in addition to those bold-faced above, are on the Whitefish Bay Architecture and History Inventory (AHI):

- The Paul S. and Margaret Grant House, **984 East Circle Drive**, an Ernest Flagg–designed home built in 1925.
- The Edward John and Florence Hornbach House, **1086 East Circle Drive**, a John Edwards–built Studi-O-Home, also called a Vaulted Tudor, built in 1928.
- The Arthur J. and Mary G. Roethe House, **1101 East Circle Drive**, built in 1927.
- The Nora I. Meahan House, **5456 North Danbury Road**, a Russell Barr Williamson home built in 1925.
- The Allen Barfield/Fred Staples Duplex, **5461–63 North Danbury Road**, an Ernest Flagg home built in 1924.
- The Frank J. and Elvira Williams, **912 East Lexington Boulevard**, an Ernest Flagg home built in 1925.
- The Frederick Sperling House, **1016 East Lexington Boulevard**, an Ernest Flagg home built in 1924.
- The Lillie Ketchum Duplex, **1017–19 East Lexington Boulevard**, a Russell Barr Williamson residence built in 1925.

Allen Barfield/Fred Staples Duplex, 5461–63 North Danbury Road, circa 1924. Designed by Ernest Flagg.

A Celebration of Architecture and Character

Lillie Ketchum Duplex, 1017–19 East Lexington Boulevard, circa 1925. A Russell Barr Williamson–designed home.

Albert S. and Leah Ethridge House, 1025 East Sylvan Avenue, circa 1929. A John Edwards Vaulted Tudor.

David and Dorothy Resnick House, 1134 East Sylvan Avenue, circa 1937. A Moderne design by Kirchoff and Rose, the architectural firm that also designed the Uihlein mansion.

- The Halbert D. Jenkins House, **1028 East Lexington Boulevard**, an Ernest Flagg home built in 1924.
- The Albert S. and Leah Ethridge House, **1025 East Sylvan Avenue**, a John Edwards Vaulted Tudor built in 1929.
- The Carl and Gertrude Daun House, **1032 East Sylvan Avenue**, a John Edwards Vaulted Tudor built in 1928.
- The David and Dorothy Resnick House, **1134 East Sylvan Avenue**, a Kirchhoff & Rose–designed Moderne-style home built in 1937. Kirchhoff and Rose also designed the Uihlein mansion at 5270 North Lake Drive.

The five Flagg homes and the Uihlein Mansion are in the National Registry.

The Idlewild Historic District

In the village's civic heart, located across the street from village hall, the Whitefish Bay Library and the firehouse, are sixty-two homes in a triangular-shaped district framed by Idlewild Avenue, Henry Clay Street

and Marlborough Boulevard with Old Schoolhouse Park at its northern peak. While development began in the 1890s with the first schoolhouse (now a park), the first village hall (now a home on Beaumont Avenue) and the residence (now razed) of Frederick G. Isenring, the first village president, most of the homes were not built until after 1920. The fifty-eight homes that are contributing historic properties are examples of the prevailing architectural styles of the day, including Colonial Revival, Tudor Revival, Bungalow and Contemporary. Half of them were built in the 1920s.

Stone & Thomas Company, a Milwaukee real estate firm, purchased nine acres in this neighborhood in 1887 with the goal of building housing for workers of a large rail yard that was to be constructed from Henry Clay Street south to Courtland Avenue by the Milwaukee, Lakeshore and Western Railway. The yard would have contained freight yards and car repair shops. But that project collapsed with the Depression of 1893. The newly formed village government jumped at the chance to develop the railroad's land for other purposes. The area was rezoned residential. The homes in the Idlewild Historic District were built to be comparable to those in the adjoining Pabst Historic District to the east.

Joseph E. and Josephine Langlois House, 700 East Briarwood Place, circa 1892.

One of the first homes in the historic district was the Joseph E. and Josephine Langois House at **700 East Briarwood Place**, built in 1892. Joseph was a conductor with the Lake Shore Railroad. The couple had three daughters, Della, Etta and Esma, and a son, Aurel. They sold the property to Colonel Phillip C. and Elizabeth Westphal in 1922, who later sold the home to their daughter Florence and her husband, Edwin Blech. Colonel Westphal led Wisconsin's 121st Field Artillery Regiment in World War I and later served as commander of the Whitefish Bay Armory. Whitefish Bay was still a farming community in the 1920s and early 1930s, and Blech's daughter Nancy recalled that she had unobstructed views north to Silver Spring Drive and west to Port Washington Road "with only a few cows standing in the way."

The following homes are individually eligible for placement in the National Registry.

- The Joseph Patza House, **707 East Fleetwood Place**, 1910
- The Walter L. and Irma S. Kuehn House, **706 East Lexington Boulevard**, 1939

Adolph H. and Grace R. Weber House, 736 East Sylvan Avenue, circa 1928.

- The Adolph H. and Grace R. Weber House, **736 East Sylvan Avenue**, 1928

The following homes and places, in addition to those bold-faced above, are on the Whitefish Bay AHI.

- The Joseph E. and Josephine Langlois House, **700 East Briarwood Place**, 1892
- The Gordon F. and Doris Daggett House, **735 East Briarwood Place**, a John Edwards Vaulted Tudor built in 1929.
- Old Schoolhouse Park, **5445 North Marlborough Boulevard**. Fleetwood School was built at this location in 1892 with its first classes held in 1893. It was destroyed by fire in 1918.

The Lake Crest Historic District

With 397 residences, Lake Crest is by far the largest proposed historic district in Whitefish Bay but also one of the youngest based on the age of its housing stock. It was not platted until 1925, and the first homes—13 in all—were built in 1926. But three years later, 93 homes had been built, and by World War II there were 178 residences.

The 392 homes that are contributing historic properties are in a variety of architectural styles, with many in the Colonial Revival and Tudor Revival styles. The district stretches from Silver Spring Drive south to Henry Clay Street and lies between the east side of Shoreland Avenue and the west side of Idlewild Avenue. Four homes in the 5500 block of Marlborough Boulevard are also in the district. The district was developed over four decades from the 1920s to the 1950s.

Two of the most notable persons to have lived in the Lake Crest Historic District were actors Jane Archer and Chip Zien. Their careers are discussed in chapter 4.

The following homes are individually eligible for listing in the National Registry:

- The Peter F. and Christene Hansen House, **5561 North Diversey Boulevard**, 1926

Peter F. and Christene Hansen House, 5561 North Diversey Boulevard, circa 1926.

Henry and Helen Turrie House, 5327 North Diversey Boulevard, circa 1935.

A Celebration of Architecture and Character

- The Henry and Helen Turrie House, **5327 North Diversey Boulevard**, 1935
- The B.F. Fisher House, **5260 North Santa Monica Boulevard**, a Russell Barr Williamson home built in 1929.
- The Eric F. and Gertrude Hartert House, **5226 North Santa Monica Boulevard**, an International Moderne–style home built in 1936.

The following homes, in addition to those bold-faced above, are on the Whitefish Bay AHI:

- The Archibald and Eleanore O'Connor House, **5262 North Berkeley Boulevard**, 1928
- The Harold J. and Marjorie P. Cheetham House, **5263 North Berkeley Boulevard**, 1928
- The Frank J. and Jane J. Kelley House, **5320 North Berkeley Boulevard**, 1928
- The LeRoy H. and Martha Brown House, **5518 North Diversey Boulevard**, 1928

Paul C. and Jeanne D. Winner, 5346 North Hollywood Avenue, circa 1928. A John Edwards "Vaulted Tudor."

- The Marshall and Eleanor Bautz House, **5549 North Diversey Boulevard**, 1935
- The Paul C. and Jeanne D. Winner House, **5346 North Hollywood Avenue**, 1928
- The Werner J. and Beulah Trimborn House, **5221 North Santa Monica Boulevard**, 1928
- The Chester A. and Esther M. Cook House, **5501 North Santa Monica Boulevard**, 1928

10
FAIRMOUNT AND HIGHLAND VIEW, CUMBERLAND FOREST AND PALO ALTO, BIG BAY PARK AND BAY VILLAGE HISTORIC DISTRICTS

In the 1880s, when Captain Frederick Pabst built his beer garden and resort on two-hundred lakeshore acres north of Henry Clay Street, real estate developers smelled opportunity and began snapping up land to the south. The Milwaukee, Lakeshore and Western Railway had a rail depot where Whitefish Bay Middle School is located today, which made it easy for workers and businessmen to commute to Milwaukee. The commute was made even easier when the dummy line began running hourly in 1892 from downtown Milwaukee to Henry Clay Street. Easy access to the railway and the dummy line made development of the land south of the Pabst Resort especially attractive to home builders.

THE FAIRMOUNT AND HIGHLAND VIEW HISTORIC DISTRICT

Platted in 1890, the forty four acre subdivisions of Fairmount and Highland View were among the first to be developed after Day Avenue and were substantially developed by the early 1930s. Most of the 212 homes in the historic district, of which all but 4 are contributing historic properties, are bounded by Fairmount Avenue on the north to Hampton Road on the south and are situated on Ardmore Avenue, Woodburn Street and Cumberland Boulevard. The district also includes the two-block stretch of

Historic Whitefish Bay

Cumberland (*lower*), Fairmount (*center*) and Big Bay (*upper right*) Historic Districts.

Cumberland and Larkin Street and the west side of Lake Drive, from Fairmount to Henry Clay. The district exhibits fine examples of the architectural styles of the time, including Colonial Revival, Tudor Revival, Mediterranean Revival and Contemporary.

The 4800 block of Cumberland attracted the first development. The oldest home in the district is the John Kohlmetz House at 4832 North Cumberland Boulevard, built before 1890. The Roy S. Strickler House at 4839 North Cumberland Boulevard was built in 1909, and the Herbert T. Pegge House across the street at 4838 North Cumberland Boulevard went up in 1919.

Three prominent actors spent their childhoods in the Fairmount and Highland View Historic District: Jeffrey Hunter, Colleen Dewhurst and Caitlin O'Heaney. Their careers are discussed in chapter 4.

There are two other homes in the district worthy of note:

- The James Campbell House at **1512 East Hampton Road** was built in 1921 entirely of logs. Campbell was a Milwaukee schoolteacher. He hauled the logs from northern Wisconsin and built his homestead by

James Campbell House, 1512 East Hampton Road, circa 1921.

Dar and Jeanne Vriesman House, 4800 North Cumberland Boulevard, circa 1940. The "Concrete Demonstration House" during an open house.

hand, placing a real log cabin amid a sea of brick, stone and stucco Colonial Revival and Tudor Revival homes. Each holiday season, the owners decorate the home with life-sized wooden figures of impish Christmas elves frolicking about the yard, windows and roof. This annual tradition, which has been observed by at least three sets of owners, goes back to at least 1950 and probably earlier.

- The Dar and Jeanne Vriesman House at **4800 North Cumberland Boulevard** was built in 1940. Designed by Milwaukee architect Frederic von Grossman (who also designed Nicolet High School in Glendale), it was the first house in the Milwaukee area built entirely of concrete blocks, although at least two other concrete block homes were built in Whitefish Bay soon after in the Art Moderne or International style: the John R. and Fannie Moore House at **4773 North Oakland Avenue**, and the Robert B. and Mary Louise Ebert House at **4617 North Idlewild Avenue**, both built in 1940.

A Celebration of Architecture and Character

Leonard L. and Laura H. Bowyer House, 5073 North Lake Drive, circa 1931.

Dar Vriesman was the managing director of the Downtown Association, the Milwaukee business association. He and his wife had six children ages six to nineteen at the time the house was constructed. The "Concrete Demonstration House" was constructed with the cooperation of the Portland Cement Association, which also provided engineering services. The residence was open to the public for inspection for a week in September 1940 before the family moved in. The Vriesman House is individually eligible for listing in the National Register of Historic Places.

Other homes in the Fairmount and Highland View Historic District individually eligible for listing in the National Registry:

- The Leonard L. and Laura H. Bowyer House, **5073 North Lake Drive**, 1931
- The Raymond C. and Kathleen Shank House, **4864 North Woodburn Street**, 1927

The following home, in addition to those bold-faced above, is on the Whitefish Bay Architecture and History Inventory (AHI):

Historic Whitefish Bay

Raymond C. and Kathleen Shank House, 4864 North Woodburn Street, circa 1927.

Clem and Fawn C. Kalvelage House, 4903 North Cumberland Boulevard, circa 1928. A John Edwards Vaulted Tudor.

A Celebration of Architecture and Character

- The Clem and Fawn C. Kalvelage House at **4903 North Cumberland Boulevard**, a John Edwards–designed Studi-O-Home, also called a Vaulted Tudor, built in 1928.

The Cumberland Forest and Palo Alto Historic District

Of all the many subdivisions platted and developed in Whitefish Bay over the past 125 years, only one still retains its original name: Cumberland Forest. The 296 homes in the historic district, all but 2 considered contributing historic properties, have long been known as prestige addresses.

Although the first subdivision was platted in 1890, most of the historic district was platted in the early twentieth century. Development began in the 1920s and was filled in over the next four decades. The earliest homes were built in 1922: 4611 North Bartlett Avenue, 4633 North Bartlett Avenue, 4620 North Newhall Street and 4631 North Newhall Street.

The district's boundaries are Marlborough Drive on the west, Hampton Road on the north, Oakland Avenue on the east and the Shorewood village limits on the south. Developers required the construction of single-family homes with minimum front setbacks and a minimum cost of construction. There were also restrictions on erecting fences, walls or other structures and on front yard landscaping with trees and bushes. The district is historically important for its examples of Colonial Revival, Tudor Revival, Mediterranean Revival and Bungalow styles of architecture.

Whitefish Bay High School Athletic Hall of Famer Earl Doug Lillydahl grew up at 1629 East Blackthorne Place, the son of Earl and Mary Lillydahl. The home is known as the Arthur A. and Gertrude Santley House, after its first owners.

Doug Lillydahl graduated in 1986 and was a star swimmer for both the Bay and Stanford University. He was a three-time state champion in swim sprint events and won one or more individual conference championships all four years of high school. He was named to the National High School All-American swim team in four individual events over his junior and senior years. At Stanford, he won PAC-10 Conference individual titles in the one-hundred-yard butterfly and was part of five relay team championships in his four years, was named an All-American over four years in six individual events and nine relay events and helped Stanford win the 1987 NCAA swim

team championship. Doug became an English teacher at Stevenson High School in Chicago, where he coached the swim team to two runner-up finishes in the state meet and won Illinois Swim Coach of the Year honors in 2003 and 2004.

The following homes are individually eligible for listing in the National Registry:

- William and Ida Temkin House, **1620 East Cumberland Boulevard**, 1929
- John R. and Fannie Moore House, **4773 North Oakland Avenue**, 1940

The following home, in addition to those bold-faced above, is on the Whitefish Bay AHI:

- The Albert P. and Marcella Kohler House, **4780 North Newhall Street**, a 1929 home designed by Sara Leenhouts, of the Leenhouts family of architects.

William and Ida Temkin House, 1620 East Cumberland Boulevard, circa 1929.

A Celebration of Architecture and Character

John R. and Fannie Moore House, 4773 North Oakland Avenue, circa 1940. International Moderne style.

The Big Bay Park Historic District

Even as an urban suburb, Whitefish Bay boasts plenty of wildlife—deer, coyotes, foxes, wild turkeys and raccoons—but few know the critters as intimately as the thirty-six homeowners living across the street from Big Bay Park. Separated from the park by Palisades Road, many of the residents have all the pleasures of lakeside living but with none of the bluff erosion concerns that are a frequent lament of their lakeshore neighbors.

The district boundaries are straightforward—it is the two blocks between Fairmount Avenue and Henry Clay Street and includes the eighteen homes on the west side of Palisades Road and the seventeen homes on the east side of Lake Drive. It also includes the home at **1500 East Henry Clay Street**, which sits on former Pabst Resort property. The district is important historically for its Colonial Revival, Monterrey and Contemporary architectural styles.

Given its location on the southern edge of the Pabst Whitefish Bay Resort, it is surprising that this small seven-acre subdivision was developed somewhat late. It was not platted until 1937, and its homes were built between 1938 and 1957. An agreement between the village and the developer, Nakima Realty Company, required all houses to cost a minimum of $12,500.

The subdivision almost did not happen. In 1924, a developer purchased a 1,600-foot strip of lakefront from Fairmount Avenue to Henry Clay Street for the construction of a $2 million hotel on the bluff. The project never got off the ground after a falling out among the partners, and the land was subsequently obtained by Nakima Realty, which platted the land west of Palisades Road for residential lots. In 1937, the village purchased land for the development of Big Bay Park, the nine-acre tract running along the bluff, and adjoining Buckley Park, a one-acre parcel at the foot of Fairmount Avenue named for Thomas F. Buckley, the village engineer and public works director from 1921 to 1933.

In 1940, the parkland got a valuable assist from the Depression-era Works Progress Administration (WPA) when it created public access to the swimming beach from Buckley Park and built shoreline protection along Big Bay Park. The project consisted of a lannon-stone walkway that followed a natural ravine from street level atop the bluff to the lakeshore. A groin was

Ralph C. and Sylvia Feerick House, 1500 East Henry Clay Street, circa 1939.

constructed near the foot of this walkway that extended out into the lake for shoreline protection. The groin also eventually led to the buildup of a sandy beach for public swimming. Extensive shoreline protection was constructed north of the beach to protect the bluff.

All the residences in the Big Bay Park Historic District are contributing historic properties. The home at 1500 East Henry Clay Street is individually eligible for placement in the National Registry. The gleaming white home with an attached three-car garage and four two-story front entry columns was built in 1939 and belonged to Ralph C. and Sylvia (Koosch) Feerick. Ralph was the only son of William C. Feerick, founder in 1896 of the funeral home business bearing his name. Ralph succeeded his father as president, and it is believed by some longtime village residents that Ralph built the house with the idea of possibly converting the property into a funeral parlor. However, the building has always been a residence.

The Bay Village Historic District

As World War II ended, developer Francis J. Schroedel conceived the idea of building a 120-unit apartment complex marketed to returning servicemen and their young families. He purchased land in the southwestern corner of the village that had recently been annexed and rezoned from light industrial to multi-family residential. But getting the project off the ground became harder than expected.

After the village rejected his apartment proposal in 1950, Schroedel went to court. While the legal case was pending, the village tried to strengthen its hand by rezoning the land to single-family residential through a village-wide referendum. But the court ruled in Schroedel's favor, and the decision was affirmed by the Wisconsin Supreme Court. The village rezoned the property to multi-family residential, and Schroedel proceeded to construct the Bay Village Apartments complex, which later was nicknamed "Schroedel's Cradles" for all the young couples with children who lived there.

Schroedel also developed the Estabrook Apartments complex on Wilson Drive in Shorewood, just south of the Whitefish Bay village limits at Glendale Avenue. That complex has also been identified as a proposed historic district by the State Historical Society.

The Bay Village Historic District comprises twenty-seven acres bounded by Hampton Road, Santa Monica Boulevard, Fairmount Avenue and

Lydell Avenue. The forty-two buildings in the district are in the Colonial Revival style. The Bay Village Apartments is the largest complex in the historic district. There are two smaller apartment complexes on Fairmount Avenue and on Santa Monica Boulevard. There are also about one hundred condominium units in the Bay Village Historic District. All of the structures within the district's boundaries are contributing historic properties.

11
LAKE WOODS AND ORTONWOOD TRIANGLE AND WILSHIRE HISTORIC DISTRICTS

As builders in the 1900s continued their development push south from the Pabst Whitefish Bay Resort along Lake Drive, they platted and built the Lake Woods and Ortonwood Triangle subdivisions, creating a long and oddly shaped historic district. Later, the Wilshire subdivision filled in the village's southeast corner. Whitefish Bay officials set strict construction requirements for the kind of housing they wanted to see in those neighborhoods, requiring the homes to have a minimum cost. In Lake Woods/Ortonwood, the village wanted the homes to be a minimum of two stories, a requirement that was dropped when Wilshire was developed. These high standards resulted in the construction of some of the most distinguished architecture in Whitefish Bay.

The Lake Woods and Ortonwood Triangle Historic District contains 162 residences, of which all but 5 are considered contributing historic properties. Five Ernest Flagg–designed homes in the district are already listed in the National Register of Historic Places, and 16 houses are individually eligible for placement in the National Registry.

The Lake Woods/Ortonwood district includes all of the homes on the west side of Lake Drive (but none on the east side) from Fairmount Avenue south to Cumberland Boulevard. It also includes all the homes on Oakland Avenue north of Hampton Road. Finally, it includes all of the homes south of Hampton Road to the Shorewood village limits on Cramer Street, Murray Avenue and Frederick Avenue. But the historic district's boundary includes this odd wrinkle: on Wilshire Road the historic district ends right in the middle of the 4600 block.

Lake Woods and Wilshire (*lower right*) Historic Districts.

 The boundaries of the Wilshire Historic District start where Lake Woods/Ortonwood leaves off, running the remaining length of both Wilshire Road and Lake Drive to the Shorewood village limits. The twelve homes on Glendale Avenue from Lake Drive to Frederick Avenue are also in the district. All thirty-five homes in the Wilshire Historic District are contributing historic properties.

A Celebration of Architecture and Character

So why did the State Historical Society determine that these are two distinct historic districts rather than one? Why would one historic district end in the middle of a block and the second pick up at that point? The answer is in the style of architecture in the two districts and in the period when the homes in each were built. If the difference is not apparent at first glance, take a second look and it will become obvious.

The Lake Woods and Ortonwood Triangle Historic District was platted in the 1890s. The first home was the Herman C. Beverung House at **4873 North Oakland Avenue**, built in 1895. Much of the historic district was substantially developed in the 1920s. The styles of its architecture are predominantly Colonial, Tudor and Mediterranean Revival.

By contrast, the Wilshire Historic District was platted in 1927. Its homes weren't built until three to four decades later. The first homes in the Wilshire district were the J.A. and Gertrude A. Keogh House at 4600 North Wilshire Road and the George F. and Jane Kasten House at 4645 North Wilshire Road, both built in 1937. The rest of the homes in the district were constructed in the 1940s, '50s and '60s. The district's architectural styles are predominantly Monterrey, Ranch and Contemporary.

Although many of the grand residences on the east side of Lake Drive south of Fairmount Avenue were built at the same time as the homes in the two neighborhoods across the street, none are included in either historic district because of the large number of tear-downs that have occurred on that stretch of Lake Drive. Tear-downs distort the integrity of a historic district. However, there are several older homes on the lakeside of Lake Drive that are individually eligible for placement in the National Registry.

Several prominent businessmen built their homes in this part of Whitefish Bay.

Edward Pritzlaff worked for the family hardware business at the time he and his wife, Erna, built their home at **4725 North Wilshire Road** in 1925. The John Pritzlaff Hardware Company was founded in 1850 by Edward's grandfather and became the largest hardware company in Milwaukee. John Pritzlaff's son Frederick took over the company when John died in 1900. Edward succeeded his father in 1951. Their Lannon stone Tudor Revival residence features half timbering at the face of some of the gables, wooden lintels over the principal windows and a slate roof. The original brick and stone residence was two and a half stories with ten rooms. A two-story addition was added for the Pritzlaffs several years later. The residence is defined by a stone fence that adds to the charm of the property. The house was designed by Milwaukee architect Harry Bogner, who also designed the

Edward F. and Erna M. Pritzlaff House, 4725 North Wilshire Road, circa 1925.

Georgian-style home at 3510 North Lake Drive built in 1923 for Frederick Vogel Jr., president of the Pfister and Vogel Tanning Company. The Pritzlaff House is individually eligible for placement in the National Registry for the significance and integrity of its Tudor Revival style.

Whitney H. and Anna M. Eastman built their home at **4716 North Wilshire Drive** in 1929. Eastman was the president of the William O. Goodrich Company, a subsidiary of the Archer-Daniels-Midland Company. As previously noted, a subsequent owner was Angela Johnston, mother of actress Kristen Johnston, who lived there during Kristen's high school years at Whitefish Bay. Roy C. Otto, the architect and builder for the Eastman home, also designed over a dozen residences in the Washington Highlands district of Wauwatosa. The Eastman House is individually eligible for placement in the National Registry.

The brick Colonial Revival residence at **4890 North Lake Drive** was the home of Otto L. and Lillian R. Kuehn, built in 1922. Kuehn was the president of the Otto L. Kuehn Company, a nationally known food brokerage firm. Kuehn was the first president of the West Park Zoological Society, which supported the West Park Zoo, then located in Washington Park.

A Celebration of Architecture and Character

The brick Georgian Revival residence at **4811 North Lake Drive** was built in 1930 for James J. McClymont, president of McClymont Marble Manufacturers and Contractors. The ten-room McClymont home was designed by noted architect Alexander Hamilton Bauer. Marble is used extensively throughout the house.

The Herman and Blanche Reel House at **4640 North Lake Drive** is an imposing Tudor Revival residence constructed between 1928 and 1929. A German immigrant, Reel opened a fur shop in downtown Milwaukee that became highly successful. A subsequent owner was attorney Herbert Spenner, one of the most prominent members of Milwaukee's German American community. Spenner served as legal representative for the governments of West Germany and Austria in Wisconsin for twenty years. The home was designed by architect Richard Philipps, who also was involved in the design of the Schuster Department Stores, the St. Joseph's Chapel at the School Sisters of St. Francis Convent and Holy Hill National Shrine in Hubertus, Wisconsin. The Herman and Blanche Reel House is listed in the Whitefish Bay Register of Historic Places.

As previously noted, Russell Barr Williamson and his wife, Nola Mae, lived in their Prairie-style home at **4860 North Oakland Avenue** for nearly twenty years. A major assistant to famed architect Frank Lloyd Wright, Williamson set up his own architectural practice in Milwaukee in 1919 and

James J. McClymont House, 4811 North Lake Drive, circa 1930. Designed by Alexander Hamilton Bauer.

worked here for four decades. He designed sixteen residences in Whitefish Bay, most in the more traditional styles of the day, including Tudor Revival, Spanish Revival and Mediterranean Revival. Nine of Williamson's homes are in the Lake Woods and Ortonwood Triangle Historic District. The Williamson House is individually eligible for listing in the National Registry.

In addition to the Pritzlaff, Eastman and Williamson homes, the following homes in the Lake Woods and Ortonwood Triangle historic district are individually eligible for listing in the National Registry:

- The Edward J. and Mary Cunningham House at **4773 North Cramer Street**, designed by noted architect Charles Valentine, built in 1931.
- The Herbert and Mildred Pritzlaff House at **2033 East Glendale Avenue**, 1926
- The George H. and Susanne H. Salentine House at **1830 East Hampton Road**, 1927
- The Richard D. and Agetha Harvey House at **4965 North Lake Drive**, a Russell Barr Williamson–designed house built in 1929.

Edward J. and Mary Cunningham House, 4773 North Cramer Street, circa 1931. Designed by noted architect Charles Valentine.

- The George and Margaret Schueller House at **4837 North Lake Drive**, a Russell Barr Williamson home built in 1926.
- The Fred O. and Viola Mueller House at **4604 North Murray Avenue**, 1928
- The Harry W. and Helena M. Bogner House at **4530 North Murray Avenue**, 1927
- Henry J. and Frances Stolz House at **4742 North Wilshire Road**, 1930
- The E.A. and Anita Weschler House at **4724 North Wilshire Road**, designed by noted architect Armin Frank, built in 1929.
- The Melvin W. and Marion Andres House at **4707 North Wilshire Road**, 1927
- The Herman and Anna Laabs House at **4706 North Wilshire Road**, 1928
- The Kellogg Patten House at **4684 North Wilshire Road**, 1930
- The Fred C. and Virginia Doepke House at **4655 North Wilshire Road**, 1940

Herman and Anna Laabs House, 4706 North Wilshire Road, circa 1928.

E.A. and Anita Weschler House, 4724 North Wilshire Road, circa 1929. Designed by Armin Frank, who also designed the Casa del Lago.

Kellogg Patten House, 4684 North Wilshire Road, circa 1930.

The following homes in the Wilshire Historic District are individually eligible for listing in the National Registry:

- The Elbert S. and Margaret Hartwick House at **2321 East Glendale Avenue**, 1940
- Dr. N.W. and Persephone Stathas House at **4629 North Lake Drive**, 1962
- The Stanley and Ruth Coerper House **4605 North Lake Drive**, 1950

The following homes on the east side of Lake Drive between Fairmount Avenue and the Shorewood village limits are individually eligible for placement in the National Registry:

- Roy W. and Viola A. Johnson House at **4850 North Lake Drive**, 1941
- The Harold E. and Esther Constant House at **4514 North Lake Drive**, 1946

The following homes, in addition to those bold-faced above, are listed on the Whitefish Bay AHI:

- The Norman and Natalie Soref House, **4786 North Cramer Street**, a Russell Barr Williamson–designed home built in 1953.
- The Olaf T. Rove House at **4645 North Cramer Street**, a Cornelius Leenhouts–designed home built in 1927.
- The George L. and Carol R. Anderson House at **4600 North Cramer Street**, an Ernest Flagg–designed home built in 1925.
- The Harrison Hardie House at **4540 North Cramer Street**, an Ernest Flagg home built in 1925.
- The Rufus Arndt House at **4524 North Cramer Street**, an Ernest Flagg home built in 1925.
- The William and Meta Van Altena House at **1916 East Glendale Avenue**, an Ernest Flagg home built in 1925.
- The Julius H. and Emilie Gugler House at **1820 East Hampton Road**, a Russell Barr Williamson home built in 1924.
- The Richard Smith and Henrietta L. Davis House, **4901 North Lake Drive**, a Russell Barr Williamson House built in 1926.

- The Charles E. and Dorothy Inbusch house at **4863 North Lake Drive**, a Russell Barr Williamson Mediterranean Revival home built in 1925.
- The Roy W. and Viola A. Johnson House at **4850 North Lake Drive**, built in 1941.
- The Frank S. and Jessie Boardman House, **4845 North Lake Drive**, a Russell Barr Williamson home built in 1925.
- The George and Margaret Schueller House at **4837 North Lake Drive**, a Russell Barr Williamson Mediterranean Revival house built in 1926.
- The Chester and Mabel Moody House, a Tudor Revival home at **4827 North Lake Drive**, built in 1927. Moody was president and treasurer of the Kozy Komfort Shoe Manufacturing Company in Milwaukee.
- The Walter F. and Marguerite Jahr House at **4730 North Lake Drive**, built in 1940.
- The Benjamin and Aimee Poss House at **4676 North Lake Drive**, built in 1929.

Chester and Mabel Moody House, 4827 North Lake Drive, circa 1927.

- The Dr. Jacques Hussussian House at **4668 North Lake Drive**, built in 1971.
- The B.G. Devan at **4601 North Murray Avenue**, an Ernest Flagg home built in 1924.
- The Dr. Edward J. Schleif House at **4850 North Oakland Avenue**, a Russell Barr Williamson house built in 1920.

APPENDIX

PROPERTIES ON THE WHITEFISH BAY ARCHITECTURE AND HISTORY INVENTORY (AHI)

Location	Historic Name	Status	Local No.	Circa
4819 N. Ardmore Ave.	Roundy Memorial Baptist Church		149	1938
4945 N. Bartlett Ave.	The Stanley E. and Katherine B. Wilson Residence		113	1937
6017 N. Bay Ridge Ave.	Edward A. and Shirley Miller (Thomas Lee Miller Childhood Home)		222	1937
6110 N. Bay Ridge Ave.	Trayton H. and Marjorie A. Davis	Individually Eligible for Listing in the NR	150	1930
314 E. Beaumont Ave.	Original WFB Village Hall		57	1893
517 E. Beaumont Ave.	Silver Spring Masonic Center	Individually Eligible for Listing in the NR	151	1964

Appendix

Location	Historic Name	Status	Local No.	Circa
739 E. Beaumont	Hatch, Horace W., House	On National and WI Registers	6	1925
5262 N. Berkeley Blvd.	Archibald and Eleanor O'Connor		100	1928
5263 N. Berkeley Blvd.	Harold C and Marjorie P. Cheetham		101	1928
5320 N. Berkeley Blvd.	Frank J. and Jane J. Kelly		102	1928
5905 N. Berkeley Blvd.	Lester and Grace Arnow House (Craig Counsell Childhood Home)		223	1950
5936 N. Berkeley Blvd.	The Edward McIntyre Residence		111	1930
5967 N. Berkeley Blvd.	Frederick and Anna Grams		145	1869
823 E. Birch Ave.	Wm. J. Oswald, then Bernard F. and Elsie Kuchlorn	Individually Eligible for Listing in the NR	152	1922
827 E. Birch Ave.	Wm. J. Oswald, then Jos. T and Mary R. Gallagher	Individually Eligible for Listing in the NR	153	1922
700 E. Briarwood Pl.	Joseph E. & Josephine Langlois House		55	1892
735 E. Briarwood Pl.	Gordon F. and Doris D. Daggett		95	1929
710 E. Carlisle Ave.	Henry C. Hettelsater		94	1928
1700 E. Chateau Pl.	Shorecliffs Apartments/E Ray Tompkins	Individually Eligible for Listing in the NR	58	1922
1712 E. Chateau Pl.	Shorecliff Apartments Carriage House	Individually Eligible for Listing in the NR	154	1923

APPENDIX

Location	Historic Name	Status	Local No.	Circa
968 E. Circle Dr.	Otto Robert and Valeska Kuehn	Individually Eligible for Listing in the NR	155	1924
984 E. Circle Dr.	Grant, Paul S., House	On National and WI Registers	4	1925
988 E. Circle Dr.	Alexander Hamilton Bauer House	Individually Eligible for Listing in the NR	71	1929
998 E. Circle Dr.	Robert B. and Ivy E. Asquith Residence	Individually Eligible for Listing in the NR	18	1923
1013 E. Circle Dr.	Arthur D. & Elizabeth Gross House	Individually Eligible for Listing in the NR	156	1925
1071 E. Circle Dr.	Mel D. and Marion Newald House/ Leon F. and Mildred Florence (Kruger) Foley House		224	1928
1074 E. Circle Dr.	Harry R. & Katherine Foerster House	Individually Eligible for Listing in the NR	157	1925
1093 E. Circle Dr.	McCoy, J.J.	Individually Eligible for Listing in the NR	16	1927
1101 E. Circle Dr.	Roethe, A.J.		17	1927
1086 E. Circle Dr.	Edward John and Florence Hornbach		97	1928
5685 N. Consaul Pl.	Gordon and Ruth Nelson Home		79	1921
4524 N. Cramer St.	Arndt, Rufus, House	On National and WI Registers	1	1925
4540 N. Cramer St.	Hardie, Harrison, House	On National and WI Registers	5	1925

APPENDIX

Location	Historic Name	Status	Local No.	Circa
4600 N. Cramer St.	Gabel, George, House	On National and WI Registers; Milwaukee County Landmark	3	1920s
4645 N. Cramer St.	Olaf T. Rove House		148	1927
4773 N. Cramer St.	Edward J. & Mary Cunningham House	Individually Eligible for Listing in the NR	158	1931
1620 E. Cumberland Blvd.	William & Ida Temkin House	Individually Eligible for Listing in the NR	159	1929
4800 N. Cumblerland Blvd.	Dar and Jeanne Vriesman Residence: The Concrete Demonstration House	Individually Eligible for Listing in the NR	84	1940
4903 N. Cumberland Blvd.	Clem and Fawn C. Kalvelage		98	1928
5456 N. Danbury Rd.	Nora I. Meahan		63	1922
5461–5463 Danbury Rd.	Allen H. Barfield House/Fred S. Staples Doublehouse	On National and WI Registers	2	1924
5464 N. Danbury Rd.	Thomas F. and Adele Regan	Individually Eligible for Listing in the NR	160	1920
415 E. Day Ave.	The Whitefish Bay Club, aka The Suburban Club, aka W.H. Goodall's Building		124	1896
506 E. Day Ave.	Mrs. Harry (Emma) Barlow's House		125	1896
516 E. Day Ave.	Robert McAllister's House	Individually Eligible for Listing in the NR	126	1893–94

Appendix

Location	Historic Name	Status	Local No.	Circa
524 E. Day Ave.	L.L. Disbro's House	Individually Eligible for Listing in the NR	127	1892–93
531 E. Day Ave.	Clarence and Cora Powers' House		128	1893
601 E. Day Ave	The Frank Baker House	Received WFB Landmark Status	74	1928
615 E. Day Ave.	A. Cressy Morrison's Cottage		129	1897
624 E. Day Ave.	Built for Alonzo Fowle; Hayes House	Individually Eligible for Listing in the NR	19	1892
639 E. Day Ave.	Benjamin A. Keikhofer House	Individually Eligible for Listing in the NR	161	1922
700 E. Day Ave.	Mrs. Marie Gether's House		130	1893
708 E. Day St.	Curtis House		53	1892
716 E. Day Ave.	Herbert Kinne's House	Individually Eligible for Listing in the NR	56	1892
723 E. Day Ave.	Frank Baltes's House	Individually Eligible for Listing in the NR	131	1892-93
726 E. Day Ave.	C. Robert Gether's House		132	1892
738 E. Day Ave.	Glendale Realty Co. Cottage		133	1880s
746 E. Day Ave.	James J. Perkins's House		134	1894
752 E. Day Ave.	Gregg Family Cottage	Individually Eligible for Listing in the NR	135	1880s
E. Day Ave.	Day Ave. Historic District	Milwaukee County Historic District	70	

Appendix

Location	Historic Name	Status	Local No.	Circa
5220 N. Diversey Blvd.	The Alfred A and Lydia Schmitt Residence		110	1928
5327 N. Diversey Blvd.	Henry & Helen Turrie House	Individually Eligible for Listing in the NR	162	1935
5549 N. Diversey Blvd.	Marshall and Eleanor Bautz Residence		218	1935
5561 N. Diversey Blvd.	Peter F. & Christene Hansen House	Individually Eligible for Listing in the NR	163	1926
5518 N. Diversey Blvd.	Jesse and Leona Taylor/Elsie Parker		105	1928
1200 E Fairmont Ave.	Whitefish Bay High School		20	1932
225–229 E. Fairmount Ave.	The Robert L Reisinger Construction Bldg.		120	1928
707 E. Fleetwood Pl.	Joseph Patza House	Individually Eligible for Listing in the NR	164	1910
828 E. Glen Ave.	John Hoeffner for his mother		217	1893
840 E. Glen Ave.	William Fritzke House	Individually Eligible for Listing in the NR	165	1895
1916 E. Glendale Ave.	Van Altena, William, House	On National and WI Registers; Milwaukee County Landmark	12	1925
2033 E. Glendale Ave.	Herbert & Mildred Pritzlaff House	Individually Eligible for Listing in the NR	166	1926

Appendix

Location	Historic Name	Status	Local No.	Circa
2321 E. Glendale Ave.	Elbert S. & Margaret Hartwick House	Individually Eligible for Listing in the NR	167	1940
400 E. Hampton Rd.	The Ludwig Leu/Adelaide Mohr Farmhouse		117	1886
519 E. Hampton Rd.	The Ludwig Leu Farmhouse		118	1880
1200 E. Hampton Rd.	Bay Shore Evangelical Lutheran Church	Individually Eligible for Listing in the NR	168	1949
1512 E. Hampton Rd.	James F. Campbell Log House		221	1921
1820 E. Hampton Rd.	Julius H. and Emilie Gugler Residence		21	1924
1830 E. Hampton Rd.	George and Susanne Salentine Residence	Individually Eligible for Listing in the NR	22	1926
106 W. Henry Clay St.	The Henry Kaestner/Fred and Clara (Kaestner) Mohr Farmhouse		116	1880
700 E. Henry Clay St.	Lee-Mar, Inc. Apartment Building	Individually Eligible for Listing in the NR	169	1954
1225 E. Henry Clay St.	Whitefish Bay National Guard Armory	On National and WI Registers; Milwaukee County Landmark	14	1928
1225 E. Henry Clay St.	12 Pounder Napoleon Gun #276		59	1863
1241 E. Henry Clay St.	Friedrick Gustave Rabe House		23	1870
1305 E. Henry Clay St.	John and Anna Pandl House		225	1925

Appendix

Location	Historic Name	Status	Local No.	Circa
1319 E. Henry Clay St.	Pandl's Whitefish Bay Inn	Milwaukee County Landmark	69	1900
1500 E. Henry Clay St.	Ralph and Sylvia Feerick	Individually Eligible for Listing in the NR	170	1939
4736 N. Hollywood Ave.	Tom P. Gullette House (Bernardine and Jennifer Dohrn Childhood Home)		226	1947
5346 N. Hollywood Ave.	Paul C. and Jeanne D. Winner		103	1928
4617 N. Idlewild Ave.	The Robert B. and Mary Louise Ebert Residence	Individually Eligible for Listing in the NR	115	1940
5007 N. Idlewild Ave.	Johann Bauch's Farmhouse		52	1865
5142 N. Idlewild Ave.	Final and Opal Young House (Miriam "Mimi" Bird Childhood Home)		227	1936
5251 N. Idlewild Ave.	The Leland and Sylvia Thorpe Residence, aka the Jane Archer Home		121	1926
5129 N. Kimbark Pl.	Sid and Shanah Stone House		228	1950
4514 N. Lake Dr.	Harold E. & Esther Constant House	Individually Eligible for Listing in the NR	171	1946
4605 N. Lake Dr.	Stanley & Ruth Coerper House	Individually Eligible for Listing in the NR	172	1950
4629 N. Lake Dr.	Dr. N.W. & Persephone Stathas House	Individually Eligible for Listing in the NR	173	1962

APPENDIX

Location	Historic Name	Status	Local No.	Circa
4640 N. Lake Dr.	The Herman Reel House	WFB Landmark Status	72	1928
4668 N. Lake Dr.	Dr. Jacques Hussussian		25	1971
4730 N. Lake Dr.	Walter F. & Marguerite Jahr		26	1940
4811 N. Lake Dr.	James J. McClymont		27	1930
4827 N. Lake Dr.	Chester and Mabel Moody		68	1927
4837 N. Lake Dr.	4837 N. Lake Dr. (Also listed as local no. 60)	Individually Eligible for Listing in the NR	28	1926
4837 N. Lake Dr.	George Schueller House		60	1926
4850 N. Lake Dr.	Roy W. & Viola A. Johnson House	Individually Eligible for Listing in the NR	174	1941
4863 N. Lake Dr.	Charles E. Inbusch House		61	1925
4890 N. Lake Dr.	Otto L. and Lillian Kuehn		29	Prior to 1922
4965 N. Lake Dr.	Doll Cokins House; aka Richard D and Agetha R. Harvey House	Individually Eligible for Listing in the NR	66	1929
5000 N. Lake Dr.	Big Bay Park		89	1940
5073 N. Lake Dr.	Leonard L. & Laura H. Bowyer House	Individually Eligible for Listing in the NR	175	1931
5200 N. Lake Dr.	Benjamin & Anna Rosenberg House	Individually Eligible for Listing in the NR	30	1927
5220 N. Lake Dr.	H.C. Wuesthoff	Individually Eligible for Listing in the NR	31	1924

Appendix

Location	Historic Name	Status	Local No.	Circa
5240 N. Lake Dr.	Carl Herzfeld House	Individually Eligible for Listing in the NR	32	1924
5290 N. Lake Dr.	B.F. Saltzstein	Individually Eligible for Listing in the NR	33	1928
5312 N. Lake Dr.	Judge Joseph A. Padway	Individually Eligible for Listing in the NR	34	1930
5320 N. Lake Dr.	Harry and Ada LeVine	Individually Eligible for Listing in the NR	35	1930-31
5370 N Lake Dr.	Harry J. Grant	Individually Eligible for Listing in the NR	36	1923
5375 N. Lake Dr.	John E. Saxe House	Individually Eligible for Listing in the NR	176	1929
5400 N. Lake Dr.	W.B. Robertson		37	1921
5425 N. Lake Dr.	Bernard Klatt House	Individually Eligible for Listing in the NR	177	1918
5486 N. Lake Dr.	Armin C. Frank		38	1924
5559 N. Lake Dr.	The Henry R. and Marian King Home		80	1890s
5569 N. Lake Dr.	The James and Anna McGee Home		81	1890s
5570 N. Lake Dr.	Casa del Lago; Also known as the Armin Frank/Blankenheim House	Individually Eligible for Listing in the NR/Milwaukee County Landmark	40	1927
5623 N. Lake Dr.	Whitefish Bay Pharmacy Building	Individually Eligible for Listing in the NR	178	1950

Appendix

Location	Historic Name	Status	Local No.	Circa
5655 N. Lake Dr.	Christ Church Episcopal	Individually Eligible for Listing in the NR	39	1925
5670 N. Lake Dr.	Otto H. and Edna J. Fiebing Residence		220	1925
5915 N. Lake Dr.	Reinhold and Anna Knop House		83	1893
5925 N. Lake Dr.	Alfred Knop House		139	1920s
5955 N. Lake Dr.	Ferdinand Grams		140	1910s
5960 N. Lake Dr.	Raymond & Teresa Jaekels House	Individually Eligible for Listing in the NR	179	1929
5966 N. Lake Dr.	Arthur J. & Margaret Butzen House	Individually Eligible for Listing in the NR	180	1940
6018 N. Lake Dr.	Dr. B.G. Narodick		143	1955
4676 N Lake Dr.	Benjamin and Aimee Poss		24	1929
5688 N. Lake Dr.	Dr. Bruno Warschauer		106	1929
5270 N. Lake Dr.	Uihlein, Herman, House	On National and WI Registers; WFB Landmark Status	10	1918
6130 N. Lake Dr. Court	Rita Jane Goldmann House	Individually Eligible for Listing in the NR	181	1931
829 E. Lake Forest	McEwens, John F., House	On National and WI Registers	8	1925
135 E. Lake View Ave.	Dominican Convent	Individually Eligible for Listing in the NR	182	1960
808 E. Lake View Ave.	Galus Isenring		82	1870s
633 E. Lake View Ave.	Reinhold C. and Irene Diekelman		93	1928

Appendix

Location	Historic Name	Status	Local No.	Circa
4957 N. Larkin St.	N.A. and Audrey Humbaugh's residence; aka Jeffrey Hunter's House		123	1940–41
706 E. Lexington Blvd.	Walter L. and Irma S. Kuehn	Individually Eligible for Listing in the NR	183	1939
908 E. Lexington Blvd.	Edward & Elinor Wenzel House	Individually Eligible for Listing in the NR	184	1931
912 E. Lexington Blvd.	Williams, Frank J., House	On National and WI Registers; WFB Landmark Status	15	1925
1016 E. Lexington Blvd.	Sperling, Frederick, House	On National and WI Registers	9	1924
1017–1019 E Lexington Blvd.	Lillie Ketchum Duplex		65	1925
1028 E. Lexington Blvd.	Jenkins, Halbert D., House	On National and WI Registers	7	1924
1100 E. Lexington Blvd.	Gustave N. and Clara Hansen (or Hanson)	Individually Eligible for Listing in the NR	185	1929
1124 E. Lexington Blvd.	L.E. and Alma L. Bartholomew	Individually Eligible for Listing in the NR	186	1930
5205 N. Lydell Ave.	Lydell School	Individually Eligible for Listing in the NR	187	1955
6156 N. Lydell Ave.	Anthony & Pearl Sottile House	Individually Eligible for Listing in the NR	188	1951
5843 N. Maitland	Sidney Siesel House		144	1950
4780 N. Marlborough Dr.	Humboldt School (Cumberland School)	Individually Eligible for Listing in the NR	189	1927

Appendix

Location	Historic Name	Status	Local No.	Circa
5445 N. Marlborough Dr.	Schoolhouse Park		219	1892
4530 N. Murray Ave.	Harry W. & Helen M. Bogner House	Individually Eligible for Listing in the NR	190	1927
4601 N. Murray Ave.	Van Devan, G.B., House	On National and WI Registers; Milwaukee County Landmark	13	1927
4604 N. Murray Ave.	Fred O. & Viola Mueller House	Individually Eligible for Listing in the NR	191	1928
4614 N. Murray Ave.	Frederick C. and Adele (Kanaley) Miller House (Miller Honeymoon Cottage)		229	1930
4780 N. Newhall St.	Albert P. and Marcella Kohler House		146	1929
4773 N. Oakland Ave.	John R. and Fannie Moore	Individually Eligible for Listing in the NR	41	1940
4850 N. Oakland Ave.	Dr. Edward J. Schleif House		62	Prior to Oct. '22
4860 N. Oakland Ave.	Russell Barr Williamson Residence	Individually Eligible for Listing in the NR	42	1921
4631–4633 N. Oakland Ave.	H.C. Beverung House		216	1895
5020 N. Santa Monica Blvd.	The Julius and Pauline Leu/Lester Mohr Farmhouse		119	1880
5226 N. Santa Monica Blvd.	The Erich F. Hartert Residence	Individually Eligible for Listing in the NR	114	1936

Appendix

Location	Historic Name	Status	Local No.	Circa
5260 N. Santa Monica Blvd.	B.F. Fisher House	Individually Eligible for Listing in the NR	67	1929
5635 N. Santa Monica Blvd.	Saint Monica School	Individually Eligible for Listing in the NR	192	1928
5654 N. Santa Monica Blvd.	William H. and Ruth Consaul's Home		76	1880s
5668 N. Santa Monica Blvd.	William T. Consaul Bunkhouse		44	1870s
5681 N. Santa Monica Blvd.	Saint Monica Convent	Individually Eligible for Listing in the NR	193	1950
5682 N. Santa Monica Blvd.	William T. Consaul Home		77	1880s
5700 N. Santa Monica Blvd.	Frank Consaul Home		78	1893
5754 & 5758 N. Santa Monica Blvd.	Margaret Brueck Bauer (5754) and Neil and Marie Manson (5758)	Individually Eligible for Listing in the NR	194	1926
5775 N. Santa Monica Blvd.	F.H. and Amy Wallace House	On National and WI Registers	11	1925
5812 N. Santa Monica Blvd.	Richards School	Individually Eligible for Listing in the NR	45	1928
5932 N. Santa Monica Blvd.	Joseph and Magdalena Patza's House		138	1860s
6166 N. Santa Monica Blvd.	Carl Steffen House		137	1860s
6310 N. Santa Monica Blvd.	Gottfried and Caroline Funke's House		136	1880s
6344 N. Santa Monica Blvd.	The Fred Zindler Residence		92	1936

Appendix

Location	Historic Name	Status	Local No.	Circa
6350 N. Santa Monica Blvd.	The John and Mina Heims' Farmhouse		141	1870s
6201 N. Santa Monica Blvd.	University School Milwaukee		46	1917
5221 N. Santa Monica Blvd.	Werner J. and Beulah L. Trimborn		99	1928
5501 N. Santa Monica Blvd.	Chester A. and Esther M. Cook		104	1928
4737 N. Sheffield Ave.	John Douglas and Myrtle Edwards		108	1930
5626 N. Shore Dr.	G.C. and Marvel Leucks	Individually Eligible for Listing in the NR	195	1939
5655 N. Shore Dr.	M.W. and Sophia Margolis	Individually Eligible for Listing in the NR	196	1939
5664 N. Shore Dr.	Clare H. Hall House	Individually Eligible for Listing in the NR	64	1921
5674 N. Shore Dr.	Dr. Dexter H. & Margaret Witte House	Individually Eligible for Listing in the NR	197	1928
5731 N. Shore Dr.	Gerhard H. & Marjorie Kopmeier House	Individually Eligible for Listing in the NR	198	1929
5770 N. Shore Dr.	F. H. Miller House	Individually Eligible for Listing in the NR	199	1921
5776 N. Shore Dr.	Arthur & Arline O'Connor House	Individually Eligible for Listing in the NR	200	1921
5822 N. Shore Dr.	John and Tillie M. Geerlings House		147	1927
5827 N. Shore Dr.	Dr. Edwards H. & Katherine Mensing House	Individually Eligible for Listing in the NR	201	1927

Appendix

Location	Historic Name	Status	Local No.	Circa
5867 N. Shore Dr.	Dr. Leon H. & Mrs. Thelma Guerin House	Individually Eligible for Listing in the NR	202	1936
5960 N. Shore Dr.	George J. and Lucille M. Meyer Home	Individually Eligible for Listing in the NR	88	1934
5961 N. Shore Dr.	The W.E. Gifford Residence		122	1949–51
6009 N. Shore Dr.	Howard and Mary Tobin	Individually Eligible for Listing in the NR	142	1939
5701 N. Shoreland Ave.	Lewis P. and Bernadette Kiehm		107	1928
120 E. Silver Spring Dr.	Dominican High School	Individually Eligible for Listing in the NR	203	1956
130–134 W. Silver Spring Dr.	Richard Seyfert Residence		47	Prior to 1897
160 E. Silver Spring Dr.	St. Monica's Catholic Church	Individually Eligible for Listing in the NR	43	1938–55
205–227 E. Silver Spring Dr.	Bay Colony Building	Individually Eligible for Listing in the NR	204	1946
302–338 E. Silver Spring Dr.	Fox Bay Theater Building	Individually Eligible for Listing in the NR		
401, 403, 409 & 415 E. Silver Spring Dr.	Berkeley Building	Individually Eligible for Listing in the NR	205	1961
427 E. Silver Spring Dr.	Powell Building		48	1926
501–513 E. Silver Spring Dr.	Gotfredson Building	Individually Eligible for Listing in the NR	49	1930
716 E. Silver Spring Dr.	William Consaul Sr. Home		75	1853

Appendix

Location	Historic Name	Status	Local No.	Circa
721 E. Silver Spring Dr.	First Church of Christ, Scientist	Individually Eligible for Listing in the NR	206	1950
736 E. Sylvan Ave.	Adolph H. & Grace R. Weber House	Individually Eligible for Listing in the NR	207	1928
802 E. Silver Spring Dr.	William H. Sherman Home		86	1892
920–922 E. Sylvan Ave.	The Frederick G. Isenring Residence (Home of the First Village President)		73	1892
942–944 E. Sylvan Ave.	Residence; The "Pines"		85	1890s (or earlier)
1032 E. Sylvan Ave.	The Carl and Gertrude Daun Residence		109	1928
1134 E. Sylvan Ave.	The David and Dorothy K Resnick Residence		112	1937
1025 E. Sylvan Ave.	Albert S. and Leah Ethridge		96	1929
4815 N. Wildwood Ave.; 4810 N. Marlborough Dr.	Holy Family Catholic Church and Rectory	Individually Eligible for Listing in the NR	208	1969
4825 N. Wildwood Ave.	Holy Family Convent	Individually Eligible for Listing in the NR	209	1960
4849 N. Wildwood Ave.	Holy Family Parish School	Individually Eligible for Listing in the NR	210	1953
4655 N. Wilshire Rd.	Fred C. & Virginia Doepke House	Individually Eligible for Listing in the NR	211	1940

Appendix

Location	Historic Name	Status	Local No.	Circa
4684 N. Wilshire Rd.	Kellogg Patton	Individually Eligible for Listing in the NR	212	1930
4706 N. Wilshire Rd.	Herman & Anna Laabs House	Individually Eligible for Listing in the NR	213	1928
4707 N Wilshire Rd.	Melvin W. Andres	Individually Eligible for Listing in the NR	50	1927
4716 N. Wilshire Rd.	Whitney H. and Anna M. E.man Residence	Individually Eligible for Listing in the NR	90	1929
4724 N Wilshire Rd.	E.A. Weschler	Individually Eligible for Listing in the NR	51	1929
4725 N. Wilshire Rd.	The Edward F. and Erna M. Pritzlaff Residence	Individually Eligible for Listing in the NR	91	1925
4742 N. Wilshire Rd.	Henry J. and Frances Stolz	Individually Eligible for Listing in the NR	214	1930
4864 N. Woodburn St.	Raymond C. & Kathleen Shank House	Individually Eligible for Listing in the NR	215	1927

INDEX

A

All-Electric demonstration house 175
Archer, Jane 105, 187
Armory 18, 34, 70, 71, 72, 74, 75, 157, 158

B

Baker, Frank E. 111
Balistreri family 143, 144
Baltes, Frank 43
Bank of Whitefish Bay 30, 141, 177
Bauch, Johann 34
Bauer, Alexander Hamilton 77, 118, 154, 178, 207
Bay Bakery 140, 141, 143
Bay Colony Building 136
Bay Ridge and Kent Avenues Historic District 171
Bay Shore Evangelical Lutheran Church 152
Bay Village Historic District 201
Bentley Brothers Inc. 60
Berkeley Building 138
Best, Jacob 103
Best, Philip 53
Beverung, H.C. 35
Big Bay Park 199, 200
Big Bay Park Historic District 199
Bird, Miriam "Mimi" 36, 108
Bolte, F.H. 35
Buckley Park 200
Buckley, Thomas F. 200
Bues, Arthur F. 178

C

Caraway, Jesse Claude "Cary" 124
Casa del Lago 49, 179
Cassel, Conrad 135
Christ Episcopal Church 147, 148, 159
Colnik, Cyril 63, 64, 109
Concrete Demonstration House 195

Index

Consaul family 18, 24, 25, 26, 27, 28
Counsell, Craig 97
Cumberland Forest and Palo Alto Historic District 197
Cumberland School 19, 103, 157
Curtis, Alice 40, 154, 166

D

Dan Fitzgerald Pharmacy 143, 144
Day Avenue 18, 19, 32, 36, 38, 39, 40, 42, 43, 45, 46, 47, 48, 56, 104, 105, 111, 112, 133, 135, 154, 166, 176, 191
Day, Fred T. 36
Dean, Randolph and Robert 167
Dewhurst, Colleen 89, 154, 193
Disbro, L.L. 42, 166
Divinity Evangelical Lutheran Church 153
Dohrn, Bernardine 86, 154
Dohrn, Jennifer 86, 88, 89
Dominican High School 148, 149, 150, 179
"Dummy Line" 18, 38

E

Eastman, Whitney H. 91, 206
Edwards, John D. 118, 128
Elliott, Robert 168
Elliott, Samuel L. 168

F

Fairmount and Highland View Historic District 191, 193, 195
Feerick, Ralph C. 201
Feldstein, William 75
First Church of Christ, Scientist 65, 77, 153, 154
Flagg, Ernest 31, 118, 166, 170, 174, 182, 184, 203, 211, 213
Foley, Leon 178
Fowle, Alonzo 19, 40, 42, 56, 166
Fox Bay Building 137, 138
Fox Bay Theater 136, 143, 150
Frank, Armin 52, 53, 55, 118, 179, 209
Frank, Dr. Louis 53, 54
Frank, Ella 49, 52, 53, 54
Fritzke, William 35
Froedtert, Kurtis 68
Funke, Gottfried 32

G

George Washington 1776 Masonic Lodge No. 337 159
Gether, C. Robert 38, 42, 43, 166
Glendale Realty Company 40
Goldmann, Rita Jane 164
Goodall, W.H. 46
Gotfredson Building 31, 141
Grams, Frederick 32
Grant, Harry J. 58
Gregg, James R. 40

H

Heaney, Kathleen 103
Heil, Julius Peter 67
Heims, John 32
Herzfeld, Carl 66, 126
Heyl, Jacob 53
Hickey, C. Hugh 115

INDEX

Hillel Academy 159
Historic Preservation Commission 15
Holy Family Church 150
Humboldt School 156
Hunter, Jeffrey 81, 84, 193

I

Idlewild Historic District 184, 185
Isenring family 22, 28, 29, 30, 95, 141, 166, 177, 185

J

James Campbell House 193
Jewish Community Center 19, 159
Johnston, Kristen 91, 92, 206
Juneau, Solomon 21, 56

K

Kaestner, George 22
Kaminski, Sally-Anne 114
Kersten, Charles J. 45
Kiekhofer, Benjamin A. 46
King, Henry 19, 42, 56
Kinne, Herbert 43
Kirchhoff and Rose 63, 64, 136, 184
Klode, Frank 116, 117
Klode Park 18, 32, 35, 110, 111, 116, 124, 162, 166
Knop, Reinhold and Anna 35
Kuehn, Otto L. 76, 206

L

Lake Crest Historic District 107, 138, 187
"Lake Drive Twins" 19, 42, 56, 57
Lake Heights Historic District 162
Lake Woods and Orton Triangle Historic District 203, 205
Lawndale Historic District 31, 39, 47, 112, 166
Leenhouts 112, 118, 131, 132, 133, 151, 152, 167, 170, 198, 211
Lehrke, Jennifer 128
Leu, Julius 22, 23, 24
Lillydahl, Doug 197
Lydell School 157

M

Markson, Cathy 171, 172
McAllister, Robert 45
McClymont, James J. 77, 178, 207
McGee, James 19, 42, 56
McKinnies, Henry H. 81
Meredig, William 141
Meyer, George J. 110
Miller, Frederick C. 98, 99
Miller, Thomas Lee 173
Milwaukee and Whitefish Bay Railway 18, 38, 56
Milwaukee Country Day School 159
Milwaukee County Historical Society 34, 39, 53, 72, 75, 122, 126
Milwaukee Jewish Day School 159
Milwaukee Jewish Federation 159
Milwaukee, Lakeshore and Western Railway 18, 19, 185, 191

Index

Mohr, Adelaide 23
Mohr, John and Ava 22, 23
Mohr, Mary 22
Morrison, A. Cressy 47, 104, 105, 166

N

National Register of Historic Places 31, 34, 35, 40, 53, 66, 75, 92, 102, 118, 122, 136, 146, 164, 176, 178, 195, 203, 205, 206, 208, 211
Nehring, John 144

O

O'Heaney, Caitlin 103, 193
Old Schoolhouse Park 27, 154, 185, 187
Our Savior Lutheran Church 153

P

Pabst Brewing Company 95, 103, 104, 176, 178
Pabst, Capt. Frederick 53, 54, 191
Pabst Historic District 31, 55, 58, 60, 61, 63, 66, 68, 70, 95, 176, 178, 185
Pabst Whitefish Bay Resort 18, 19, 27, 28, 38, 39, 59, 68, 70, 74, 135, 191, 199, 200, 203
Padway, Joseph Arthur 60
Page, Sam 168
Pandl's 70, 71, 72
Patza, Joseph 32, 186
Perkins, James J. 45
Philipps, Richard 70, 79, 118, 207

Plunkett, Henry P. 137
Powell Building 140, 141
Prince, Joan 178
Pritzlaff, Edward 205

R

Rabe, Frederick Gustave 18, 33, 72, 74
Rambadt, Donald C. 17
Reel, Herman 77, 78, 79, 207
Richards School 157
Rosenberg, Benjamin 68
Roundy, Judson A. 151
Roundy Memorial Baptist Church 133, 151

S

Saltzstein, Benjamin F. 62, 63
Schandein, Ella 52, 53, 54
Schandein, Emil 53, 54
Schandein, Lisette 53, 54
Schandein Manson 55
Scheife, Lewis F. 26, 27
Schmidt, Dr. Henry 45
Schroedel, Francis J. 201
Sendik's Food Market 143
Seyfert, Richard 135
Sherman, William H. 35
State Historical Society 60, 64, 72, 124, 141, 145, 146, 153, 201, 205
Steffen, Carl and Hannah 32, 45
St. Monica Church 148, 150
St. Monica Convent 149
St. Monica School 148
Stone, John 110
Stone, Sid 108, 109

236

INDEX

T

Tullgren, Herbert W. 34, 74, 158
Tweedy Land Company 154

U

Uihlein, Herman and Claudia 63, 64, 65, 66, 72, 136, 154, 176, 184
United Methodist Church of Whitefish Bay 146, 159
University Bible Fellowship Church 151
University School 19, 159

V

Valentine, Charles 118
Vieau, Jacques 21, 56
Village Fruit Market 138

W

Weisel, Thomas "Thom" 112
Westphal, Col. Phillip C. 72, 186
Whitefish Bay Architecture and History Inventory 13, 14, 15, 24, 28, 57, 72, 80, 85, 108, 113, 122, 126, 129, 133, 141, 152, 158, 159, 169, 171, 182, 187, 189, 195, 198, 211
Whitefish Bay Armory 18, 34, 71, 74, 151
Whitefish Bay High School 19, 34, 81, 86, 88, 89, 90, 92, 96, 97, 98, 103, 107, 110, 113, 114, 115, 150, 157, 167, 168, 172, 197
Whitefish Bay Historical Society 107
Whitefish Bay Middle School 18, 70, 153, 154, 191
Whitefish Bay Pharmacy 144
Whitefish Bay Register of Historic Places 14, 66, 79, 112, 167, 207
Whitefish Bay School District 155, 157
Whitefish Bay State Bank 141, 145
Whitefish Bay Women's Club 154, 160
Williams, Dr. Thaddeus W. 29, 93, 94, 95, 177
Williamson, Russell Barr 67, 79, 80, 118, 123, 180, 182, 189, 207, 208, 209, 211, 212, 213
Wilshire Historic District 203, 204, 205, 211
Wisconsin Historical Society 146, 162
Wright, Frank Lloyd 123, 124, 207

Z

Zien, Jerome "Chip" 96
Zilber, Joseph J. 164
Zuckerman, Angela 113

ABOUT THE AUTHORS

Jefferson J. Aikin, a former journalist for the *Milwaukee Sentinel* and the *Associated Press*, is president of the Whitefish Bay Historic Preservation Commission and a member of the Whitefish Bay Historical Society.

Thomas H. Fehring's previous work with Arcadia Publishing and the History Press includes *Images of Whitefish Bay* and *Chronicles of Whitefish Bay*. He is co-founder of the Southeastern Wisconsin chapter of the Society for Industrial Archeology and a member of the Historic Preservation Commission, as well as the Whitefish Bay Historical Society.

Visit us at
www.historypress.net

This title is also available as an e-book